Successful Self-Promotion
for Photographers

Successful
Self-Promotion
for Photographers

Expose Yourself Properly

Elyse Weissberg

with Amanda Sosa Stone

AMPHOTO BOOKS

an imprint of Watson-Guptill Publications/New York

Acknowledgments

The author and editors wish to credit the following people for
their contributions to this book:
Emily Vickers; American Association of Advertising; Amanda
Sosa Stone; Trudy Comarnitsky; Katie Wacha; ASMP Articles;
Peter Skinner; Lucy Raimengia; SI; Steve Fine & James Colton;
JoAnn Giaquinto; Carol Brandwein; Andrea Kaye; Heather
Duggan; Brewer-Cantelmo; Keith Gentile; SPAR.

Special thanks go to Ted, Sonny, and Hannah Spero; Katie
Wacha; and Amanda Sosa Stone.

HALF-TITLE PAGE: Gary Parker
TITLE PAGE: Hoachlander Davis Photography

Text copyright © 2004 Elyse Weissberg.
Unless otherwise noted, all photographs or other images in
this book are copyrighted © by the photographers, publications,
or other persons credited.

First published in 2004 by Watson-Guptill Publications,
a division of VNU Business Media, Inc.,
770 Broadway, New York, NY 10003
www.wgpub.com

ISBN-13: 978-0-8174-5926-0
ISBN: 0-8174-5926-X
Library of Congress Cataloging-in-Publication Data is available from
the Library of Congress.

Senior Acquisitions Editor: Victoria Craven
Editors: Patricia Fogarty, Stephen Brewer, Elizabeth Wright
Photo Editor: Amanda Sosa Stone
Designer: Areta Buk/Thumb Print
Production Manager: Ellen Greene

Manufactured in Malaysia
First printing, 2004

3 4 5 6 7 8 9 / 08 07 06

Contents

About
Elyse Weissberg

Born in Washington, D.C., on April 9, 1956, Elyse Weissberg grew up in New York City and Rockland County, New York. She studied painting at the Rochester Institute of Technology and in 1978 graduated with a degree in fine art. After spending a few years in Washington pursuing her art career, she returned to New York in 1982. The following year she began her career as a photographer's representative.

Elyse brought to her work a wonderful personality—she was sparkling and smart— and high standards of professionalism. She was widely respected in the business by photographers and clients alike. Elyse was known for her innovative ideas as she promoted and provided creative consultations to many of the country's top photographers. She forged strong personal relationships with people throughout the industry and won top accounts for the people she represented.

A strong supporter of industry trade associations, Elyse often gave presentations and seminars. One of the most popular was "Expose Yourself . . . Properly: Proven Strategies for Creating a Successful Portfolio and Marketing Plan," which she used as the basis for this book.

After a long illness, Elyse died on July 21, 2001. Everyone in the industry who knew Elyse will remember her generosity and her consistently upbeat attitude— about her work, about people, and about life in general.

JAMEY STILLINGS

Foreword

In March 1987 I started working at an entry-level advertising job as an art buyer at D'Arcy Masius Benton & Bowles advertising agency. My previous job had been in public relations, and I knew very little about the workings of an ad agency and absolutely nothing about art buying. During that first day on the job I kept busy leafing through photography sourcebooks, trying to familiarize myself with the world of commercial photography.

Just before noon the phone rang. The very friendly person on the other end identified herself as Elyse Weissberg. She said she was a photographers' agent and wanted to set up an appointment to show me portfolios. I was a little afraid to meet with Elyse, as I had never met with a photo agent or seen a portfolio. But she sounded warm and kind, and since my calendar was completely open, we planned to meet the next morning. I'll never forget meeting Elyse—she was like a force of nature. She had such genuine enthusiasm and love for what she did. She cared deeply about her photographers, her fellow agents, and the advertising industry. She made me excited to be a part of it all.

Elyse quickly saw my inexperience and decided to take me on as her personal project. She taught me everything I needed to know to be a successful art buyer—the fundamentals of good photography, the technical aspects of lighting, visual aesthetics, the fine art of negotiation, and how to evaluate a photographer's work for commercial applications.

Elyse instilled so much confidence in me that after only two years at my first job I pursued a more senior-level art buying job at another agency, Young & Rubicam—and got it. I owed a lot of my quick advancement to Elyse's tremendous belief in me and to her support. It was also Elyse who was least surprised when, several years later, I was offered the much-coveted position of Manager of the Art Buying Department of the advertising agency Foote, Cone & Belding.

After working as a photographers' agent for many years, Elyse expanded her business to include photography consultations. She said she was so often asked to critique photographers' portfolios that perhaps she could turn it into a business opportunity. Elyse's consulting business was an immediate and huge success. She consulted photographers individually and traveled the United States speaking to large groups about self-promotion, marketing, and artful negotiation. Elyse was also a mentor to photography students, employing one each college semester to work in her office as an intern. Students everywhere clamored to be chosen by her.

One day in March 1999, as I sat at my desk leafing through photography sourcebooks (kind of like that March day twelve years earlier), the phone rang and it was Elyse. But her voice sounded different. She was in front of my office building and needed to see me—to tell me something. She had just come from the doctor and had been diagnosed with melanoma, a serious form of skin cancer. At the time, I was certain that there had to be a cure somewhere and that we just had to find the right doctor and the right medicine. Sadly, in spite of Elyse's positive outlook and incredible bravery, and the valiant efforts of her family to find a cure, Elyse lost her battle with melanoma on July 21, 2001. Even in Elyse's final days, she worked tirelessly on the completion of this book. She had a huge amount of incredible knowledge and wanted to share it with the photographers she might never get to meet.

I was so very fortunate to have met Elyse and to have become her friend. She was an original—there was no one like her. Elyse had the trust and respect of clients and colleagues alike. We valued her wisdom, her common sense, her honesty, and, most of all, her passion for her profession. I hope that all the photographers who did not have the good fortune to meet with her will find, in this book, the next best thing to their own personal consultation with Elyse Weissberg—photo agent extraordinaire.

—Lucy Raimengia, Vice President, Art Buying Manager, Foote, Cone & Belding, New York City

Introduction

E lyse Weissberg was the best friend a photographer could ever hope to have. She was visual, and knew a good photograph when she saw one, and she was practical, too, and was a real pro at finding a market for a photograph. After many years working as a photographers'

representative and creative consultant, and speaking at seminars and conferences, she took an often-repeated question to heart. People would ask, "Why don't you write a book filled with your ideas for creating portfolios and marketing yourself in the photography business?" So Elyse sat down and did just that. She passed away soon after turning in the manuscript to her publisher, but a team of editors and her talented and gracious former assistant Amanda Sosa Stone took over the project from there.

With her typical professionalism and enthusiasm, and drawing on her own experience and that of the many professionals with

LONNA TUCKER

whom she worked over the years, Elyse amassed an enormous amount of information and set it down in book form. As always, she was thorough and detailed, with an eye for all those small incidentals that can make an enormous difference. These range from recognizing personality traits that can lead to success to knowing how to present a series of photographs on a portfolio spread.

As a result, this book serves as a stand-in for a series of sessions with a professional who had many, many success stories to her credit. Of course, there is no substitute for the presence of Elyse herself. Any photographer who ever worked with Elyse will forever remember those sparkling eyes, the wit, the shrewd observation, the force-of-nature energy, the unflagging practicality. Elyse was supportive, but not blindly so— a compliment from her was all the more special because it was founded on what she believed was the right way to present a photograph and do business.

In the following pages you will learn a lot about marketing yourself and becoming a successful photographer. Elyse Weissberg will continue doing her job. In her no-nonsense way, she will help you find your vision and your strengths and show you how to present these assets to the world.

Define Your Goals

MARCUS SWANSON

Getting Started

So you want to be a commercial photographer. First, let's do a reality check. The market is tough and very competitive. It can be hard to get your foot in the door. You must do a lot of up-front work to prepare yourself to go out there and enter the market: You need a portfolio, promotional pieces, contacts with whom you can meet and to whom you can send promotional materials. Once your foot is in the door, you will compete for job assignments against people with similar styles and qualities, and you must be able to offer something that other photographers can't.

*Know what you want
and try to capture
your vision in your
photography.*

It's not easy to establish yourself as a commercial photographer. But once you have gotten through the door, competed for and won jobs, and successfully completed work, the payoff is significant. Your ability to express yourself artistically and personally, and to experience an acknowledgment of your talents within the industry, provides a satisfying sense of achievement. Plus, you will be making money—provided, that is, you learn how to target your market properly. To be successful as a commercial photographer, you must be not only good but excellent at executing your art and skill and running your business.

The hardest part will be establishing yourself. And once you're established, you'll need to continue to actively promote yourself. In this book, I've condensed what I've learned about self-promotion in my years as a successful photographer's representative and creative consultant. I'll tell you how to get started, how to maintain and build your client list, how to get repeat assignments and even regular clients (house accounts), and how to become well known within the industry. Your goal is to ensure that art buyers, art directors, photo editors, and other creative people think of you first.

Thinking about Your Career as a Photographer

What motivates you to want to become a commercial photographer? Perhaps you have a dream of working for yourself, being your own boss, and setting your own hours. What most photographers—commercial or not—strive for is the freedom to create images that emerge from a personal aesthetic and about which they are passionate. Commercial photographers often have a desire to make people think, to allow people to see things they wouldn't ordinarily see, and to make people visually aware.

Many of the commercial photographers I've worked with are motivated not just by a passion to create images, but by a desire to have an audience for their work. They enjoy the idea of creating images for people who will enjoy their work and keep an eye out for it. Many photographers like the idea of creating a style all their own that not only defines them as photographers, but also influences trends and the work of other photographers. The style you establish as a photographer could drastically change a demand in your field; for example, the flare look of 2001 was in every fashion magazine.

I have written this book for any commercial photographer who wants to promote his or her work. Perhaps you are just leaving school. Some beginning photographers fantasize that they will leave school ready to work, with a professional portfolio that will allow them to start shooting jobs (ads, editorial work for magazines, fashion photography). They see themselves quickly and easily landing a job assisting a well-known photographer. The trouble is, real life usually doesn't work this

way. Most photographers leave school with a portfolio that is made up of their schoolwork and is thus a mix of styles. Most art directors and art buyers can easily spot such a book and will not take it seriously. To be considered as a candidate for commercial photography assignments, a photographer must have a portfolio that reflects a consistent style.

Even a student who, against all odds, leaves school with a professional-grade portfolio cannot expect to get shooting assignments quickly and easily. Photographers who want to start working commercially must market themselves—which means, in the simplest terms, making sure that people in the industry are familiar with their work. Beginning photographers should plan to spend a couple of years shooting images for their portfolios and marketing and promoting their work.

If you are a photographer who has spent some years working in one area, you may want to "reinvent" yourself and explore the possibilities in another area of work. Perhaps you're considering moving out of catalog work into magazines, or leaving magazines behind and starting to shoot for big corporations or for companies in the music industry. You may simply want to renew your enthusiasm for your work or evaluate how you are going about promoting yourself.

In this book I give my professional advice, based on years of experience, for beginning photographers or for working photographers who want to reinvent themselves. The two groups are similar in that they will need to create a winning portfolio and successfully market and promote themselves. Meanwhile, as you work through the chapters of *Successful Self-Promotion for Photographers,* shoot, shoot, shoot! And start setting goals for yourself, both artistically and in terms of marketing.

To find photographers whose work, values, and marketing skills you like and respect, read magazines such as *Communication Arts* and *Photo District News,* which showcase the work of photographers in editorial pieces and carry creative ads and other marketing devices from a variety of commercial photographers. Keep in mind that these photographers are all real

Photographer Jack Reznicki has reinvented himself over the years with several different logos and type treatments.
JACK REZNICKI

people and all had to start at the beginning as well. The first step is to think of yourself as a professional commercial photographer.

Assessing Your Education, Experience, Equipment, and Skills

Obviously, education is always important, but can you become a successful photographer without a degree from a college or art school? Probably. Each individual is different, and many photographers have degrees and sometimes even graduate degrees, while others don't. Your education is not what makes or breaks you in this industry.

While if you want to work as an intern or an assistant to another photographer, you might send a résumé (which normally includes a section for education), as a general rule, a résumé doesn't play a role in getting you hired for a photo shoot, and your education is unlikely to come up at a portfolio review. The people who are going to hire you are interested in your talent.

Before you start marketing yourself as a commercial photographer, you need to make sure you have acquired a sound knowledge of the art and craft of photography. Whether you attend school or assist a photographer, you need to equip yourself with certain skills. These include:

- How to compose an image so it is most effective
- How to use lenses, filters, and other equipment to their maximum effect
- Lighting techniques, using both natural light and flashes and strobes
- A knowledge of color
- A sense of design
- The ability to find personality within the shot
- How to print: If you work with film, you must know your way around the darkroom, and if you shoot digitally, you must be familiar with the possibilities offered by computer programs such as Photoshop and Quark.

If you discover that you lack some of these skills, don't feel defeated—simply go out and acquire them. Remember, as you accumulate experience you'll acquire more and more skills. That's why it's important to get to work as soon as possible.

As a beginning photographer, you should also own or have access to and know how to use the following equipment:

- One or more cameras
- Flashes and strobes
- Reflectors
- Tripod
- Gels and filters, for color correction
- Light meter
- Color meter
- Polaroid backs
- Insurance policies, for equipment and also for liability
- Computer and printer, for digital work and for marketing databases

Don't get hung up on equipment, though, and certainly don't let a lack of a particular item keep you from moving ahead with your goals. "Don't worry about what you don't have," one of my very successful clients, photographer Denise Chastain, counsels. "You can always rent it and expense it. Having the talent and putting together a portfolio that exhibits it is the most important thing." In the chapters that follow, I will show you how to shape your talent for the commercial market and how to design and use a portfolio to get work.

While a sound education is a good foundation for creating compelling imagery, it doesn't replace experience. My advice to anyone who is getting started in photography is to get into the real world as soon as possible—experience is what counts with photo editors. According to Steve Fine, director of photography at *Sports Illustrated*, the way to break into that magazine is to get a job with a newspaper or a wire service job and become a full-service (wide-ranging) photographer who can shoot news, features, a-day-in-the-life stories, and portraits. Then come to the magazine with five or seven years of experience, he says.

The general point is that your first priority should be to accumulate experience.

Your first step might be to work as an assistant to an established commercial photographer or to intern in a studio. Spending a year or two in such a position can give you invaluable knowledge and experience and help you sort out what you want to do with your career. Think of an internship with a photographer as course work—basically, you're working for free instead of paying tuition, but you're learning a lot. Call photographers whose work you admire and explain that you are willing to intern for free. Visit photographers' websites. When you notice work you like in a magazine or another outlet, type the photographer's name into Google or another search engine. You'll probably find his or her website, and you can send an e-mail saying how much you enjoy the work and would be interested in interning. Attach a résumé and follow up with a call.

Meanwhile, shoot, shoot, shoot. With every photo shoot you will learn more and more about photography.

Qualities That Lead to Success

There's no one single secret to becoming a successful photographer. Over the years, though, I've noticed the qualities that successful photographers have in common. Some of these qualities are intangible, others are practical.

Be true to yourself. The only way to know if a picture works is to make sure it is the image you want to create. Know what you want and try to capture your vision in your photography. People will respect you more if you create art that drives and inspires you. Not only will you feel fulfilled as a photographer, but photo editors, art buyers, and others in the business with a good eye are able to spot work that's inspired.

Know what you want. It is important to know what you want so that you can set goals for yourself and act accordingly. If you want to work for magazines, you should use your energy trying to break into editorial work and not let yourself be diverted by doing advertising shots or other sorts of work that don't interest you. If your love is fashion, shoot fashion, and not gritty, realistic street scenes that don't compel you. If creativity drives you and money is secondary, you might be willing to take jobs that pay a little less, knowing that you are going to shoot a creative assignment. If you want to put your photography skills to use to make big money, you should channel your resources into breaking into lucrative work, such as advertising.

Have the ability to work with people. Think of all the people involved in a photo shoot and what your responsibilities are. You are part of a team that includes the photo editor and art director, who have hired you to execute

This simple but graphic image could work well alone or in conjunction with another image to create a story.
JACK REZNICKI

15

their vision and expect you to be able to communicate with them. Meanwhile, the art buyer needs you to be flexible and resourceful, and models will do a better job if you can make them feel comfortable. You need to be a bit of a mind reader, too, because sometimes even the best art director or photo editor can't express what he or she really wants. The ability to lay on the charm doesn't hurt, either, when it comes time to talk yourself into an event you want to shoot or to get a reluctant subject to pose.

Your first priority should be to accumulate experience.

Be a risk taker. As a photographer, your reputation is on the line every time you shoot. You can be a hero on one job, a disappointment on the other. Photography is not the career for someone who needs emotional security, nor is it a field for someone who requires financial security. One year a photographer may shoot five big jobs for $30,000 each and the next year get only one big assignment. The market for photographers goes up and down, and unless you work directly for a company and are being paid a salary, your income will go up and down, too.

Be willing to challenge yourself. Stretch yourself. Do test shoots to see what you can create within your own style. Try shooting in a new style. Use new techniques, work with different films and lenses. Photography is not a static business, and the most successful photographers are those who continually exercise their vision in new and challenging ways.

Be willing to keep up with trends. Trends in photography change all the time. You need to keep up with them—look at magazines, check out the trade publications, and in other ways make sure you are in the know about what other photographers are doing

and what art buyers seem to be buying (see "Spotting Trends" in chapter 10). Try taking a new direction when necessary and testing techniques you don't normally use— all the while keeping your unique vision intact. That is, you need to keep up with the times while remaining true to yourself and to your vision.

Be a good businessperson. Being creative and being practical about your business are not necessarily contradictory. If you are going to make it as a commercial photographer, you must know how to budget a business. Getting jobs and bringing in money is one thing, but reinvesting money in the business is important, too. Be prepared to spend money on marketing (throughout this book I address ways to market yourself and how to do so most effectively). You'll also need to spend money to update equipment and computer programs, attend conferences, and to travel when necessary to experience the challenge of shooting in new locations.

Have a strong sense of yourself and your abilities. Photography is a competitive business. As good as you are, there are many other good photographers out there competing for the same jobs and clients. Think about what you can offer clients that other photographers can't. Have faith in yourself and operate from a position of strength. That way, you will know how to put your best foot forward when you market yourself. You must also toughen yourself to losing a job now and then and be able to learn from a negative experience (see "How to Turn Disappointment into a Positive Lesson" in chapter 10).

Be flexible. As a commercial photographer, you must know how to adapt to new situations: a change in art direction, a last-minute schedule change, a shakeup in which your favorite art buyer leaves the company. Clients will appreciate you all the more if you can roll with the punches and be a team player who performs well in challenging situations.

Finding Your Own Vision

Photographer Matt Proulx, who started out as an assistant to three established, successful photographers, came to me for a consultation. When I looked at his original portfolio I saw beautiful images in three categories. Each category represented the photographers he had assisted. I closed the book and said, "Now I know who you assisted because I could tell from the influences in your portfolio. But who is Matt Proulx? What kind of images do you want to make?"

Matt told me he had always wanted to shoot "real people" portraits. I asked if he would consider reshooting his whole portfolio in the style in which he wanted to find assignments. It so happened that at the time another photographer was doing a project that involved shooting "real people." Matt hired on to assist this photographer and made a deal with him to take a little less money in exchange for being able to shoot his own material while they were on the road. This way Matt's expenses were covered—all he had to pay for was the film and processing for the photos for his new portfolio. Matt came back to New York with a stunning set of images of the "real people" he had photographed on the road. He created a new portfolio, and he continues to exercise his vision and create haunting portraits.

When I first met photographer Kevin York, he was shooting for local clients in his home state, Pennsylvania. He categorized himself as a generalist. He shot still lifes, people, and locations. His original portfolio was a combination of different formats: laminated tear sheets, 4 x 5 chromes, and 35mm slides. He also had a separate collection of images—he referred to them as his personal project—that were photographs he had taken at auto races across the country. Kevin's passion was shooting these races, but he never did anything with the images except keep the slides in sleeves.

When I looked at his images I saw that Kevin had a great collection of work. He was very resourceful when it came to being in the right place at the right time, and he had a wonderful eye. However, I was overwhelmed because he had never edited these images. We decided that he would do the initial edit and bring back the images that he thought best represented his style.

After a couple of weeks, Kevin called me and told me he had been unable to edit his images. It was too difficult for him to make editing decisions. He felt he had too many good ones and could not choose between them. A couple of days later, a package arrived. It was every image he had ever taken from his racing project. He wanted to be a nationally and internationally recognized racing photographer. "The best of the best," he said. He wanted to shoot for magazines and eventually work in the commercial world for advertising agencies that had racing-related clients. From those racing images we put together a powerful portfolio that Kevin has used to get assignments photographing the racing circuit.

Matt Proulx was able to compile a compelling portfolio based on his "real people" photographs, and got much work as a result.
MATT PROULX

I asked Matt Proulx, "What kind of images do you want to make? and he said, "real people portraits." So, he went out on the road, assisting another photographer. He came back with these images, all shot in black and white, to include in his portfolio.
MATT PROULX

We'll return to the stories of Matt Proulx and Kevin York in the chapters that follow. The point I want to make is this: You must discover what your vision is. Whether you are just beginning your career or want to reinvent yourself, you must take a hard look at what your are trying to achieve. Your vision—how you see your life and work unfolding—will help you set objectives and will help you determine a strategy, the broad strokes of how you will work toward those objectives.

As you develop this kind of self-awareness, you will be on the road to becoming a successful commercial photographer.

Shoot, shoot, shoot. With every photo shoot you will learn more and more about photography.

If you are following the advice in this chapter, you've already accomplished a lot. You are determining why you want to be a photographer, assessing your skills, equipping yourself with the basic arsenal of cameras and lenses, giving thought to what qualities you need to succeed as a photographer, and beginning to find your vision. You're on your way to success. Now, read on to learn how to put a spin on all these elements and move to the next step.

DO . . .
- Begin thinking of yourself as a commercial photographer.
- Get into the real world as soon as possible and acquire the skills you need to succeed as a photographer.
- Give some serious thought to whether or not you have the personality to succeed as a photographer.
- Find the vision that inspires you to make pictures and be true to it.
- Shoot, shoot, shoot!

DON'T . . .
- Worry if you don't possess every piece of equipment—you can rent it as necessary and acquire more as your career develops.
- Shoot a certain way because you think it is right, rather than what you want to be doing.
- Be afraid to do what it takes to begin shooting images about which you are passionate.
- Feel defeated if you find yourself lacking certain skills and experience—remember, you're just beginning!

Kevin York saw himself as a generalist who shot still life, people, and locations. His original portfolio combined different formats: laminated tear sheets, 4- × 5-inch chromes, and 35mm slides. He also had a separate personal project—a collection of 35mm photographs he had taken at auto races but had never edited.
KEVIN YORK

Focus Your Image

SCOTT SPIKER

Creating an Identity for Yourself

As a photographer, you have a vision. There are subjects you are most comfortable shooting, and a way that you like to shoot them. Perhaps you already know exactly where your passions lie, or it may take you a while to make this discovery. The answer may already exist in your photographs, or it may be out there in photographs you haven't yet taken. Perhaps more important, at some point you also need to decide what kind of photographer you want people to think of when they think of you.

Creating an identity for yourself is one of the most important things you must do before starting or renewing your business. You have to ask yourself who you want to be in this business and how you want people to see you.

It's useful to make a list of what you feel your attributes are and what you want them to be. In creating this list, choose attributes that will convey your value to a client, but also include qualities that you want to develop in yourself. The list, then, will be not only a description of who you are in reality, but also who you are ideally, who you aspire to be.

When I first started as a rep in the commercial photography world, I took out a piece of paper and made my own list. It had five words.

- The first word was *experience.* I wanted people to see me as someone who was experienced and knew how to make decisions in the business.
- *Honesty* was the second word. A client should feel that he knows exactly what is happening before, during, and after a shoot. I wanted clients to be able to rely on me for accurate information.

- The next word on my list was *caring.* I wanted clients to know that I really cared about the job—the whole job, not just getting paid.
- The fourth word was *thorough.* I wanted clients to be able to call me knowing that, if they were hiring one of my photographers, I would ultimately be responsible for seeing the job through to its fullest potential. I wanted clients to understand that I was on top of all aspects of the job and that I knew all of the shots in my photographers' portfolios so well that I could answer any question about them.
- The last term on my list, kind of a slangy one, was *"with-it."* I wanted to be the kind of rep who followed and understood the trends in our business.

I've gone back to this list time and again. Once an art director asked me to do something that I didn't feel comfortable doing. I looked at my list and saw the word honesty. The request made by this art director didn't feel honest to me, and if I was going to grant his request, I was going to have to change my identity. I didn't want to. I told the art director no. I was missing out on a job, but in the end I felt better.

To me, being "with-it" means understanding how the business changes every couple of years and trying to be on the cutting edge. I want to be able to appreciate the mind-set of a twenty-five-year-old art buyer and the point of view of a sixty-five-year-old art director and everyone in between—to be able to discuss the business on their terms. An important part of creating my identity was to make people understand my knowledge of the business and my active interest in what will be happening next.

Take an hour, sit quietly, and come up with five words. Try to think of words that explain the wholeness of your business. Once you select your five words, try to incorporate them in the way you do business. Any time you feel unsure of a decision you need to make, go back to the list, think about the person the list describes, and ask yourself what decision that person would make.

Editing Your Images

It can be difficult to look at your work objectively, because you are so close to it. But you must be objective in order to decide how your work can fulfill the needs of clients who use commercial photography. When editing your photographs—that is, choosing the images that will appear in your portfolio—there are three things you should look for. A photograph should have good composition, gesture (personality within the shot), and great lighting.

When you are editing images that will become candidates for your portfolio, put the good images on one side of the table and the bad images on the other. A photo can be "bad" because the lighting is not good, the composition is awkward, or the subject looks stiff. That pile (the bad images) should be put away and not taken out again. Many photographers save images in the "bad" pile and go back to them because, say, a client is looking for a person in an orange shirt and there happens to be an image of person wearing an orange shirt in that pile. This is a mistake: Do not show a client exactly what they want to see if the image isn't a success—a bad image is a bad image. Create a portfolio using your best images.

In the process of editing your work, remember to search through your files for images you may have forgotten about. Go back to your files to see if any of those images still hold up today. I understand that styles change, that haircuts change, that clothes change (especially important if you are a fashion photographer). But every now and then you will see a wonderful image that is timeless. These are the images that you should consider for your portfolio.

In chapter 1, I began telling the story of Kevin York, who gave me the job of editing his slides. Some of Kevin's photographs are really special and convey emotions and the sense of what was happening at the moment the shutter clicked in a remarkable way. He and I made a pile called "single images" that would be displayed in the portfolio separately from any other images. Next were images that played off each other. I coupled

This image displays good composition and exposure, and firmly establishes the photographer's skill in shooting architecture and interiors.
HOACHLANDER DAVIS PHOTOGRAPHY

This is a timeless image that photographer Jack Reznicki included in his portfolio as an example of his approach to shooting traditional subjects in a compelling way.
JACK REZNICKI

23

up the images that worked in pairs, in which one shot needed the other to balance out or finish the "thought." Then there were the multiple images, which told a story using groups of shots. We lined up the different categories in piles on my light box. Then we took our time editing the photos, choosing the ones that we determined were best.

Establishing Your Style, Choosing Your Subject Matter

Your portfolio must reflect who you are as a photographer. A stranger should be able to pick it up and know what he or she needs to know about your skill, and also be able to see a definite style and the sorts of subjects you are passionate about. So it's important to establish these elements as part of your identity.

Some style and subject matter categories follow—a few among many, many more—that are relevant in the world of commercial photography. These categories may not apply to your work; if not, take my examples as a guide and come up with categories that do describe your work. The important thing is to think about your work in relation to the marketplace.

As you will see, categories can blend into one another, and pretty much any style or subject matter can be applied to any part of the market. Again, the important point is that you must understand what your style is and be able to describe what it is you like to shoot.

Three different markets, three different styles (counter clockwise): Gary Gelb's promotional piece shows the unique style he brings to editorial photography. By sending out an image like this, he makes a strong statement about his distinctive approach. Marcus Swanson does commercial work, and this well-produced and styled image is meant to appeal to art buyers in that market. Sally Russ, on the other hand, specializes in fine arts photography, and notice the difference in the style of the work she shows. GARY GELB/DESIGN BY JOHN GENTILE; MARCUS SWANSON; SALLY RUSS

A Consistent Style. Your photographs should reflect a consistent style—that is, a style that sets your identity and that the industry will recognize as uniquely yours. When you've developed a consistent style, the industry will know what to expect and clients will hire you on the basis of the style they know you can deliver.

What can you say about your style? Do you shoot in one consistent style, or more than one? Perhaps your photographs have an **editorial or documentary** look, which can mean many things, from capturing a moment in time to telling a story in one photograph or a series of shoots, in a style that has a quality of reality. If so, newspapers or magazines may be your primary target market. However, shooting in an editorial style doesn't necessarily mean you have to work for a newspaper and document stories in portraiture or field work; sometimes advertising clients want an editorial look.

Perhaps your style is more **commercial** with setups that look "produced" and styling—of makeup, props, wardrobe—that conveys an idea or could sell a product. In that case, you are headed toward advertising. Photographers who shoot in a commercial style are often hired to shoot ads because they are able to produce a job from start to finish and give the client an image that will help sell a product.

Or maybe your style could be defined as **fine arts** because you produce imagery that is mainly shown in galleries and museums, and sold for display or personal use. However, today fine art photography is also sometimes used in commercial advertisements, and fine art photography is used for editorial purposes as well.

Within these broad categories of style, photographers shoot in many different types of formats and media. They produce photographs in small, medium, and large formats (sizes), in black and white, and in color. Some may cross-process, hand-color, tone, and digitally manipulate their photographs, among many other techniques.

All of these photographic styles, formats, and media can be used for both editorial and commercial assignments. While you may be strongest in one style or one format, to maximize your appeal in the marketplace you should aim, over the long run, to learn many different techniques.

A stranger should be able to pick up your portfolio, know what he needs to know about your skill, and see a definite style and the subjects you are passionate about.

Subject Matter. Another important consideration is the subject matter you prefer. Are you a specialist in one area? For example, the ability to shoot architectural images—everything from an overall design of a grand building to small details that enhance a summer cottage—can be a valuable asset for a commercial photographer.

Some photographers have a talent and a love for shooting the natural world. **Landscape** or **location** photographers have the ability to capture a specific place under many different lighting and weather conditions. Some photographers specialize in making images of animals—their behavior, expressions, and gesture (expression and body language).

Macrophotography (magnified shots) and **microphotography** (much more greatly magnified shots) capture everyday elements of both manmade objects and objects in nature in ways that the human eye cannot always see. They allow people to see familiar things from a new point of view or even show us things we have never seen or could never see without the macro lens.

Still life photography focuses on elements that make an object interesting. It can be done against the backdrop of an environment,

in a studio, or as part of a lifestyle assignment. Still lifes are used for a wide range of purposes, from editorial to advertising.

Portraiture captures personality, emotions, and beauty—the elements that tell the story of a person. All this can be done using lighting, gesture (expression and body language), and composition. Lifestyle portraits produce images that catch people in everyday moments. Portraiture can show someone within casual surroundings or, more formally, in a studio shot. Your portraits may be perfect for annual reports; if so, design firms that produce these and other types of business publications will be your target market. If your portraits look more editorial, you should be thinking about approaching magazines that feature pictures of individuals.

These are just a few examples, among hundreds or thousands, of types of styles and subject matter. They may relate to your work; if they don't, come up with your own categories. The important thing is to start thinking about what you are good at and thus which clients will be interested in your work. As a photographer who is trying to establish an identity in the marketplace, you must know what your strengths are. Understanding the photographic skills you have a mastery of will help you know where to start in searching for clients (we'll take this up in chapter 3).

What If You Have a Split Personality?

Are you a photographer with a split personality? Do not think you have to

In a single image, Len Rothman creatively demonstrates his skills as both a still life and portrait photographer.
LEN ROTHMAN

represent yourself by presenting all your images in one portfolio. It may be necessary and to your benefit to show your different styles separately.

I once had a consultation with a photographer from California. She had a good client base and all of her business came by word of mouth, so she had never felt she needed a portfolio. She came to me when she wanted to expand her business and get new clients. It was time for her to assemble a portfolio. Her work ranged from celebrities to kids and included lifestyle and editorial images. With each category, there was a different style of photography. We divided the work into piles and looked at each pile separately, and it soon became evident that she had two distinctly different styles, each of which could be marketed—she had enough good images to support each style. She had a lot of images of kids, so that become one portfolio. Her other large collection of images were the celebrities, and they became another book.

New York–based photographer Jack Reznicki has two completely different groups of portfolios for the two styles he shoots. Jack shoots kids and has four portfolios to represent that style. He has another four portfolios that showcase his editorial lifestyle shots. Each book goes out separately to different clients. We advertise both styles separately, and we have different promotion cards to represent each style of work. Every now and then I will get a phone call from an art director or art buyer who asks, "Is this lifestyle really Jack?" Or someone who has used us only for lifestyle is surprised to see Jack's shots of kids in an ad. We also have some clients who use Jack for both styles of photography.

Having a split personality—or, better said, showing multiple directions of the photography you like to shoot—can be a great benefit: It expands the opportunities for you to get work. Just be sure that there is a body of work that supports each style and that you have a marketing strategy that supports both directions.

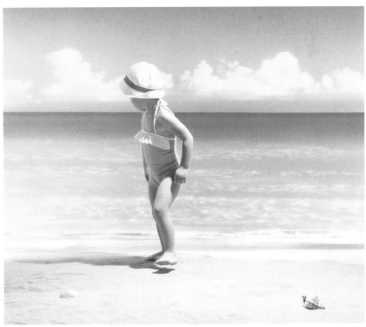

Jack Reznicki does both lifestyle photography and child photography, and has different portfolios of images to show off these different styles.
JACK REZNICKI

Designing Your Look

The impression you make will depend not just on the quality and style of your photos, but on your presentation as well, right down to what your business card looks like.

For the most effective presentations, many photographers choose to work with a designer. Expert advice can be invaluable: A good designer can help with anything from choosing the right color and weight of the paper you use in your portfolio to designing marketing pieces for you. However, if you feel comfortable working without a designer, by all means give it a try.

Here is a short list of the sorts of projects designers have done for me and what they can do for you.

- *Choosing a typeface.* Something as basic as a typeface says a lot about you—it can be funky, staid, playful yet serious. How you use type—combining capital letters and lowercase letters, mixing different fonts, spacing letters—can also make a statement, and make you look

A designer came up with eight possible type treatments for Kevin York's company logo and letterhead, but we decided they were over-designed and didn't really reflect who Kevin was. We opted instead for a simple type treatment not shown here.
KEVIN YORK/DESIGN BY JOHN GENTILE

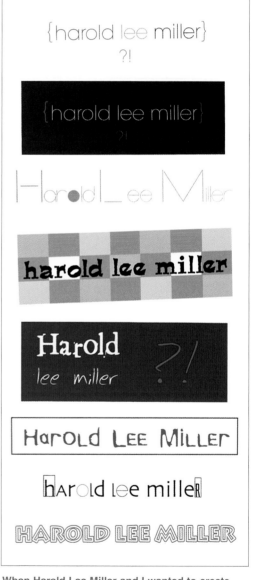

When Harold Lee Miller and I wanted to create an identity for his company, we hired designer Young Seo, an intern in my office who later became an art director at the ad agency J. Walter Thompson in New York City. Young came up with eight different logo type faces.
HAROLD LEE MILLER/DESIGN BY YOUNG SEO

professional or careless, tasteful or a little cheesy. Use type to your best advantage, first by finding a typeface that best reflects your taste, then by using the type in an attractive way.

- *Designing a logo.* Not all photographers have a logo—a graphic symbol that establishes identity. I don't think a logo is necessary, since your photos do the same thing. However, a logo can be a quick and handy way to make yourself known as it usually appears on envelopes, labels, letterheads, and promotional pieces. An art buyer sees a photographer's distinctive logo on an envelope and knows immediately who it is from. A designer can create a logo for you, but remember, this is not an easy task—a logo must capture who you are in a way that is going to have positive connotations for everyone who sees it. A logo that doesn't say who a photographer really is or, worse, gives the wrong impression can be a disaster.

- *Selecting images.* It can be a godsend to have a good designer sitting next to you when you choose images for a portfolio. He or she will help you determine the strength of a composition, gesture, and lighting, as well as the style that will emerge.

- *Laying out a portfolio.* A designer can help you place photos on the pages of your portfolio for the maximum effect—grouping shots that tell a story, playing images off one another, and combining colors.

- *Designing marketing pieces.* Throughout this book, especially in chapter 6, I will be discussing the different promotion pieces you will want to send out from time to time. A designer can play a huge part in their success. Ideally you will work with a designer who understands you and will design pieces that reflect who you really are and what you are trying to accomplish with your photography.

Finding a designer with whom you can work well is essential. Because you will rely on him or her to design materials that reflect your style and to help you make important promotion decisions, your designer should share your sensibilities.

Beth Green had been using a multi-image card for her direct-mail pieces. I suggested that a new designer could add a fresher look.
BETH GREEN

Beth Green needed help creating a new identity for her business. She tried a variety of designs for the back of her promotion cards.
BETH GREEN

At the same time, you want to find a designer who doesn't just follow your wishes but can contribute new ideas, challenge you when necessary, and push you to try new things.

As a photographer, you have probably come across some good designers in your work or at school, and you probably have friends who know designers. Or if you see a design you really like, find out who did the work and contact the designer.

How much you pay will depend on where you are in your career and where the designer is in his or her career. That is, if you're starting out, you probably won't be working with a designer who is used to charging top advertising-agency rates. On the other hand, you might find an excellent designer who, like you, is beginning, eager to get good-looking designs into the marketplace, and is willing to work for rates you can afford.

Beth Green worked on new images and used one of them to create this 6- × 9-inch promotional postcard. Her new card, created by a student designer, has a feel that is quite different from her earlier cards. The new typeface is more current and works well with the photograph.
BETH GREEN

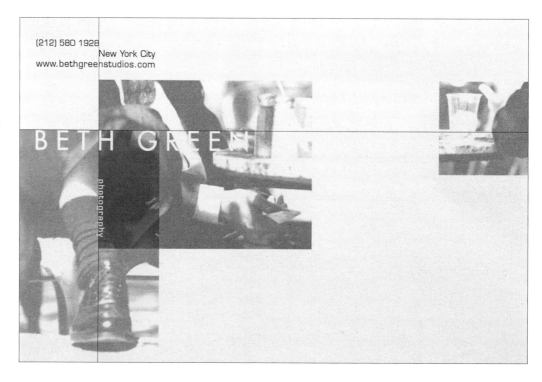

The back of Beth Green's card had to be printed in black and white, so we ghosted an image at a lesser percentage of black. The designer picked up parts of the images on the card's front for an interesting pattern that makes the back of the card come alive.
BETH GREEN

Y ou've pondered a career as a photographer. You've assessed your capabilities and the intangible qualities that will lead to success, and you've taken steps toward finding your own vision. You've refined your identity with five words, edited your images to reflect a consistent style, and chosen an identifying look for promotion cards, letterhead, and labeling on photographs.

Now you are ready to start thinking about the market. These are the five steps that are essential to creating a successful marketing strategy:

1 Define your market
2 Create a strong portfolio that reflects your promotional message
3 Discover the decision makers in your market
4 Understand your value as a professional photographer
5 Create a marketing plan that attracts the work you want

In the chapters that follow you will get both general and specific information about the categories of clients who use photography (chapter 3) and learn how to design and structure your portfolio (chapter 4).

*Understand your value
as a professional
photographer.*

Five Steps to a Successful Marketing Strategy

DO . . .
- Make a list of the words that best define your identity and use them as a guideline.
- Discover within yourself what you most like to photograph and the style you like to use.
- Edit your images to reflect a style that is consistent.
- Think about the subjects you are most comfortable shooting and make sure your portfolio reflects these interests.
- Design marketing materials that project the image you want to establish.

DON'T . . .
- Worry if you have multiple interests and strengths; just make sure you have a body of work to reflect them and a marketing strategy for each.

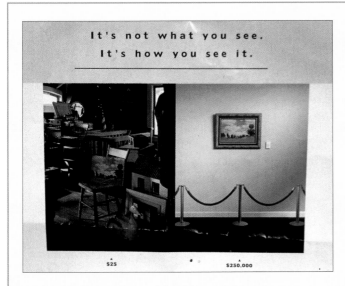

It's not what you see. It's how you see it.

The idea behind this visual is that your packaging is the most important thing you can do for your business. It is quite obvious that both shots include the same painting. Sitting in a messy studio, it is not worth much, but when you present yourself in a very professional manner, people will respect you and believe in the value that you have to offer as a photographer.
MONTGOMERY FUNDS

Identify Your Market

Types of Clients

You have now done some disciplined thinking about what you have to offer clients who use photography. You have pondered your capabilities and have decided on an identity and a style that you want to bring to the market. But what market will that be?

In this chapter we'll look at the major client categories within commercial photography, what these clients require, and how to find out who they are. Included, too, are helpful tips on how to find, target, and qualify clients.

Advertising Agencies

Doing an assignment for an advertising agency means photographing for a client who is selling either a general image of the company, a single product or a line of products, or a service. We're talking about the whole world of commerce here, so photographers who work in virtually all photographic styles and who shoot almost any subject matter can consider themselves candidates for advertising work.

The challenge for the folks at the agency is to hire a photographer who can meet the needs of the client and the agency. Some photographers are hired to shoot advertisements because their images look well produced, while some are hired because their work doesn't look highly produced, though in reality it is.

If you decide to build your own list, use *The Workbook Directory* online (www.workbook.com) to research advertising agencies: their locations, and contact and website information. Use the Red Books site (www.redbooks.com) to research the owners of brand names and the agencies that represent them. The Red Books provide the Agency Database, which contains detailed profiles of nearly 13,500 U.S. and international advertising agencies, including accounts represented by each agency, fields of specialization, breakdown of gross billings by media, contact information on agency personnel, and much more; see redbook.com for a description of what's available.

It's also possible to buy a database of advertising agencies from a mailing house. Mailing houses offer a large variety of lists for advertising agencies, in "personalized" categories, meaning that you can choose to mail to particular people within the agencies, such as art buyers, art directors, associate art directors, creative directors, associate creative directors, graphic designers, print production managers, and production managers. You can also choose lists of ad agencies broken down into "top agencies" and "award winners."

Seeing great innovative images in the portfolio is the main consideration in making the final decision about which photographer to hire for a shoot.

If you are going after advertising clients, the most streamlined database to use is a **national art buyer list.** Art buyers are generally your first entry into an advertising agency. The more you know about their needs, wants, and expectations, the easier it will be to work with them. Art buyer Andrea Kaye worked at BBDO New York before moving to McCann Erickson. Based on her experience, she estimates that in a month a large agency produces between fifteen and twenty ads. Currently her department has seven art buyers.

Carol Brandwein, an art buyer at ad agency DDB Worldwide, has this advice for photographers eager to find an art director who has assignments that would

be right for them: "Do your homework." Read *Adweek, Ad Age,* and *Archive* magazines, she says. Look for the creative people who are producing the kind of work you want. "Working blindly is the worst thing you can do," she says. For instance, quizzing a receptionist about accounts the agency handles is not likely to be beneficial. Be selective with your potential client choices, especially if you have limited resources.

Who decides which portfolios should be called in for consideration for a particular job? According to Carol, at DDB Worldwide the art director and the art buyer decide. "Sometimes the art director has a few photographers in mind and I will add a few names to that list. At other times, the art director has no one in mind and it becomes my choice."

Seeing great innovative images in the portfolio is the main consideration in making the final decision about which photogra-

pher to hire for a shoot, says Jayne Horowitz, an art buyer for the ad agency Grey Global Group. For example, sometimes special attributes are required, such as the ability to direct talent in a natural way when working with a large group of models, and seeing an ability to do this in a photographer's portfolio can definitely help decide who gets the job.

Editorial

Editorial work provides a creative outlet for photographers. Photographers who are hired for editorial shoots are chosen because they can capture something real or true in a still image or a series of images. Editorial photographers capture a moment in time. An excellent place to view the best in editorial photographs is the website of Magnum Photo (http://www.magnumphotos.com).

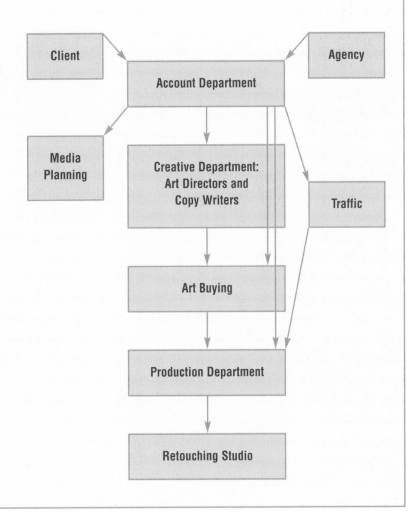

The Birth of an Ad

How is an ad created? First, the client assigns the agency a project. Client representatives discuss with the account team the product or service that needs to be marketed and the market they are targeting. Then the in-house work begins. The account team discusses the assignment with the creative people, the art buyers, and the media planners (who decide where to run the ad) and with the production and traffic departments (who take care of the technical and scheduling details).

The "creatives" come up with concepts for the ad that are presented to the client. When the client approves a concept the art buyers recommend photographers and call in portfolios for the creatives to review. One or more photographers are selected and asked to submit estimates, or "bids." The photographers' work is then presented to the client, the job is awarded to a photographer, and a shoot takes place.

Once the job has been shot, production and creative oversee any retouching, production makes sure that mechanicals are correctly prepared for the print or broadcast media, and the traffic department makes sure that the agency delivers to meet the deadline.

Often a magazine will assign a story based on an idea a photographer provides. Or a magazine might hire a photographer to provide images for a story the editors or a writer have developed. It's possible, too, that a magazine will build a story around existing images that a photographer provides. In all of these cases, the editors are looking for your eye and your interpretation of the subject matter to carry the story visually. As a photographer, you can develop excellent working relationships with the photo editors at magazines. They will get to know your work, welcome your ideas, and come to count on you to produce good stories for them.

Book publishers, too, are a good market for photographs. Some publishers assign photographers to shoot specific subjects to illustrate a subject. More commonly, publishers work with stock houses and photo agencies to supply existing images—they send out a request for a specific subject, and the stock house or agency supplies a

selection of choices. (See chapter 8 for a discussion of working with stock houses.) Or a publisher might go through source-books and work with photography agents to obtain the necessary images. Your job as a photographer is to make yourself known to photo editors, who will make a point of using your work when the need arises.

Although editorial fees are low compared to commercial assignments, having your name appear as a photo credit in a magazine or a book is very helpful and can enhance your credibility. Since a lot of photography for ad agencies is anonymous, you often hear people say, "Who did that? I love that," or "I didn't know so-and-so did that campaign." With book or magazine work your name is on the photo.

As with advertising agencies, when you buy a mailing list of magazines and books from a mailing house, you can "personalize"—that is, you can buy lists with the names of art directors, beauty

This work that photographer Jack Reznicki shot for *American Way* magazine accompanied an article written by Larry Olmstead. I think it's an excellent example of how effective great photography, complemented by great design, can be. *AMERICAN WAY*, ARTICLE BY LARRY OLMSTED, PHOTOGRAPHS BY JACK REZNICKI

STORY BY
LARRY OLMSTED

PHOTOGRAPHY BY
JACK REZNICKI

NEW BOSTON BITES

IT'S NOT ALL CLAM CHOWDER AND BAKED BEANS. TODAY, BOSTON SETS THE TABLE FOR ALL KINDS OF DINING DIVERSITY.

38 | AMERICAN WAY | 11.15.00

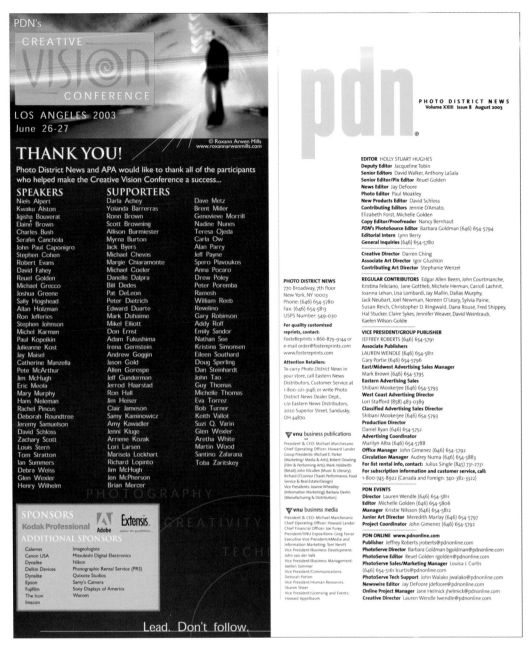

Look through magazines, make a list of the ones you would like to shoot for, then turn to the masthead to find the names of the photo editors and art directors to contact. This masthead is from *Photo District News.*
PDN

editors, creative directors, story editors, fashion editors, photo editors, or production managers.

Targeting Magazines. Doing research for a smaller, more targeted list of magazines to market to is simple—and actually enjoyable. Just go to a newsstand (a bookstore with a large newsstand section is ideal) and spend a few hours leafing through various publications.

Decide which magazines would be the best match for your photography. Write down the names and addresses of the magazines; be sure to get the names of the photo editor and the art director from the masthead as well.

Sometimes it's the photo editor and sometimes it's the art director who makes the hiring decisions at magazines. Since they work closely together, include both on your list.

When you find the magazines you like, start a pile. The first time I did this, I had my assistant follow me around. I went up and down the aisles while she held out her arms. I kept putting magazines in her arms. We ended up with forty! We found a table and sat down. We found the mastheads and found out who the photo editor was and who the art director was. I wasn't sure which position was responsible for buying the

A Note on Client Lists

There are two basic ways of obtaining lists of potential clients. You can buy them, purchasing the use of databases with up to thousands of names. And you can build them yourself; through your own research, over time you might end up with a list of dozens or perhaps hundreds of names.

This is not an either/or proposition. Many photographers do both, especially when they are starting out. They purchase a large list from a mailing house (a mailing list and mailing service company—there's much more on this subject in chapter 6). At the same time, they start to compile an "A list" of clients they especially want to target. You can send promo materials to a large list of people and then give special attention to your A list, mailing to those names more frequently or following up with them more thoroughly. And you can create special promotion pieces that you send only to your A list.

photography, so we copied it all down, along with the address of the magazine. Then I took the list back to my office and started to make phone calls to find out who hired the photographers and if they had a drop-off policy (see chapter 7). Most magazines do have a drop-off policy, and they are happy to look at your book. You just need to know with whom to leave your book.

Make it a practice to do a newsstand review once every two or three months. This basic and easy research will do wonders for keeping you abreast of trends, giving you new ideas, and allowing you to spot opportunities for getting assignments.

The photo editor or art director's job responsibilities vary from magazine to magazine. Magazine budgets are lower than those at advertising agencies, so in addition to hiring and assigning photographers, these people also find the location, hire stylists, arrange catering, and oversee the other elements of producing a shoot. For the final decision on which photographer is going to shoot an assignment, a photo editor or art director will often consult the creative director and, for very important shoots, the editor in chief.

Try to come to an understanding of the aesthetic of the magazine you are targeting. Chances are it's not your technical skill that's going to win over the person who buys the photography. The photography buyers at magazines expect a good photographer to be technically adept and to have a good eye; aside from something complex like an extremely refined beauty shot, a photographer should be able to catch a good image of any subject. Beyond those basics, which every photographer should offer, you should be able to show that you can capture a certain aesthetic that is consistent with the magazine's identity.

When you are shaping your portfolio to show to magazines, including images of celebrities can make a big difference. They show that a photographer has access to big-name people and can get them to cooperate, says Steve Fine, *Sports Illustrated*'s director of photography. The best way to break into his magazine, he says, is to be a dynamite portrait photographer who can get celebrity sports figures to be photographed and then use their imagination to come up with something spectacular. However, even if the magazine you are pitching runs celebrity portraits, you don't necessarily have to include photos of celebrities in your portfolio. The

If you keep your information organized, it will be easier to retrieve when you plan your drop-offs. This sample chart notes the name of the magazine, the photo editorial director, and contact information.

Magazine	Photo Editor	Address Phone Number	Drop-Off Policy	Action
PDN	Paul Moakley	770 Broadway, New York, NY 10003 (646) 654-5802	By appointment	Portfolio Sent: 12/01/03

important thing is to include portraits. If you can work with people and are creative, your pictures will show that you can "make something out of nothing."

Fine says that *Sports Illustrated* needs people who can either construct a set or come up with an expression or something subtle that will make the reader stop turning the pages between action stories to read this feature. The days of shooting a guy in his uniform against a white wall with his arms crossed are over, he says. The photo editors go through a lot of magazines and portfolios looking for freelancers who have a certain kind of style.

> Although editorial fees are low compared to commercial assignments, having your name appear as a photo credit in a magazine or a book is very helpful and can enhance your credibility.

James Colton, the photography editor and chief portfolio review person at *Sports Illustrated*, comments that a lot of people bring him photographs that don't belong in the magazine. An editor at *Sports Illustrated* should not be shown the same type of work that someone at *Real Simple* would want to see. A still life isn't going to impress anyone at *Sports Illustrated*, whereas sports, action, features, and portraits might. Having a good portfolio isn't enough. You should be willing to change the content so it's suited to the magazine you are targeting. Do a little homework before you show up at a magazine.

Hard as it is to get a foot in the door at *Sports Illustrated*, the magazine is always on the lookout for images for its "leading off" section, and if a photographer has what he thinks would be a great image for this section, there is no harm in making a low-res jpeg of it and sending it in by e-mail, says Colton. He remembers showing a tray of "leading off" photos at a workshop in Florida and telling the participants to let him know if they came across an idea they thought would be appropriate. A woman told him about something called high-tech racing, a combination of a marathon and x-games that combines mountain biking, kayaking, running a marathon holding a brick, and being blindfolded and strapped to logs. "It sounded so weird that I said, 'Fine,'" he remembers. He had seen her book and was confident enough with her work to give her a $500-a-day-plus-expenses assignment. The photographer came back with such a wild assortment of images that the magazine did a three-page photo story. These kinds of things happen all the time, he says. In fact, to gather unusual photographs, the editors give out their transmit address whenever they speak, anywhere in the world; it's transmit@siphoto.com.

Finding a Market in Books. Remember the trip to the bookstore to look for magazines? Repeat the same exercise with a focus on books. Many bookstores have large sections concentrating on illustrated books. For instance, take a look at the Home Design section—chances are, shelf after shelf will be filled with lavishly illustrated books. Subjects like nature, beauty, art, and architecture also lend themselves to illustrated books. Many stores have photography sections.

If you have a specialty, check out that section: You might notice, for instance, that some books on health or child rearing use a lot of photography. Make a note of the publishers that seem to be likely candidates to use work like yours. You'll often find a list of editorial staff, including photo editors, at the front of the book, as well as the address of the publishing house.

Jot down the pertinent information, then get to work. Call the publisher (you may need to get the number from directory assistance) and ask who hires photographers for their projects and how to get in touch with them. Ask if the publisher has a drop-off policy for portfolios (see chapter 7). If not (and some book publishers don't), send promotion pieces to the editors who assign photography and ask if you can send your portfolio directly to them.

Agency Access sells a list of publishing names (see p. 95 for more).

Corporations

Corporate photography is usually done directly for a company, with the purpose of enhancing public awareness of the company as opposed to advertising its products or services. The photographs are used in, for example, annual reports, marketing publications targeted to potential clients, in-house newsletters, or for special events or news stories featuring the company. Probably the most common type of corporate photography is the head shot, although often companies want shots of their corporate headquarters or factories, both exterior and interior. Though the word "corporation" suggests a large organization, these clients for photography can range from small local businesses to multinational corporations.

Barron's Annual Reports Service operates a website (www.icbinc.com) that will send annual reports of many companies. There is no charge for the reports or for shipping them, and you can order up to 200 annual reports. Not all of the annual reports list the designer, but many do. If you find an annual report that you really like, contact that company's public relations department or advertising department and find out who designed the piece, then call that person or company directly.

The corporate world is a good place to nurture house accounts—once you establish a good rapport with a corporation and the designers who create their work, you may be able to become a regular photographer for them.

Design Firms

Publishers, advertising agencies, corporations, fashion houses, and many other businesses often use independent design firms, or studios. They usually fill the same role as an in-house design team, and often have photo editors as well as designers on staff, or the designer may fulfill both these

Gary Gelb's promotional cards are well suited for marketing to corporations.
GARY GELB

www.garygelb.com

gary gelb

photography

gg@garygelb.com • 888 691.0727

Life is Beautiful

SUGEN 1998 Annual Report

This annual report, designed by Cahan & Associates for Sugen with photography by Robert Schlatter, is beautifully designed and uses photography in an elegant way. I ordered it from the Barron's website because I thought some of the photographers I represent could do work like this. In this particular book, the names of all the photographers as well as the names of the copywriter and the design firm are clearly marked on the last page of the book. Be warned, though, that gathering the contact information you need from these annual reports can be difficult.
SUGEN ANNUAL REPORT/PHOTOGRAPHER: ROBERT SCHLATTER

functions. Since design firms tend to work for many clients and often a variety of types of clients, they can provide a lot of interesting work for photographers.

Usually your relationship with a photo editor or creative director in a design firm will be similar to your relationship with a photo editor at a magazine or publishing house. He or she will ask you to supply an image or set of images for a specific project. You will either shoot original work or provide images from your archives. In most cases, you will bill the design firm directly.

For researching designers, I use *The Workbook Directory* (see chapter 8) and talk directly to the designers to find out what they are working on. Mailing lists can target particular people within design firms, including art directors, creative directors, and graphic designers.

Entertainment Industry

It's nearly impossible to suggest ways to get your foot in the door in the entertainment industry—movies, television, theater and dance, and the music industry. There are few useful lists (though Agency Access sells a list of music company names), and there is no one reliable mode of attack. Much of the marketing is by word of mouth, and the bottom line is that when someone sees your work and likes it, he or she will contact you.

If you're determined to work in entertainment and want to take active steps toward doing so, you need to forge relationships with the talent. In other words, marketing to the record labels will not get you work in the music industry; you need to know the musicians, actors, and other talent, who often have a say about who photographs

them. One way to do this is to get editorial work that brings you into contact with these people and allows you to develop relationships. Another way is to go to local clubs, introduce yourself to the band members, and hand them a promo card. You can introduce yourself and ask to test with them; there would be no fee, just an exchange of their time for prints.

Of course, it helps if you understand, say, dance and the language of dance, or of acting and theater. To gain experience, you can offer to work for free or for a low fee for Off-Broadway and other theaters. Create a portfolio of your work in the entertainment field. Although there's nothing guaranteed about doing this, you can look up press agents in the phone book and contact them to see if they know of individuals or groups or troupes or theaters in need of photography.

Once you gain the confidence and trust of a talent, you must then pass muster with all of the many other decision-makers—including account executives at design studios, the publicists, the creative managers, and the photo editors.

Catalogs

As anyone knows who shops by mail, there are many catalogs and they are full of photographs. Given the sheer volume, catalog work can be lucrative, and it can be ongoing, because you can be sure that a successful company will continue to produce catalogs for print and the Internet.

There are three broad categories of catalog work: retail catalogs, direct-mail catalogs, and Internet catalogs, and the types of photography vary somewhat for the three. For example, many online catalogs offer only still life shots of products, while retail and direct-mail catalogs showcase products using more environmental still life shots or models.

Although some catalog companies have in-house photographers, the majority hire freelance. Quite often a catalog can turn into a house account—a client that comes back to a photographer again and again.

Photographer Denise Chastain recommends, "Get a job with a catalog company, where they shoot all different styles and you are able to find your niche and get experience."

Where do you start if you want to explore catalogs as a source of potential clients? Agency Access sells a list for department stores and for catalogs. Or simply get catalogs (or go to the company websites) that feature the type of thing you want to shoot (Lands' End, Pottery Barn, Marshall Fields Direct) and go from there. The key is to find who assigns the photography and then send your catalog portfolio to that person.

First, study the catalog and see if it's the kind of work you do or would like to do. Then find the home office's address and phone number, information that's usually printed somewhere in the catalog. Before calling the company, make sure you have framed the right questions—ones that will lead you to the key people. Keep in mind that the company's telephone operators might not have a clue about who assigns photography. But they will know the numbers for departments such as marketing, advertising, and public relations. You can help narrow the search, and find the right person more quickly, by asking the right questions. Once you're at the appropriate department, ask who assigns the photography.

The photo teams at catalog companies are most likely to choose photographers based on their direct-mail promotion cards and portfolios. You need to pay attention to the kind of photography a company is using and come to an understanding of what the essence of the particular brand is and what its photo style is all about. While the photo teams look for photographers who have a distinct style, they are also looking for photographers whose distinct style works well with the style of their catalog. So do your homework first, then listen to the client and respond with what the client wants from you. You need to be able to deliver what the client wants while bringing to the project the talent,

the eye, and the magic that every good photographer should bring to any project.

Fashion and Cosmetics

Fashion and cosmetics houses typically either maintain an in-house photography department or work with an outside advertising agency. Obviously, this market is very diverse—each brand is different and needs to be marketed and photographed differently—and so lends itself to various styles of photography.

In order to succeed as a fashion or cosmetics photographer, you need to understand fashion and who you are marketing to. Marlène Saunders, a consultant who currently works as an executive producer for a variety of companies, was formerly the in-house producer for print advertising and catalogs at Banana Republic. She says,

"Get under the skin of the brand so you know what their image is and what type of photography they need. You must do your research." For example, Banana Republic is very organic and likes to use models who are natural beauties. If your style does not work well with the style of a particular brand, do not market yourself there.

Lists—from another mailing house called Ad Base (www.adbase.com) or Agency Access—can help you locate the correct people to contact. They will give you names, addresses, e-mail address, and other contact information. If you can't afford to buy a list, call the brand's main number and ask for the in-house producer and mailing address. You can then send off a promotional piece. Most companies have a portfolio drop-off policy (see chapter 7) if you are interested in having your book seen. If you are marketing to an in-house department, you will be contacting

Russ Harrington, a photographer from Nashville, Tennessee, often targets the music industry.
PHOTOGRAPH OF TIM MCGRAW BY RUSS HARRINGTON

and perhaps meeting with an executive producer or in-house producer. These producers perform the same function as the art buyers at an ad agency, but they have more of a say and more "pull" about who gets hired than an ad agency art buyer does.

Marlène Saunders offers these words of advice: "Be on top of the fashion pulse and understand what fashion is. Each brand is different and seasonal and forever changing—a constant revolving door of what is in and what is out. Trendy may be your style, or classic and predictable may be your thing. Each brand needs to project an image and they need a photographer who can convey that image."

Marcy Maloy, a fashion photographer from San Francisco, is known for her lifestyle/fashion work and kid photography.
MARCY MALOY

Fine Art

Photographers who market to the fine art market are selling their work as art and art alone. That is, their work is put to no commercial or promotional use; it exists solely to be displayed—and viewed and considered in terms of its visual content. (However, sometimes fine art is purchased and used for advertisements.)

This client category has two main subcategories: individuals and businesses. However, that's where the categorization stops, for in the fine arts market each client is unique. The same is true for the price your work may command. Here there are no "industry standards." As with any art form, the monetary value of a photographer's work is linked to the subjective appreciation of those who own it or would like to own it.

Individual dealers often sell to corporations and to individuals. The Association of International Photography Art Dealers (AIPAD), an international organization dedicated to selling, buying, and exhibiting photographs as works of art, holds an annual convention that brings together curators from major art galleries to view photography; you can find more on this opportunity at www.photoshow.com. An Internet source that brings together dealers and collectors who purchase photographs is www.fine-art.com.

Mailing houses, such as Agency Access, sell lists of businesses that buy art for display. *The Workbook,* probably the most widely used source book for photographers, publishes the magazine *Framed,* which is distributed twice a year to corporate buyers of fine art.

Titles and Terms

When you have conversations with clients, you will want to understand the language and terms they use in talking about your photographs. For example, to make the most of your first contact with a company, you should be familiar with the titles of people who hire and work with photographers in various types of companies.

At an advertising agency an **account executive** or **manager** directs and coordinates the agency's efforts on behalf of a client's product or service; an **art buyer** or **art producer** purchases and assigns photography, illustration, and stock photos for use in print ads; a **stylist** performs specific services required for photo shoots, such as hair, makeup, food, props, and wardrobe; and a **production coordinator** manages all aspects of a photo shoot, including arranging transportation, booking talent, and renting equipment.

In an advertising agency or design firm, or on the staff of a book or magazine, an **art director** is responsible for the conception, design, and execution of innovative visual materials, and a **creative director** oversees the art director, **designers,** and **copy writers.** At a magazine or book publisher, a **photo editor** chooses photographs or photographers to support the editorial content in the publication, and works with **designers** on positioning, cropping, and otherwise styling the photograph for publication.

It's also important to understand the terms used in marketing and advertising. For example, in retail establishments, **point-of-sale** or **point-of-purchase** (POP) or **collateral** materials are displayed, such as display cards, shelf hangers, signs, leaflets, shopping cart posters, catalogs, and brochures that are made available or placed on display.

And photographers should understand two key terms clients use when planning what to do with a photograph. **Usage** refers to the time period, the area of distribution, the number of insertions, or the size of a print run in which a photograph is used, and **media** refers to the vehicle in which a photograph is used—print, television, collateral materials, etc.

At some point, turn to the back of this book and look over appendix A, "Terms and Titles Used in the Business of Photography." It gives basic definitions of many terms that photographers encounter as they work for commercial clients, including titles of other people who help produce shoots; terminology for different kinds of print ads; basic business and financial terms; and much more.

Finding and Targeting Clients: General Tips

By now, you are probably aware of one or more types of clients for whom you'd like to work. For some of the categories presented above, I offer ideas for finding specific clients to target, including the option of buying a database of companies (see chapter 6 for more on mailing lists). If, instead, you want to create your mailing list yourself or want to target a specially selected smaller group of clients within a larger database, here are some ideas for things you can do.

Be organized. Make a form to organize your information. Include the name of the company; the personal names you will contact; the address, telephone, and e-mail information; and the kind of photography they use. Allow space for making notes about when you have mailed them promotions and shown them your portfolio, and for any miscellaneous information about them that you want to keep track of.

Regularly review photo industry magazines. *Photo District News* (*PDN*), the award-winning monthly magazine for the visually creative, has been covering the professional photographic industry for more than two decades. Every month, *PDN* delivers news and analysis, interviews, and portfolios that keep you informed on everything that's happening in the world of photography.

PDN is packed with the very latest trends and techniques, business and legal news, and new products.

PDN's editor, Holly Hughes, says her magazine is a publication for a community, and she hopes that photographers will continue to want to share their experiences and expertise with others in their community. "I think that photographers lead isolated existences and are often very competitive with the other photographers out there," she says. "That is a really unfortunate thing." She is happy that certain photographers have always been extremely generous—to younger photographers, to other fellow shooters, to other people in their community—and that they share business, technical advice, even the stories of their own struggles, self-doubts, ambitions, dreams, and what it took to get their dream project done. Other people can learn from these accounts.

> *PDN is packed with the very latest trends and techniques, business and legal news, and new products.*

American Photo showcases the latest work of photographers from around the world and tells the story behind each image. Whether it is war-front, fashion, landscape, celebrity, or sports, and digital or analogue, the work is beautifully displayed. Each issue also provides in-depth equipment reviews and valuable how-to information.

In 1952, the heyday of photography-driven magazines such as *Life* and *Look*, *Aperture* was launched in California by some of photography's greatest practitioners, including Ansel Adams, Dorothea Lange, Barbara Morgan, and Minor White. At the time, however, there was no photography magazine targeted to serious photographers. *Aperture* reaches a large and diverse audience for fine photography worldwide.

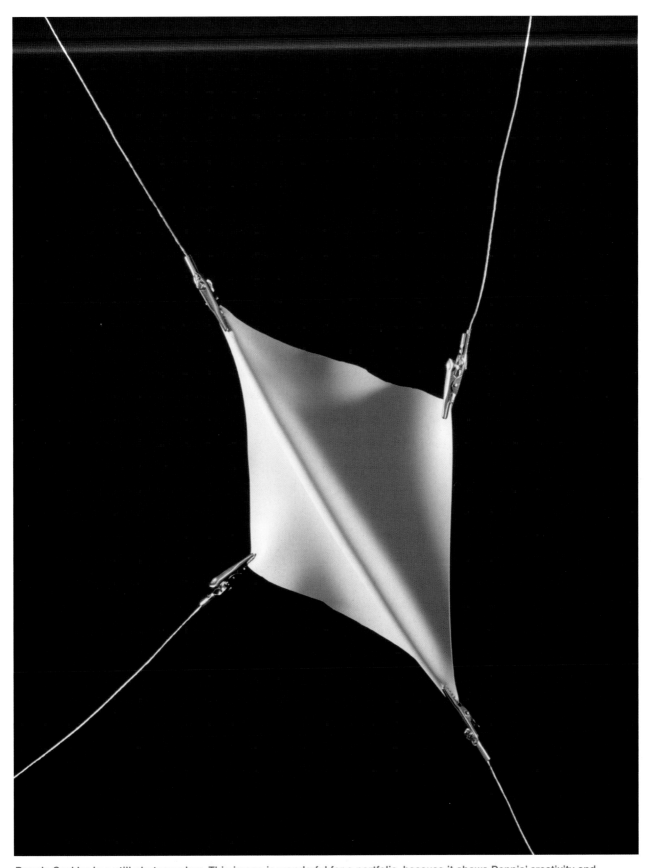

Dennis Seckler is a still photographer. This image is wonderful for a portfolio, because it shows Dennis' creativity and technical abilities.
DENNIS SECKLER

Three leading photography magazines: *Photo District News* keeps up with the world of photography through news coverage, interviews, and, of course, examples of stunning work. *American Photo* devotes a lot of space to showcasing the work of photographers from around the world and is an excellent place to keep up with trends and new work. *Aperture* is geared to fine photography.

PDN, PHOTOGRAPH BY ANDREW HETHERINGTON; © *AMERICAN PHOTO*, PHOTOGRAPH OF NICOLE KIDMAN BY JAMES WHITE; *APERTURE*, PHOTOGRAPH © FLOR GARDUÑO, *HOJA ELEGANTE* (ELEGANT LEAF), MEXICO, 1998.

Communication Arts is the leading trade journal for visual communications. The largest design magazine in the world, it showcases the top work in graphic design, advertising, illustration, photography, and interactive design. Each year the editors produce eight issues.

"Let your fingers do the walking . . ." This slogan about using the yellow pages of your telephone directory is good advice for photographers. A case in point: A New Jersey electrical engineer who was also an architectural photographer left his secure company job in order to freelance. He started by doing the most basic market research—he used the phone book, going through the builders' section entry by entry, calling each company, and setting up appointments to show his book. His photography was clean, well lit, and ideal for most builders' requirements, and his work for his initial clients led to assignments by other builders. This photographer created a client base by diligent use of the yellow pages and then benefited from another time-honored source of work: word of mouth among the building fraternity, which resulted in a steady flow of work for him.

Use Publications to Find Top Companies. The weekly newspaper *Crain's New York Business* publishes lists such as the top 50 architectural companies in New York and the country's top 50 companies in a variety of categories. The paper is available online at www.crainsny.com, on newsstands, or by subscription (call 212-210-0277). For targeting clients in specific business segments, there are many trade publications that publish lists of top companies in the field.

Go to a Barnes and Noble location or another bookstore with a large newsstand section to find these publications. For example, the magazine *Condé Nast Traveler* frequently publishes lists of top resorts, spas, and other destinations; if you are a travel and location photographer, you need this magazine for background information, notes

Photography Annual 43

Communication Arts

August 2002
Sixteen Dollars
www.commarts.com

of clients to target, and to see the kinds of photography they use. You can contact the destinations or their advertising agencies.

Rely on Local Trade Associations and Their Publications. Professional groups—such as organizations of women in business, of executives in a particular industry—can be excellent resources, especially if you specialize in a field such as executive portraiture. One way is to advertise in their publication. Another is to offer to present slide-supported programs—of your specialty, a current project, or a recent interesting trip. Organizations are always looking for interesting speakers, and a concise, lively slide show or Power Point presentation can be a lead-in to possible assignments and a way to connect with key people in the organization.

Be sure to choose or create a theme your audience can relate to, make it informative and entertaining, and don't make it too much

Communication Arts Photography Annual shows the work of winners in its prestigious annual contest; this is a good place to see new work and to show off your work, too, since art directors use the annual when looking to hire new talent.

of a "hard sell." The point is to introduce yourself and to position yourself as an interesting photographer who is available for work. Getting involved in trade or professional groups can also lead to being active in other networking groups that tend to form around businesses.

Do Internet Research.

Begin your Internet search for trade associations, potential clients, or business publications the way you would search for anything on the Web: Use a search engine like Google or Yahoo. Type in the category you are searching for—for example, "architectural organizations," "garden supply companies," or "direct-mail clothing." The secret to getting the best results is in the keyword that you use.

It's hard to tell what a company's needs are from its website. Still, take a look at the site's use of photography for some initial clues, and see if the site tells where they advertise. For overall information about the company, go to the "About Us" section of the site, which will tell you what the company is and often its history (good information to know if you are able to set up an interview), and it will probably also describe the image the company is trying to convey. The site may also include recent advertising campaigns or give an idea of where a company advertises.

Understand Clients' Needs.

You should learn as much as possible about an area of business or industry that you will target, but there is one factor you must focus on above all others: the needs of the business segment or the particular client. Selling a product or service is usually the main goal, but companies' strategic directions change surprisingly often, and it pays to know the current goals of a potential client before you contact its representative. This doesn't have to take a lot of time; even half an hour a day reading business magazines or the business section of your newspaper is time well spent. You should also read *Ad Week* and other advertising publications to see what's going on in the industry.

Become an Active Networker.

"Networking" simply means regularly talking with people in your chosen field and keeping up with opportunities, trends, and other news. Trade associations often host social events for the sole purpose of allowing people to make new contacts; in reading about your field, you are likely to come across notices of such gatherings. Even if you don't like socializing, make yourself attend a few of these. Meeting even a few people may be just what you need to get connected. Once you have a few acquaintances in your field, keep in touch—through a friendly phone call, meeting for coffee, etc. You can also network in a more direct way: Many companies are willing to set up brief "informational interviews," in which you can ask questions about the company and learn about its needs.

Qualifying Clients

Before you send a direct-mail piece (chapter 6) or show a client your portfolio (chapter 7), you should conduct enough research to ensure you are targeting the right person. How do you find out who does what and how they find photographers? How do you find who is hiring the photographers for shoots? It's simple: Just ask!

Targeting the Correct Person.

A good client database lists the people who make the decisions about hiring photographers. This may sound easy, but quite often it can turn into a full-time job. I consulted with a photographer who shot corporate work and targeted design firms that produced corporate annual reports. There was one designer in particular who produced many annual reports, so she promoted to him for a year and a half. She dropped off her portfolio and did repeat mailings to this designer but never got a response. Finally, she confronted him directly and asked if he was the person that hired the photographers for shoots. He said no, that his boss picked the photographers; he just designed the pieces. That was a costly mistake in both time and money.

Simply ask, "Are you the person who decides which photographer to hire?" If the answer is no, ask, "Who should I call?"

Calling for Information. A telephone call is the most effective way to get direct answers. Before calling, get as much information as possible on the Internet or printed publications. When you make the call, confirm the information you have gathered and then ask for the other information you need.

You should have the answers to the following questions as part of "qualifying" potential clients. Some of them are obvious, but, believe me, you will be glad that you have asked them.

- Do you use photography? Stock or assignment?
- How often do you shoot? Twice a month, four times a month?
- What subject matter categories do you prefer? Still life, people, kids, location, fashion?
- What photographic styles do you prefer? Do you prefer an editorial style of shooting? Do you use a graphic style—that is, vivid and strong colors, angles, contrast, expressions, lines?
- Do you make appointments or do you prefer portfolio drop-offs?

Keep your conversations short. You are not trying to make friends; you are calling to get information. If you get the feeling that it is not a good time for the person to talk, get off the phone immediately. Sometimes I will get answers to only the first three questions. Time is precious, and often people cannot stay on the phone. Call back at a later time to ask them your remaining questions; when I do that, I often quickly recap the prior information to show them that I have done my homework.

Now you have an idea of the kinds of clients that are out there, including perhaps ones you are best suited to approach, plus how to target particular clients within the major categories. The next chapter will focus on the creation or refinement of your portfolio.

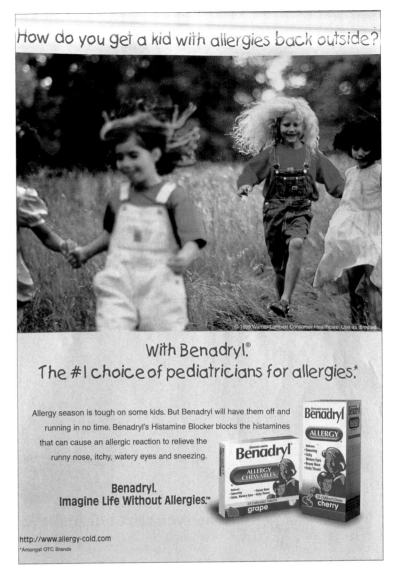

Going through magazines and finding ads that use your style of photography is a good way to target potential clients.
BENADRYL

DO . . .
- Go to a newsstand and spend a few hours leafing through various publications that might be markets for your work.
- Explore the many websites that will lead you to sources for your photography.
- Become familiar with the title and roles of people in the various companies you want to target.

DON'T . . .
- Waste time and money targeting the wrong contact person in a company.
- Take up a contact's time on the phone with chitchat—you are doing business, not making friends.

Structure Your Portfolio

DENNIS SECKLER

What is a Good Portfolio?

Chances are you have some type of portfolio, even if you haven't worked professionally yet. When was the last time you took a hard look at it? Do the images in your book best represent the style you are currently shooting? Is it well edited? Does the presentation look current? Is it positioned toward the type of assignments you want to shoot? If you answered "no" to one of these questions, it is time to get to work on your portfolio.

Your portfolio is both a showpiece and a selling tool. It shows potential clients who you are and what you can do for them.

Your portfolio is both a showpiece and a selling tool. It shows potential clients who you are and what you can do for them. Your portfolio represents you—your style, your technique, the subject matter you prefer. It summarizes your areas of expertise. This chapter looks at how and why a good portfolio works for you—how it can best function as a strong introduction of you and your work. Of course, clients take pricing into account in choosing a photographer, but the portfolio is most often the determining factor in the final hiring decision.

Your portfolio shows work you can create and produce— "create," because people want to know your style and vision, and "produce," because your clients are going to want to know that you can recreate that style and vision onto their layout and that you know how to produce it.

You should have at least two portfolios. If you have only one, you may be reluctant to send it out, when you should feel just the opposite. Your portfolio should never be in the studio. It should be out trying to get you work. If you have more than one book, you also have another one to send out if someone calls or if you want to do a cold call. The optimum number of portfolios is three, which allows you to have one with you if you have an appointment and still know that you can send out one or two when someone calls for your portfolio.

Be sure to keep track of where those books are. A simple way is to number the books for yourself (you can pencil in the number in an inconspicuous spot, such as in a corner of the back inside cover), and note on a sheet of paper or a computer file: portfolio number, date sent out, client (company name and person's name), and the date it came back.

I first met photographer Denise Chastain when she came to me for a consultation. Denise was already doing photography within the music industry, but she wanted help getting more work and improving on her self-promotion ideas. She had a black-and-white portrait portfolio, beautifully printed. The age range of her subjects was generally eighteen through twenty-five, and they were all interesting-looking people.

Portfolio Consultants

A consultant, in providing a professional point of view, can help in assembling your portfolio. You may have a firm sense of how you want to assemble and design your portfolio, but you may lack a sense of direction and need help in organizing your book or focusing it toward the proper market or category of clients. Or you may sense that you need an objective opinion about which images are your strongest. You will hear about particular consultants in conversations with other photographers, or you can research them on the websites of *Photo District News* (www.pdn-pix.com/) and other industry magazines and websites. The fees consultants charge can vary widely. Don't be shy about inquiring about fees; this is business.

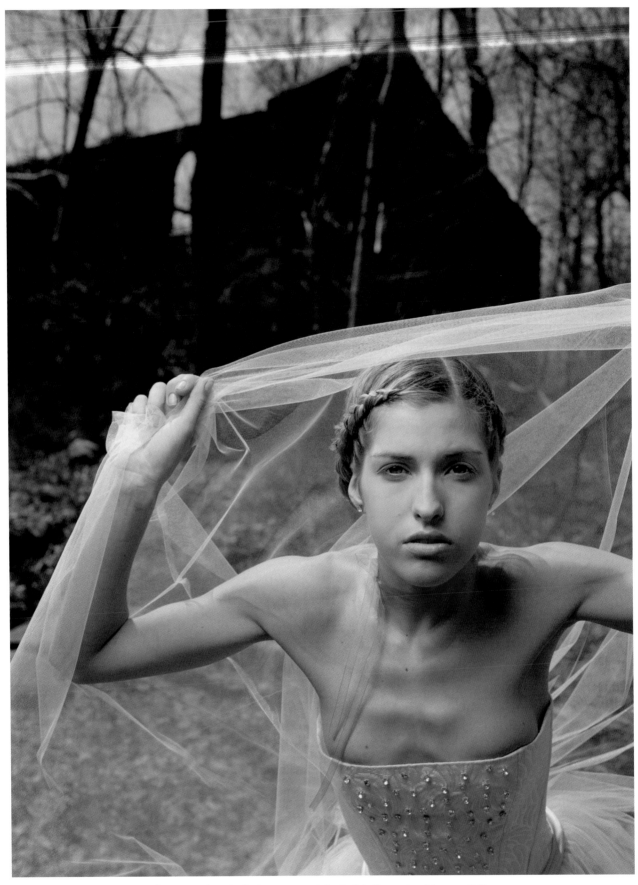

Denise Chastain's strong environmental portraits have a consistent style throughout her portfolio.
DENISE CHASTAIN

There was nothing that needed changing in her portfolio. Denise is an excellent outdoor location portrait shooter. Her lighting is beautiful. The emotions, the faces, the gestures of her subjects come through. In this chapter and the ones that follow, I will show you examples from Denise's portfolio, as well as other promotional pieces she has created.

Selecting Images

Whatever else you do in assembling and designing your portfolio, keep this primary rule in mind: Always show your best photographic images—the ones that show how you light, compose, and think visually. Make sure they reflect the direction you want your work to go in.

Second, be selective. Don't include too many pieces to review—"less is more." A common mistake is having too many images in a portfolio. How many are ideal? There's no absolute number. I've looked at books with forty pieces and didn't realize there were that many. And I've suffered through a portfolio of twelve images. If you have five excellent images, that is your complete portfolio for now. When you have more excellent images, add them to your book. In general, a good number of pieces ranges between fifteen and twenty-five images. If you present in 35mm (not very common today), six to eight slide sheets is a good number. Bad editing can weaken a portfolio. Make sure the pictures in your book are your strongest "photographic" images—as opposed to images you personally like.

Third, take a visual inventory for consistency. Is your shooting style consistent throughout? Are your portraits stronger than your location work? If you are showing a mixture of subjects (for example, still life, corporate, and portrait) in a portfolio, be sure to support each of these categories with equal numbers of images.

When you are putting together a portfolio, you must constantly keep in mind who the end user will be, what type of client you are pursuing, what kind of accounts you are going after. Let's say you want to work for business magazines. Make a mental list or even an actual list of the magazines you want to shoot for. Or maybe you want to shoot for annual reports and shoot portraits of the executives (I call them "guys with ties"). Do you want to do national ads? Here are all the people who invested in Citibank or here are all the faces of the world that use Sprint. Those are all portraits as well. So which category of portraits do you want to shoot? That is the first question you should ask yourself. If the answer is "magazines," then you should create more of an editorial book. If it is "advertising," create a more commercial-looking book.

We are marketing to creative people. Respect their knowledge of the industry. Use your portfolio as a vehicle to communicate to them that you are a master of your craft. Ask yourself the following questions, in which the overriding concern is "What is my portfolio saying about me?"

Whatever else you do in assembling and designing your portfolio, keep this primary rule in mind: Always show your best photographic images—the ones that show how you light, compose, and think visually.

What statement is my portfolio making?

Paul Moakley, former photo editor of *Photo District News,* says that the question that always stops him when someone arrives with a book is—and this sounds clichéd—"Is this work really different? Is this person doing something that I haven't seen?" To make a statement about yourself, you need to put what you are doing into some consistent form. Visually, your portfolio has to have a good feeling, consistency, and an aesthetic that carries through it. Once you've done this, people like Paul will see your vision and the tone of your work.

Does my portfolio show the real me?
Regardless of the number of images it contains, a good portfolio should immediately establish your identity in the mind of the viewer. Ask yourself: Does your photography have a specific style? Although you may be a generalist—for example, shooting different categories: still lifes, people, locations, etc.—there should be an observable style to your photography. That style should be carried across into your portfolio presentation, promotion, and company identity. Having one "look" for your total package will position you and your company in the way you want to be thought of.

Many photographers shoot different styles (depending on the client and subject matter), and that's a good thing. However, a portfolio with "mixed styles" can be confusing. In the chapter 2 section "What If You Have a Split Personality?" I talked about New York photographer Jack Reznicki and how he maintains two types of portfolios that represent his shots of children and his editorial lifestyle photography. Another approach is to present a variety of images in a single portfolio, supporting each style with five or six strong images. That will show the viewer that you are well versed in each area.

Denise Chastain shot this image for *Request* magazine in a studio but it has the same feel as an image shot on location.
REQUEST MAGAZINE/ PHOTOGRAPH BY DENISE CHASTAIN

If your portfolio has had the same look for the past three to five years, think about making some changes. The changes do not have to be drastic. Adding new images—whether they be test shots or personal work—can bring more of your point of view to the portfolio. Take chances; don't try to second guess what you think clients may want to see. Go with beautiful, well-lit photography. Isn't that why you became a photographer in the first place?

When I first met Denise Chastain, she was shooting for the music industry. At that time she shot Marc Anthony for the cover of *Request* magazine. For Denise's portfolio, we decided to use the image that was chosen for the cover of the magazine. However, quite often the image that an art director will chose for a job might not be your favorite. Your portfolio should be a reflection of what *you* think is the best work or the work that best reflects the style you want to put forward. Do not feel that you have to choose the exact image that was a client's choice.

Does my portfolio reflect the type of assignments I want to shoot? Looking through magazines, annual reports, and other visual material in search of "I wish I had shot that" images will help you to define your market. I ask the photographers I consult with to keep a file like this. It helps them to see how their potential clients are using photography and shows them the type of ads that are being produced. Then ask yourself if the images that exist in your portfolio relate to the shots your potential clients are using. If they don't, it's time to shoot some tests. Use the materials that you have collected to inspire you to create your own new images.

If you are a generalist—someone who shoots many different types of photography—be sure that when you edit images for your portfolio you have enough images that support each category you shoot. It helps to balance the book so that each category is equally represented.

For this purpose, it is helpful not to forget the images in your files that you have not selected for your portfolio and outtakes from shoots. Go back to these periodically and see if they can be used to supplement your portfolio, showing your strength in one area or another.

Shooting New Images for Your Portfolio

How do you know when you need new images? If your images are outdated or have been in your book too long, you should consider adding new shots or replacing some of your older ones. Many art directors will call in your book several times, and it's nice to keep it fresh and show them new imagery from time to time.

There is no real formula for knowing when to add images or deciding how many and which of your existing portfolio shots to replace. Many people in the industry who call in books—or even other professional photographers who see your book—will offer comments and advice. While you may receive mixed signals from these sources, that advice can give you a good indication of what should stay, what should be taken out, and what new shots might be added. One constant factor in deciding whether to add to or diversify your portfolio is the type of imagery and style used by the market you are targeting.

However, you need to balance your targeting of the market with showing who you are as an individual photographer. Holly Hughes, editor of *Photo District News,* says she would hesitate to have people imitate what is out there or to buy *Self Service* magazine or *Dutch* and then say, "It looks weird to me, so I am going to shoot weird. Or gory is in now, so I am going to shoot that way." When she and her staff look at the work of young photographers, they often spot purposeful imitation, and that is not a good thing.

You need to personalize, to know what will appeal to the market but focus on the elements that interest you or find some way to be yourself within what the market wants. You should look at a lot of photography for inspiration, and take from it elements that will come across as truthful when applied to your work.

For example, you can go through magazines, pull ads, or editorial photography that you like, put those tear sheets up on the wall, and look at them. But you are not going to shoot the exact same objects or in the exact same style, says Holly Hughes. Instead you should say, "Why do I like this so much? Why does it look fresh and different to me?" Try to understand what it is that is registering and say, "Maybe it is the simplicity of the styling. Maybe it is historical references, and I really like that. Maybe I like the colors. That is a palette I haven't tried before in my work."

Shooting new images for your portfolio can be costly. Film is expensive and so are props and renting equipment and studio time. If you shoot people or fashion, hair and makeup and models can be expensive. When you find yourself in the position of needing to shoot for your portfolio and you don't have the money, stop to take an inventory. Ask yourself what you have at your disposal. Can you barter or call in a favor?

A few years ago I consulted with a children's photographer from upstate New York. He needed to create new images on a shoestring budget. We made a list of what he had access to. He had three kids and a house. The kids were his models. His kitchen became our set. He used what he owned for props and wardrobe. Our plan was for him to light his kitchen for early-morning sunlight. He set up his camera to shoot his kids eating breakfast. His wife was in the background (the sink area) washing dishes throughout the shoot. His kids, who were used to seeing Dad with a camera, totally ignored him. Their gestures were natural in most every shot. The lighting was controlled because that was all done in advance. The film looked great. The test was a success. The photographer's main expense was the cost of the film.

Another photographer I worked with specialized in travel. She needed to shoot new images but didn't have the money for a trip. I suggested that she take her camera to Chinatown in downtown New York City. We created a shot list before she went. I asked her to create a visual story about the people who lived there. I also wanted some environmental still life shots. We waited for a day that had good light. She shot three rolls of film, and we edited the film down to nine shots. She used a student designer to create a multiple-image spread for her portfolio that I thought could also be used as a promo card. It was a very successful test. Her only expense was the cost of the film.

Finding creative ways to solve some of the financial burdens of shooting tests often involves simply figuring out how to use the resources you have.

Make it a habit to shoot new film for your portfolio.

Finding the time to shoot is up to you. My suggestion is to schedule it into your week. Often photographers plan test-shoot days—sometimes on a weekend and sometimes during the week. This often means that you are shooting every day, which reinforces your commitment to shooting. The proof is in the portfolio—are you shooting enough to keep your portfolio fresh? Make it a habit to shoot new film for your portfolio. Do it often. You have nothing to lose and you will gain a better-looking portfolio.

There are so many subjective factors in selecting and shooting images for your portfolio that it is impossible to give detailed advice that will suit all cases. The most important consideration is that in doing your final edit, you create a portfolio with a voice—one that represents you and what you want to do.

Presenting Images

There is no right or wrong way to present your images, but there are a few universal guidelines that are good to follow. You should select a format that makes it comfortable for potential clients to view your images. Explore the different materials that are available to you for presentation. For example, black portfolio pages are fine, but they also come in different colors and textures. See if grouping images next to one another helps to tell a story

about how you shoot; if single images make you look stronger, keep one image to a page.

Most of all, a portfolio needs to be entertaining. Every time you turn the page, you want to engage the viewer. At the same time you want to educate the viewer about your strengths as a photographer. When you are creating a portfolio, you want to make sure that each spread says something about the talent of the photographer.

Creating Categories. You need to think about creating categories within your portfolio when you are presenting several different styles or subjects. There are no standard or even common categories, as every photographer shoots differently.

Let your images create the categories for your portfolio. Looking at all your work spread out, find the images that are similar in subject matter, style, lighting, or feel. Do not force categories that do not exist.

Kevin York and I created these categories for his images:

- Helmet heads (a large collection of racers wearing helmets)
- Car shots with crowds
- Car shots without crowds
- Action in a pit stop
- Winners of the race
- Miscellaneous shots around the track
- Portraits of racers
- Stories (photo essays) of a "day in the life of a racer"

Once Kevin's images were sorted into categories, we used a designer to create portfolio layouts (see p. 66 for more on using a designer). We created the category single images, in which every image would stand alone on a spread. There are many ways to place your image on a spread. It may be a double-page bleed that flows over the gutter of the book. It can also be a single bleed. (In a bleed, an image runs from one edge of the page to the other edge, filling the entire page, without a margin. In a double-page bleed the image takes up both the left and right sides of the spread; a single bleed takes up the entire page of only one side.)

The next pile was the multiple images. Multiple images included photographs of the crowd, a close-up of someone fixing a tire, one of the racers with a helmet, all telling the story of a day in the life of a race.

We had another multiple-image pile that was titled "a moment in time at a pit stop." All of those images were actually created at different times and at different races. Together they showed the energy generated at a pit stop. We edited Kevin's book to illustrate Kevin's various strengths.

Many of the racing magazines use black-and-white photography, so Kevin York includes this spread in his portfolio. The images tell a visual story about "man and his machine," while creating an exciting atmosphere.
KEVIN YORK/DESIGN BY JOHN GENTILE

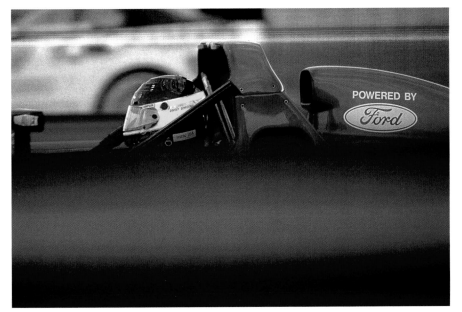

The designer pumped up the blue color in the car and the green color in the background on this double-page bleed, enhancing the overall look of this photograph by Kevin York.
KEVIN YORK/DESIGN BY JOHN GENTILE

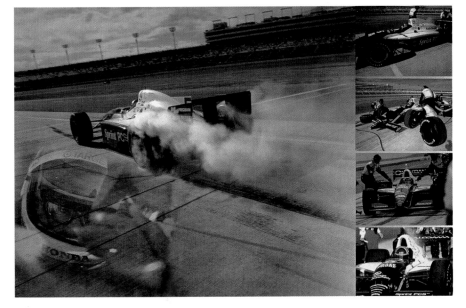

Designer John Gentile felt that this layout of photographs by Kevin York showing a "moment in time" at a pit stop needed an extra element of design. So, he manipulated the larger image by adding the driver in the mask to the lower left corner.
KEVIN YORK/DESIGN BY JOHN GENTILE

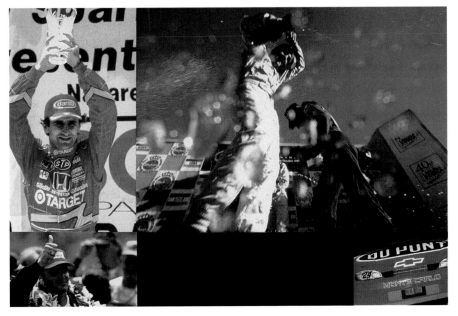

These images by Kevin York are from different races, but they are placed together in his portfolio to show the energy that's present when a driver wins a race. Together, they show that Kevin can capture the magic of that winning moment. The images work well together, all the more so since designer John Gentile manipulated the colors in the computer so that they would work together better visually.
KEVIN YORK/DESIGN BY JOHN GENTILE

Which Media to Use? Chromes, prints, or tear sheets? The format you use to display your images depends on the client. Most clients prefer prints, and my favorite way to show a portfolio is in print format. For one thing, prints are much more convenient than chromes. When I go on appointments I realize that clients looking at chromes never use a light box, and I get tired of people looking at my photographer's images out the window. Besides, the assignment you shoot will likely end up in a print format, and I think it is a good idea to present your portfolio in the format in which the client is going to ultimately use your images. Desktop printers make it is easy to make a beautiful print.

The Portfolio Case. In choosing your portfolio case—the exterior package that represents you and your work—there are a few ground rules. First, you can be creative, but be sure that your exterior package, your portfolio case, looks professional. Make sure the case is easy to open and that it is not too heavy—heavy cases are not popular with clients. Never use a photo album. A photo album says that you are a wedding photographer.

A shop like Brewer-Cantelmo, a manufacturer of high-quality portfolios and presentation cases, can show you many styles, sizes, and samples of portfolios, and though shop personnel will work with you and guide you, you will need to make the final decisions. "Some customers come to us and ask, 'What is everyone doing? What color is everyone using?'" says Richard Verdini.

"Many do not know what they want." He says it's best to have some idea of how you want to present your work and what work you want to present. The company's web address is www.brewer-cantelmo.com.

Which Format to Use? I went to see a photo editor friend to discuss portfolio formats. She had just called in the portfolios of ten of the top photographers in the country. She let me look at all the books. The images were wonderful. But what was most striking to me was that they all were presented in the same way, in a portfolio book. The books were all black or gray or red, and they were very conservative presentations. The books had screw-post bindings, were leather (or artificial leather), and the photographers' names were embossed on the fronts. All the images were under plastic sleeves.

I was really surprised because there are so many other options out there, but today people are showing their work the way they did when I first came into the business in the 1980s. Later we got into some fancy and outrageous stuff, such as showing loose prints in a presentation box. But now everyone has gone back to portfolios, which can be more solidly organized.

> A portfolio needs to be entertaining. Every time you turn the page, you want to engage the viewer. At the same time you want to educate the viewer as to what your strengths are as a photographer.

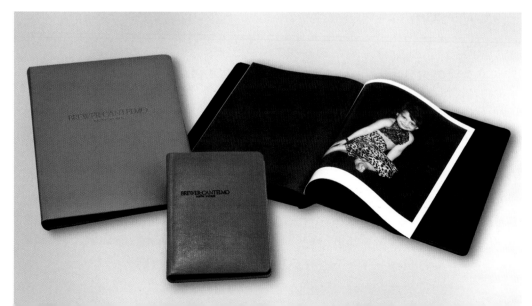

A portfolio book with screwpost binding, padded covers, and a pocket is an excellent vehicle for showing your work in a professional way.
BREWER-CANTELMO

If you want to be hired for print media you should show your work in the context in which your client is going to use it. If you're showing your book to a magazine photo editor, it's just common sense that the pages should turn the way they do in a magazine. Art directors, art buyers, people looking at portfolios typically will not turn the book sideways. They will either look at the image sideways or they will turn their head sideways. It upsets me to sit at an appointment with art directors and see them tilt their heads for a second to look at a horizontal image. Is that the way you want your image to be looked at? The way to get around this situation is to use the spread like you would in a magazine. An image can go across the binding clearly, especially if the portfolio has screw posts.

It's also hard to view loose prints, even if they are hard-mounted. In most offices it's difficult to find a clean surface to lay them out on, so looking at them becomes a juggling game with the prints inevitably falling on the floor. It's a lot easier to look at prints when they're bound together in a book.

Other Considerations. Everything in a portfolio is hole-punched, whether it is a plastic page, a cloth-hinge page, or a raw print itself, and the pages need some kind of binding. My favorite binding is screw post. This is basically a binding system where pages are held by screws to give the look of a bound book. You may add or subtract pages. European books, on the other hand, are bound, so you can't replace pages. If those pages become worn, scratched or dirtied, that's it. A common complaint about screw-post binding is that the pages of a portfolio do not lie completely flat. On the other hand, find me a magazine where the pages lie flat.

The black pages in the plastic sleeves are called "fillers." It bothers me when photographers use those fillers as the background to their photographs—the black filler was never supposed to be part of the presentation.

The portfolio Denise Chastain uses is a man-made leather black book with her name embossed on the front. Her plastic pages are

There are many ways to place a single image on a spread. The gray areas here represent the placement possibilities.

nonreflective. Denise prints all her own work for the portfolio with her desktop printer.

Most art directors are bothered at the little care some photographers take with the "upkeep" of their portfolio. Portfolios that are falling apart and those with worn boards and badly scratched plastic pages and plastic sleeves do not look professional. Your portfolio needs constant maintenance. As an alternative to plastic sleeves I ask photographers not to use plastic sleeves but to mount their photographs instead on beautiful paper with linen tape. Today you can make beautiful prints with a computer at minimal cost and have a professional shop score and punch them.

When you are preparing for a portfolio appointment or drop-off, plan to take or send along materials that the person who views your book can keep after reviewing your work. These "leave-behinds" provide the art director or art buyer with a reminder for future jobs. Many photographers use their direct-mail pieces as leave-behinds, while others offer tear sheets of their work for other clients. Direct-mail or other promotional pieces can be placed in a "leave-behind pocket" on the inside of the back cover, with the opening at the left (facing the gutter)

and running vertically from top to bottom so that the materials don't fall out. Companies that make presentation cases often offer such a pocket as a standard feature; check with the company to make sure that your case will have one.

Make a Statement with Design. Design is an important element in presenting your work. Design heightens the visual experience and allows viewers to see your images in a way that they wouldn't normally see them. A well-designed portfolio demonstrates that the photographer understands layout and

the idea of "shooting to concept," or how the images will have to work on a page, as they do in a story. Let your images decide where they should sit in relation to one another on a spread, especially if you are going to place one picture on the right and one on the left.

Placing shots to emphasize colors or shapes can enhance the look and feel of your images. A photographer who shows a strong design sense is going to instill confidence. More and more books have a portrait and a still life on facing pages, and I think this trend is wonderful. By presenting images in this way, a photo editor gets a sense of how

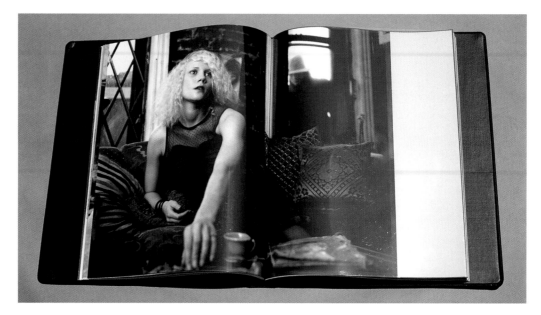

A simple black (11- × 14-inch) portfolio makes it easy to present Denise Chastain's work in a professional format. Denise insists on printing all the images for her portfolio herself. Her strong images just jump off the page. A screw-post binding creates a soft gutter, making it easy to bleed images across the spread.
DENISE CHASTAIN

Matt Proulx slips these leave-behinds into a pocket at the back of his portfolio case.
MATT PROULX

a photographer sees both animate and inanimate objects. Be careful, however, not to take too much of a "fine arts" approach. An iris print on watercolor paper is gorgeous but won't give an editor a real sense of how that image will print in a magazine. The final product is going to be a real disappointment, because the colors won't be saturated on a magazine page the way they are on fine paper. It's better to present your work as a clean traditional print in which the image appears as it will on the printed page.

There is an Avon ad I love, which I call "women of the world" that uses nine different photographs of women of all ethnicities on one page. When you group images together that speak the same language or talk about the same subject matter, just looking at the result makes you feel right. In this ad, I see a woman who might be from France, one from New York, one from Asia. They all look like working women or women on the go. As you are designing your portfolio spreads, look at your images and look for categories. When you see a category—say, shots with a common subject matter—group

them together and see how the photographs and their energy play off one another to create a nice spread for your portfolio.

The Nine West ad below shows how much a single spread can do to showcase a photographer's abilities. The shot on the left catches your attention, establishes an emotion for the spread, and sets the stage for the products, while the fifty-plus images on the right show the product in several different ways—they provide the where, when, and how—while they give a feel to the ad.

ABOVE: **The color design in this Crate & Barrel ad is terrific and helps create a striking spread. Changing colors in your photographs, with the aid of your computer, can enable you to position images next to each other that might not otherwise be compatible.**
CRATE & BARREL

When designing your portfolio, look for inspiration in other media. The layout in this ad is an interesting way to showcase images on a portfolio spread.
© NINE WEST; PHOTOGRAPH BY ROBERT ERDMAN

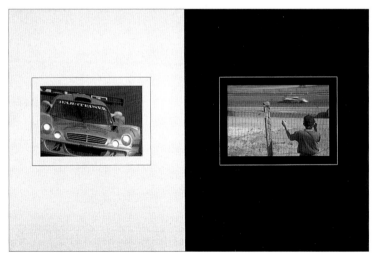

TOP: **All the images in Kevin York's book are digital printouts. This double-page spread bleeds on three sides to maximize the image area.** CENTER: **Kevin York had a lot of "helmet heads" in his film outtakes. We used many of them for a multiple image that demonstrates the range of Kevin's racing experience.** BOTTOM: **Kevin York and I created this spread for his book because we wanted to show more concepts within the theme of racing. Black and white is perfect for enhancing the dreamy hopes of a young racer.** KEVIN YORK/DESIGN BY JOHN GENTILE

Working with a Designer. You should consider working with a designer when you feel less than 100 percent confident in your ability to create amazing spreads in your portfolio. Remember, you are a photographer, not a designer—someone trained to size, juxtapose, and sequence images for a particular effect.

While the fees designers charge vary tremendously, they generally relate to how well established and in demand a particular designer is. Some designers work within a large or small design firm, and others work independently (that is, freelance). You may hear about good designers via word of mouth. Or you can use the various industry directories (see chapter 8) to identify design firms or schools with design departments.

If you don't have the budget to hire a designer, consider getting help from students at your local art school. Call the school, ask to speak to the department head, and let that person know you are interested in hiring a student for work. Often someone at the school will recommend one or two people, or mention the opportunity to a class. You can also go to the school and put up a flyer advertising your need for a designer. I see incredible designs from students.

Kevin York had particular "future clients" in mind, and he provided me and the designer of his portfolio with racing magazines as examples of the work he wanted to do. The portfolio I had in mind for Kevin was a basic "book" format with his name embossed on the front. We chose both color and black-and-white images to show, because Kevin works in both and it is nice to show a variety to an art director.

The first spread in Kevin's portfolio is a three-way bleed that crosses the gutter. You don't see any spiral binding or any gap in the gutter, providing one continuous look that reflects the context in which Kevin's work is normally used. Throughout the portfolio, we show images that Kevin likes big and we stretch them across the page, some as double-page bleeds. Kevin had a lot of "helmet heads" (racers in their helmets, shot up close) in his portfolio. I chose what I thought were the best. Our designer, John

Gentile, came up with a spread that used multiple images to show that Kevin has access to many famous race drivers.

Kevin and I also wanted to create a conceptual spread in his portfolio. We had an image that I had chosen because it was a beautiful black-and-white photograph of a car, and Kevin and I talked about doing a complement to this image, perhaps a shot of a young boy looking at the car, wishing one day he would be a racer. Kevin came up with an evocative shot that conveys warmth, hope, and good feelings. It creates a great story.

Shipping Your Portfolio. Sooner or later, you should invest in an external case for transporting your portfolio. A weather-resistant, padded carrying case can be custom-sized to fit any book, box, binder, or other object, and can be made of extremely strong and durable nylon or genuine leather; either will withstand a lot of wear. The case comes in two styles: zip top or full zip (zips along three sides) and with a double handle or a shoulder strap, or both.

A presentation mailer, a lightweight box that holds laminations, boards, and other materials can be built to fit any standard-size air-express mailer or any other size. Presentation mailers come in a variety of colors and materials, and they can be imprinted with your name and/or logo. You can also use the carrying case to mail or air-express your portfolio. We sometimes put a portfolio into a nylon bag from Brewer-Cantelmo, take off the strap and/or fold down the handles, and ship it in a large air-express box.

It's important to put a luggage tag, with your name, address, and phone number, on

Brewer-Cantelmo's luggage tag.
BREWER-CANTELMO/PHOTOGRAPH BY ROBERT WILEY

the outside of the package in which you send your portfolio, even if you send your portfolio by Federal Express. Jo Ann Giaquinto, art buyer/art producer at Young & Rubicam, says it's also important to put your name on your portfolio—not just on a shipping tag on a removable exterior case, but on the book itself. Art buyers and art directors often review many books at one sitting, and often the books become separated from their exterior cases. A photographer's book that has been sent in without a name can be literally lost in the shuffle.

Don't send a portfolio that doesn't fit into a standard-size shipping case. It's possible that the original shipping case might get separated from the portfolio, so when it's time to return the material another case is needed. If the portfolio needs a special box—not a standard delivery service carton—it becomes a hassle for the art buyer and might delay the return of your book. This might sound trivial, but art buyers have enough to worry about without making a custom box to return a photographer's portfolio.

TOP: **Brewer-Cantelmo sells customized weather-resistant, padded carrying cases to fit any book, box, or binder. The cases come in two styles—zip top or full zip sides—and are available in leather, nylon, or cordura and in several colors. They can be produced with a double handle, a shoulder strap, or both.** BOTTOM: **A lightweight "presentation mailer" box holds laminations or boards and can be built in any size. Presentation mailers come in a variety of colors and materials, and can include your name and logo.** BREWER-CANTELMO

Your Portfolio on the Internet

Are the buyers of photography currently checking out portfolios on the Internet, or are they still calling for a traditional portfolio when awarding jobs? I surveyed the decision-makers—I called creative people from New York City to Los Angeles. I contacted art directors, magazine editors, and art buyers. I interviewed them about their use of the Internet and how it related to their everyday photography buying needs.

When I asked them if they use the Internet to hire photographers, I got a mixed bag of answers. Many creative people use the Internet to find photographers. They like the sourcebook sites (see chapter 8) because most are easy to search. A website also helps them to view additional images when an art director needs to see something quickly. But an equal number of creative people told me that their clients like seeing a portfolio. "It's easier to carry into a meeting," one art director told me. Many people said that they would go out of their way to visit a website if the address was listed on a direct-mail piece they liked or a URL link on an e-promo.

Perhaps the decision to "web or not to web" is better thought of in terms of short-term and long-term goals. A photographer with limited funds might do better to create a traditional (paper) portfolio first and use direct-mail marketing to reach a targeted creative audience—for more immediate results. A photographer who has house accounts—clients he can rely on for continuous income—doesn't have to be so concerned about getting an immediate return on his investment in an Internet site.

According to Holly Hughes, editor of *Photo District News,* what makes websites really handy is when you don't have enough portfolios to go around or you just can't get the portfolio to someone. You can say to someone, "Look at my website." Or, as Paul Moakley, former photo editor of *PDN,* notes, it's handy if you are in an inconvenient place, if you don't live in the city, or for some reason you can't get your book to someone quickly and they need it today.

Creating Your Own Website. Where does one go for advice about how to create a website? To a website, of course. Three sites to begin with are www.2createawebsite.com, www.make-a-web-site.com, and www.killersites.com.

If you're looking to create your own website with the free providers—this is not recommended! —you don't need a domain name because your provider will provide you with one. Just remember that you won't have nearly as much freedom to do what you want in creating your web pages, and you'll have to put up with annoying pop-ups and banners.

If you're looking to build a long-term website—this is the best route to take—the first thing you need to do is reserve your own domain name (sometimes called a "dot-com" name). If you want to be found in the major search engines and directories,

DO . . .
- Have at least two portfolios.
- Arrange the images in your photo so they tell a captivating story.
- Make sure your portfolio case looks professional.
- Consider working with a designer to create a professional-looking portfolio.
- Put your name and contact information on both the portfolio and the shipping case.

DON'T . . .
- Include too many pieces in your portfolio.
- Let your portfolio become scratched and in other ways fall into disrepair.
- Send a portfolio that doesn't fit into a standard-size shipping case.

you should take some time to understand how a domain name can benefit you when it comes to receiving traffic.

Next, you will need to register your domain name. A few years ago you had to go to Network Solutions and pay $35 per year for a domain name because this was the only domain registrar available. Thanks to deregulation, companies can now sell domains at a lower price. See www.2createawebsite.com for more details.

After you register your domain name, you'll need a hosting company. A "web host" provides you with the space to create your web pages and grants access to many other features that allow you to enhance your web site. Again, www.2createawebsite.com explains further. Once you have a web host, you can start creating or having your web pages designed.

Use the principles discussed above for selecting images and creating categories for your photographs. In terms of creating the design—how the images will appear on the screen—I definitely recommend speaking with a web designer. To start your search, visit www.1234-find-web-designers.org.

Design your site so that it comes up quickly. Keep navigation simple, and keep the focus on the photos, which is what anyone who visits the site is interested in. You don't want to distract from the photos by getting carried away with bells and whistles. Think about what you do when a site is too complicated—you click off and don't come back. If you make it easy for people to get around your site and make it attractive to look at, they will return. Finally, this may seem obvious, but be sure to include your name and phone number in an easily visible part of the main screen or somewhere easily accessible.

As you think about design options, ask around, look at websites that you like and that are well designed; contact the webmaster to find out who designed the ones you like best. Go to *PDN*'s Photography Annual and see the winning websites, along with the names of the designers.

In order to make your website—which is your portfolio online—an effective marketing tool, you must market it. Of course, you will list it on all your direct-mail pieces (see chapter 6) and include it as part of any sourcebook advertising (see chapter 8). And you must have your site address listed on search engines.

Kevin Banna is consistent with sending out his e-promos: They are always simple and well designed, showing his style and basic contact information.
KEVIN BANNA

Marketing Basics

SALLY RUSS

Understanding Your Value as a Photographer

Y ou've defined your goals and focused your image, and at the end of chapter 2 I suggested five steps to a successful broad marketing strategy. You went on to think about the various types of clients who use commercial photography. Hopefully you've zeroed in on a particular market or two to focus on, and perhaps you have in mind specific clients you want to target and how to identify the decision-makers at those clients. You've created a strong portfolio that reflects who you are.

At this point, it is crucial that you come to thoroughly believe in your value as a professional photographer and understand how to add to that value. You must also accept the importance of connecting strongly with potential clients and creating a marketing plan that attracts the work you want.

Being hired as a photographer is the result of a combination of many factors, from the client's reaction to your portfolio to your or your rep's personality and the knowledge each of you has about how to get things done from several different angles. Don't be afraid to discuss your value with a potential client. This may mean that you are sharing your ideas about how you would shoot a job. It is important for a potential client to know how you think.

TOP LEFT: For adventure photographer Gordon Wiltsie's portfolio, I had a notion that it would be interesting to use old-fashioned travel stickers on the case. Gordon took my advice and used these exotic emblems that immediately suggest "travel," "excitement," and "daring."
TOP RIGHT: In keeping with the idea, we put an elastic climbing rope and mountaineering carabiner (snap link) on the front of his portfolio.
BOTTOM: The first page of Gordon Wiltsie's book is vellum, which functions almost like a curtain that opens before you see the first image. His had his name and logo ghosted onto the paper.
GORDON WILTSIE

When Gordon showed me his portfolio, he wanted to tell me a story about the making of each image. I said, "Gordon, if you want to talk about each image, you are going to have to furnish a tape recorder when you send out your portfolio." Instead, Gordon designed this diary-like presentation.
GORDON WILTSIE

The images in Gordon Wiltsie's book were reproduced with an Iris printer. High-quality desktop printers can achieve the same impact at much lower cost. Gordon's name is visible throughout his portfolio because it is printed on the back cover of the book.
GORDON WILTSIE

Gordon had a lot of tear sheets. I suggested that he arrange them in an overlapping way and photograph them for a final portfolio spread that presents his credentials visually—the "greatest hits" of his published photographs.
GORDON WILTSIE

The essential values that a photographer should offer a client include the following:

- You must be able to conceptualize images with the art director and/or client. This begins with the ability to understand the client's need and to see the client's view, and extends to working until you understand exactly what the client wants.

- While you should be able to be inventive and constructive in providing ideas on how to do a shoot, the most successful photographers know when to be creative and assert their own ideas and when to listen to the client and focus on the client's approach. Being cooperative in this way doesn't mean being a "yes person"—a client needs to know that he or she can work with a photographer.

- You must be able to determine how you are going to make the concept come alive. The final step, of course, is using your ability to create and produce the shots.

- Experience is a value that you can bring to an interview or job negotiation. Have you shot in the same location before? Do you know what the lighting on a location will be at different times of day? Are you experienced in working with models? With children or animals?

- It may sound corny, but enthusiasm is a key value. Don't do a job if you can't get into it.

- Other, more "practical," values include coming to the shoot on time, with all needed equipment and personnel, and delivering the finished photograph(s) by the agreed deadline. Creating a fair and descriptive estimate of your fee shows you are enthusiastic to work on the project and are not overcharging or padding.

Make a list of your assets as a photographer, and keep in on your desk or in another place where you will see it often. Understand your value as you see it, but don't be thrown if you are offered an assignment that seems to not be a good match with your abilities. If an art director gives you an assignment that does not reflect the style you show in your book, don't be confused. Receiving such an assignment can often be a compliment.

An art director once told me that he had given a photographer a very simple assignment—to photograph a chair on white seamless—even though the photographer's work was far beyond that scope. The art director told me, "That's all I had. It was the only assignment I had to give out, and I wanted to work with the talent of this particular photographer. I hired him to do what my client needed, knowing that with his great talent, I would get the best chair on white seamless I possibly could get." Sometimes when you are offered a simple assignment you shouldn't take it as an insult. Art directors want their assignments to be shot by talented photographers.

Brian Bailey's images can be used both for editorial or advertising. Though these models look "natural," they were cast for the part—proof of how good casting can make or break an image.
BRIAN BAILEY

Know What You're Doing

When you take an assignment, it should be because you want to do it, whether for the money or a creative challenge—not because you have nothing else to do that day. Whatever your reasons, you should never be judged by them. Just make sure that you understand the reasons you are accepting the assignment. On the other hand, don't accept a job that you know you can't do well or that you don't really want to do. Being in over your head is a nightmare, and there's nothing worse than an unenthusiastic creative person.

Adding to Your Value

In your relationship with a client and in what you produce, try to add value to what the client receives from other photographers offering similar talents and similar estimates. For example, explaining how you see producing the shoot will separate you from the other people vying for the job. If you sell yourself to a client based on the fact that you provide more than film, you are more valuable. Your style and unique approach will be worth paying for.

Photographers need to have fresh visual ideas to apply to traditional assignments. Ideas are so important. Bring a positive, professional attitude to the relationship. Don't be negative. Deliver what is expected, then go beyond that and deliver the unexpected—if for no other reason than your own creative satisfaction.

You must thoroughly believe in your value as a professional photographer and understand how to add to that value.

One great technique to learn when you are communicating with a client is to use the word "we." If you use "I," you are one person alone with a camera. If you use "we," you are implying something larger: You can use "we" to say that you are part of the client team that's working on a job. Or you might want to use it to suggest that there are a lot of people behind you—such as a studio manager, or cost-control person, or a basic staff or crew. You can make your operation seem much more like a company rather than just an individual person—just by using the word "we": "We do it this way," or "This is our philosophy."

I once did a bid for a national campaign for one of the photographers I represent. We were competing against two other shooters. The assignment called for a photographer

Dancing Boston Bulldog

to travel to different cities to shoot a variety of models in various airports. We needed models, hair and makeup, production people, stylists, and location scouts. There was a healthy budget to produce this job. As my photographer and I compiled the costs for the estimates, I kept checking in with the art buyer at the agency. I had a good relationship with her, having worked with her in the past with another photographer that I represent. When the estimate was finished, it was accepted and I proceeded to tell her that my photographer was looking forward to shooting this job. I even made some comments about how he saw producing the shoot. The art buyer was waiting to receive the last estimate. Although the she couldn't promise me the job, she did confide that we were the "front runners."

All that changed when the art buyer received the final estimate of the three-way bid. The last photographer provided an estimate that was comparable to the other bids submitted. Then that same photographer added additional value to his estimate.

In a one-page letter to the art director that the art buyer read to me later, he explained in detail how he saw producing the shoot. Since all the shots were on location at different airports, he was quick to point out that since he was well traveled, he was familiar with most of the national airports. He talked about the natural

Gary Parker is well known for photographing animals. In this image he combines composition and gesture to create interest.
GARY PARKER

lighting that specific airports had. He was able to interweave the "specs" the client provided for the estimate with actual locations in particular airports. In other words, he was making helpful suggestions and contributing particular locations—by name. He was producing the shoot before he got the job.

Needless to say, he got the job. The art buyer said that after the art director read the letter he was so impressed that they both shared it with their client. That sealed the job. I realize that it may be a bit unrealistic to accompany all estimates with a lengthy commentary on how you are thinking of producing a shoot, but your individual "value" as a photographer is one of your most important assets. Focus on your particular value as a photographer as it relates to the assignments and use that value to help secure the job.

There are other ways of adding to your value. Perhaps you are great at casting. You know the casting agents and are always looking for faces. You often stop people on the street who have interesting faces, test with them, keep their names and addresses on file. A talent like that can be your added value.

Or you may be good at locations. A photographer who recognizes how to interpret a layout for a good location is very valuable. Likewise, paying close attention to detail in locations might be something that makes you valuable. You might say to the art director, I see that your layout has a park. I am wondering if on the outskirts of the park you want to see buildings so that you know it is a park in a city, or if you want to see mountains? Do the mountains have cactus on them? Or are the mountains topped with snow? You might suggest places to shoot where the art director can find exactly what he or she is looking for.

An added value may be a "hidden value"—something you know how to do or create that you take for granted but that clients may highly prize. Our studio manager was a model booker before she took her current job at the studio. When I give her job specs, she starts making a list of all the best agents for that particular casting. Her "hidden" or "added" value is that she knows all about models and how to cast. She knows the language; she knows the questions to ask.

When you go into a portfolio appointment or a preproduction meeting and can offer three or four "added values" that the client isn't expecting, you are reassuring your client that you are the photographer for the job. When you leave that meeting, the client's decision maker will feel more secure in the decision to hire you. This is important because it gives more language to the art buyer or art director to use to make the client excited about the shoot.

Do you use PhotoShop? Do you offer digital? Do you usually shoot the layout and then shoot an interpretation of the layout? What is it that you as a studio offer to the client? It is similar to going to a rental studio that presents a list of everything they have to rent—lights, equipment, catering, etc. It is all part of what makes your studio a place that clients will want to come to or come back to.

Understanding the people you want to get work from will make it easier for you to relate to them.

As silly as it may sound, your asset may be the fact that you have a cappuccino machine or use a terrific caterer. Many times I have said, "By the way, if you end up shooting with us, I can guarantee you a great lunch," or "A friend of mine is a caterer," or "I know someone who is a caterer, they work with us all the time. The food is going to be delicious. Just keep that in the back of your mind. And as far as dessert goes, I can guarantee you as well that they make the finest desserts."

W hen it comes to promotion, consider the people who are in your target market. Identifying the decision makers is the easy part. Understanding who these people are is a bit more difficult. That is your challenge.

A good way to start is to look at a typical mailing list (these are explained in detail in chapter 6). A quick scan will tell you that the majority of art buyers in the United States are female. That's good to know. Keep a list of other observations you make. You should also pay attention to where most of your target clients are located.

If you are seeking editorial (magazine) assignments, find out more about photo editors. I interviewed the associate photo editor of *Real Simple,* a well-designed magazine. I asked questions and learned a lot about the way they choose their photographers. Before I approach a targeted client I try to find out as much about them as possible. Their personal life is not my business, but when I know their professional achievements they respect me more.

I once met an art director from a New York agency and knew I wanted him as a client. He works on good accounts and is extremely creative. I left him a "congratulations" message on his voice mail when I read that he won an award for a campaign he did. He returned my call from a shoot he was on in LA to discuss his winning campaign, one more time. We connected. He asked me how my photographers were doing and what they were working on. After the phone call, I made a few notes and I have a plan mapped out on how I will be targeting him in the future.

Understanding the people you want to work for will make it easier to relate to them. Take a step back and see that these are real people with individual desires and feelings. Acknowledge their requirements, and deliver what they need. Although it may sometimes be difficult to read your clients or potential clients, it is your job to supply them with what they need for a successful job.

For example, I once spent an hour in a client's studio playing cat's cradle (the game in which two people take turns making design shapes with string), with the ten-year-old son of a client. She had brought her kid to the studio one day during a three-week shoot. My client was visibly relaxed as she watched us play. Every now and then she flashed me a "thank you" look. I was really having fun; the boy was a pleasure. But I understood the mom's reaction, since I am a working mother, too. I put myself in her place and decided that the best way I could assist my photographer was to play with the client's child.

Be careful when trying to connect with a potential client. For people in staff positions with clients, it can be annoying to get calls from folks who suddenly want to be great friends. Also, know when to try to *not* connect—that is, you might find yourself in a situation with an art director with whom you know you really can't work well.

Connecting with Potential Clients

After Kevin York created his effective portfolio, national racing magazines started to hire him. This montage represents some of his assignments. Photographing tear sheets of his work (magazine covers and inside pages) was a terrific way to show Kevin's credentials. After his first year in business, Kevin reeled in some great magazine work and decided to procure some advertising clients.
KEVIN YORK

Your Marketing Plan

So far, this book has concentrated on your marketing strategy—the broad strokes of creating your identity as a photographer and choosing the type of client you want to shoot for.

Now you're ready to take practical steps and present yourself to potential clients, but what should you do? Deciding on the details of how you will approach clients is what is known as a marketing plan. Photographers who lay out such a plan in advance and stick with it are giving

themselves a huge advantage. Adhering with persistence to a marketing plan greatly increases your chances of success.

Your marketing plan does not need to be complex. It should include the following elements, each of which is covered in detail in the chapters that follow:

- *Promoting yourself with mailings.* Chapter 6 explains how to create direct-mail promotion pieces, and how to choose and use mailing lists and mailing houses.
- *Making the most of portfolio reviews.* Chapter 7 tells you how to make an appointment and how to conduct yourself as you show your work to clients.
- *Paying attention to other sources of information, contacts, and assignments.* Chapter 8 describes these sources, which include the Internet, photography sourcebooks, industry directories, contests and competitions, stock houses, and word of mouth.
- *Taking steps to make sure your marketing is effective.* Chapter 9 is a roundup of advice on how to understand and interact with clients to maximize your attractiveness as a photographer.

Establishing Your Budget

How much money should you set aside for promotion? The biggest determining factor is how much you are willing to spend. If you are like most people and have a finite amount of dollars in your budget, start with what is available. If you have only $1,000 to spend, your budget is $1,000.

By far the most important item on your budget is your main selling tool—your portfolio. You are not in business as a photographer if you don't have a portfolio. For most people, at least at first, the largest percentage of marketing dollars are allocated to designing and printing for the portfolio and producing multiple copies of the book (see chapter 4).

Everything else comes next. Once you have a solid portfolio to send out, then put your efforts and dollars into creating direct-mail promotions that will grab the

Michael Weiss wanted to show still life work on white seamless and at the same time highlight his more creative imagery.
MICHAEL WEISS

The spreads in Michael's portfolio, all beautifully designed, range from whimsical to sophisticated.
MICHAEL WEISS

This spread shows Michael's range.
MICHAEL WEISS

OPPOSITE: Michael Weiss used this spread from his portfolio to create his first promotion card. It measures 6 × 9 inches and is mailed in an envelope. When you keep your information organized in a simple way, it's easier to retrieve it when you plan your drop-offs.
MICHAEL WEISS

attention of your target market and pave your way to getting your portfolio seen. Chapter 6, "Promote Yourself with Mailings," explains how to create these pieces, how to assemble a mailing list, and how to use a mailing house. You don't have to spend a lot of money to create attractive, well-designed promotion pieces, and if you don't buy mailing lists but instead create your own, and if you don't use a mailing house, these costs can be manageable.

By far the most important item on your budget is your main selling tool— your portfolio.

Many photographers maintain a website to showcase their work. The cost of doing this depends on whether you have the site designed (probably a smart move if you want it to look professional) or buy a program that helps you create one yourself. In either case, you have to buy a domain name, and if you want to get hits, you need to get your site registered with search engines. For an introduction to this topic, see chapter 4. For a complete "to do" list and a rundown of costs (including scanning in artwork and updating the site), consult a professional web designer; start with www.1234-find-web-designers.org.

Once you are up and running as a business, you will want to add to your budget smaller amounts that reflect your minor costs, such as entering contests, entertaining clients, holiday gifts for clients, and token fees to interns.

Keeping Track of Potential Clients and Getting Started

Once you have a qualified list of potential clients, including the names of the person or people you want to contact, go after them. First, organize a simple system for keeping track of the clients you are targeting such as the chart below. Essential information includes the client name, the name of the person at the client, and the address, telephone number, and e-mail and/or website addresses.

Then work out a plan for getting your portfolio in front of them. Start by sending a direct-mail piece (see chapter 6), and then try for an appointment or drop off your portfolio (chapter 7). For example, if editorial work is what you seek, I would suggest that every week you do a drop-off to a magazine. Organization is important. Having the name of the magazine and the photo editor at your fingertips as well as the address and the drop-off day, makes it easy for you to keep track of this process as it continues.

Don't stop. The process may take a while. Having your portfolio called in for review usually requires a combination of meetings, mailings, and other efforts.

Company Address and Phone Number	Contact Person and Title	Mailer/Promo Sent	Drop Off Day	Notes/ Comments
ABC Agency Address Anywhere, USA 10000 123-456-1890	Name Title	Promo Sent: 12/1/03	*No policy— Call first	Clients that are . . .

Getting Paid: Fees and Bids

The fees paid for commercial photography vary widely, from pro bono work up through many thousands of dollars per shoot for the wealthiest clients. (Work that is called pro bono—short for **pro bono publico,** a Latin phrase that means "for the public good"—is done for free or for a very small fee, perhaps just enough to cover expenses. Pro bono jobs are often done for community and other nonprofit organizations. Since ad agencies also do this, pro bono work is good way for photographers and agency personnel to become acquainted.)

It would be nice if I could give you some guidelines about how much certain types of clients pay photographers for their work. Unfortunately, this is impossible. First, fees are negotiable 99.9 percent of the time. And despite continuing efforts to create and uphold "industry standard" fee levels, there are many clients who don't have the budget to pay high fees (though there are also many who do and can), just as there are many photographers who are hungry to work and who underbid in order to get assignments (as well as many who insist on high fees and are handsomely paid).

On the other hand, there are clients who pay handsomely for the work of photographers they value highly. Making your photography—and the way you work—attractive to clients is the best way to be paid well. Your best bet for becoming informed about fee levels is to "network" in the segment of the industry you are targeting.

Some magazines pay a set fee, but as I said above, fees are nearly always negotiable when an agency, company, or publication hires a photographer to shoot. Usually the agency or the client has a ballpark figure in mind for what they want to pay, and they ask photographers to submit estimates, or bids. Clients want estimates when they are considering more than one photographer, when internal cost-control factors are involved, or when a client has a set budget and wants the lowest bidder.

Often photographers want me to tell them the amount of money to charge for their creative fee so that they can complete an estimate. Calculating an estimate may sound simple, but it is not. Generally a fee is based on usage (a term that includes how an image is used, how long, where it is distributed or located, the type of media, the image size and placement in comparison to the total side of the ad, the quantity of printed material). However, providing numbers on paper is just the beginning and hardly constitutes an estimate. A photographer's job (when you do not have a rep to do this for you) is to explain an estimate and justify the expenses.

These are the elements of an estimate, or bid—the details of what it will take to produce a particular job. The items shown below are the most common elements. Some may not be necessary for a given job or a particular photographer, and some photographers combine some of these items (for example, they combine the creative fee and usage and media into one line item) or break them down into individual line items (for example, making separate entries for usage and media, shoot days, and pre- and post-production days).

- Creative fee: Your fee for (1) creating and shooting the photograph(s) and (2) pre-production and post-production work. The fee for the actual shoot day is usually higher than for pre- and post-production.
- Usage and media: Usage is where (the area of distribution), when (time period), and how (number of insertions or size of a print run) the photographs will be used. Media is the vehicle in which the photograph is used.
- Travel expenses.
- Crew (assistants and stylists).
- Film and processing and/or digital materials.

- Studio and equipment rental (if needed).
- Props or costumes (if needed).
- Catering (if needed).
- Models (if needed).
- Shipping expenses for material.
- Miscellaneous.

There is no set format for submitting a bid, and the amounts given on bids can vary widely—and not just for materials or rental expenses. The creative and usage fees of a very well-known and in-demand photographer may be several times those charged by a beginner.

When a photographer is hired, prior to the shoot the photographer usually receives a purchase order (abbreviated as PO), which is a contract between the client/agency and the photographer. The PO sometimes spells out how the photographer is to invoice the client; if it doesn't, just call and ask the art buyer or producer.

I discourage photographers from taking a job with a client who promises the photog-

Jack Reznicki demonstrates his creativity and technical abilities with this photograph.
JACK REZNICKI

rapher will get the next job if he or she shoots this one for less money. Accept every assignment because you want to do that assignment. Maybe you may have nothing else to do that day, or maybe you haven't worked in a month and feel it would just be good to shoot an assignment. Just make sure that you understand the reasons you are accepting the assignment. I have lowered an estimate (a bit) to stay within a client's proposed budget or rearranged shoots to accommodate clients who are promising better jobs with higher fees.

In any case, making the best presentation and giving the right impression is the professional thing to do. You never know when that client will come back to you with another job. It has happened to me. Approach all of your jobs in the same manner. Being consistent is important. In other words, even if you are paid a low fee for a project, shoot the assignment and produce final work just as you would for a high-paying job. Be consistent in your presence, quality of shooting, style, and presentation.

Most clients pay invoices at 30 to 45 days from the invoice date. Use the day (or last day) of the shoot or the following day as the invoice date to ensure that you are paid as quickly as possible. Generally, expenses—travel, lodging, supplies—are itemized separately on the original estimate (see above). When you file an expense report, you must include receipts for each item you include. If the purchase order does not spell out details you need for completing your invoice and expense reports, call the person who hired you or the accounts payable department at the company or agency.

Photo Agents or Representatives

A photographers' agent or representative procures assignments for a photographer—for a commission (usually about 25 percent of fees billed). However, within that simple statement there are a multitude of variables, including such issues as how the commission is calculated. For example, "fees" can be defined as moneys paid for travel days, weather days, casting days and pre- and

post-production days. In establishing a contract with an agent, it is important to establish who pays for what expenses (portfolio costs, messenger services, phone charges, and other costs of doing business).

If you are a "people person" you may want to be in charge of getting out there with your book to meet clients. If you are shy, this can be painful, and having someone go on appointments for you will relieve you of this stress.

The issue of coverage can also be complex. Do you want a rep to open doors to national advertising agencies? Are you seeking work from markets, such as New York, or looking for exposure to New York–based clients who might assign work nationally, including within the photographer's region? Or are you looking for a rep in your region? These questions need to be addressed before the actual search process starts. Geographical boundaries are not as limiting as they once were, and it could be that a rep located in any city can also bring you national exposure; it depends on the rep's contacts. While many reps are located in the larger markets, such as New York, Chicago, and Los Angeles, they also are located in other cities and have contacts in the major markets. The methods of finding them and making initial contact can be tailored to your needs. The basic procedure is the same, regardless of where you want to search.

The easiest way to start a search for a rep is to look through sourcebooks—such as *The Black Book, KLIK, The Workbook, Select, Alternative Pick,* or any of the other sourcebooks out there. Look for different work and for styles that appeal to you. These books will list names of reps and their photographers. If you see photographers whose work you admire and their reps are listed, that's a lead you could follow. (I respect a photographer who has done some preliminary investigating before calling me about representation. He may start off by mentioning who I represent. If I can tell that a photographer has done his homework, I listen more carefully.) You can also ask colleagues or clients if they have had dealings with a rep whose approach they liked. Use whatever contacts you have to ask about potential reps.

Ask clients you know if they can refer you to a rep whom they work with and respect. If you do not have a referral, do your homework. Use the visual directories to research which reps work with the photographers whose work you like. Reference their names in the note that accompanies your promotion. It shows that you took the time to find out about the rep.

Some photographers may not be ready for a rep. A photographer who represents himself or herself for a while learns to understand the responsibilities a rep has.

At this point, a harsh truth must be told: In general, most reps will have all the photographers they can handle. In other words, most photographers looking for a rep will not find one. This does not mean you won't, but be warned that the ideal photographer/representative match is not easy to make.

If you do find a rep who wants to take you on, develop a letter of agreement or a contract and get the terms of your relationship in writing. From a practical point, a letter of agreement is easy to work with, while a legal contract will protect you (and the rep) better if a breakup occurs.

For more on finding and using a photographer's agent or representative, please see appendix B.

DO . . .
- Make a list of your assets as a photographer, and keep in on your desk or in another place where you will see it often.
- Think about what your "hidden" values may be.
- Work out a plan for getting your portfolio in front of potential clients.
- Develop a marketing plan for approaching clients.
- Have fresh visual ideas to apply to traditional assignments.

DON'T . . .
- Be annoying in your efforts to connect with clients.
- Overlook assets that may be of great value to clients.
- Let up in your efforts to get your portfolio in front of potential clients.

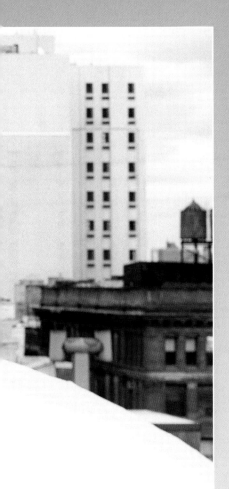

Promote Yourself with Mailings

WALTER SMITH

Getting Your Name Out There

Never, never, underestimate the value of a mailing—or, better yet, a sustained series of mailings. In order to make your business successful, you need to get your name and images out to prospective clients, and the best way to do that is by mounting an effective direct-mail campaign. Photographers who don't do mailings are depriving themselves of a simple and extremely effective way of getting their name and their work circulating among potential clients.

When you have sent half a dozen or more pieces over a series of weeks or months, it's just possible—and is even probable—that a buyer will recognize your name, remember the type of work you do, and grant your request for an appointment to view and discuss your work. That, in fact, is the primary purpose of sending materials through the mail—to serve as the groundwork for getting your portfolio seen (chapter 7 covers portfolio reviews).

Promotion does not have to cost "an arm and a leg." The basic necessary elements are: a designer, a well-qualified mailing list, and a mailing schedule that has your promo pieces arriving on clients' desks with frequency.

Direct-mail campaigns can cost anywhere from a hundred dollars—if you have a small mailing list, you can print the promotion yourself and mail it out yourself—to a couple thousand dollars if you have someone else create the piece and do the mailing to a large list. The factors that determine cost include:

- A designer, if you use one (recommended)
- Paper style and quality of the pieces you will send out
- Printing costs
- Postage, determined by the size and weight of the piece and the size of your mailing list
- Purchase of a mailing list (optional)
- Charges from a mailing house (optional)

No photographer can be successful without having an excellent portfolio—that is an absolute. While doing promotional mailings may not be absolutely essential, photographers who don't do mailings are depriving themselves of a simple and extremely effective way of getting their name and their work circulating among potential clients.

The people you are marketing to are visually oriented, and viewing attractive images definitely works for them. Arresting work presented on a postcard or poster will remain in the memory of an art buyer, a photo editor, or other creative person on your mailing list, many of whom keep their favorite direct-mail pieces for later reference, sometimes in special files they set up for the purpose.

Jayne Horowitz, an art buyer for the ad agency Grey Global Group, says, "A mailing is often preferable to a phone call that interrupts a busy day—and can be more

Your direct-mail piece must stand out amid the pile of mail an art buyer receives every day. Your promotion piece has to scream, "Open me. Read me."

Ad agencies often keep photographers' promotion pieces on file, sometimes by category (still life, lifestyle, babies and children) and sometimes by style (graphic, editorial, personal work, fine-art). Your task is to make sure your piece is a "keeper" that makes it into one of these files.

memorable." She receives between five and ten direct mail pieces a day, saves the pieces she likes, and refers to them when looking for a photographer.

Mailing Pieces

No matter how good a photographer you are, you will not have a chance to prove yourself until you make such a good impression that a client is willing to look at your portfolio and hire you for a shoot. Mailings in all their guises—postcards, promotional posters (covered below), even sourcebook reprints (see chapter 8)—are an excellent and cost-effective way to make yourself known.

Probably the most frequently mailed promotional piece for photographers is the **postcard.** What can you do with such a small format? A tremendous amount. You have several elements to work with—the choice and cropping of the image, layout, type, color, patterns.

Designing a postcard is a challenge, but one you should welcome because it offers such striking rewards. You (and perhaps a designer) can create, within the "limitations" of a postcard's size and proportions, a design that opens eyes to the value of your work and opens doors to your success as a photographer.

Modern Postcard, located at 1675 Faraday Avenue, Carlsbad, California, provides nice quality, and their low prices make it easy for a photographer to create attractive pieces for use in monthly mailings. The people at

Modern Postcard are very easy to work with if you follow their rules. For example, on the front of the card they print color with a glossy finish, and on the back matte black and white; they will print images and text on the back of the card, with a maximum number of words for each card size. Call their toll-free number (800-959-8365) or go to their website, at www.modernpostcard.com.

The standard-size postcard produced by Modern Postcard—4.25 × 6 inches—is the largest postcard you can mail for the first-class postcard rate. If you want type on the back, Modern Postcard will typeset up to 50 words. The deluxe card (6 × 8.5 inches) provides more room for a larger image or multiple images; it mails at first-class letter rates, but you can also send it by bulk rate. Modern Postcard's Sumo Size™ postcard, which measures 6 × 11 inches, is the largest card you can mail at regular postage letter

"I've Seen That Before"

A photographer called me and said, "I am running out of new images to send out for promotion."

I asked him, "Did you send all the images in your portfolio?"

He said, "No, I don't send any because I am afraid that if I send any images from my portfolio when they see the portfolio, an art director might say, 'I have seen that before'."

I said, "That is exactly what you want the art director to say. You want the recognition. You want the familiarity of the images."

rates. They also can do a custom job for you—for example, they can produce several different formats and use different types of paper; they can create scored tri-fold cards and custom sizes, like 8 × 10 inches or 8 × 12 inches.

The advantage of sending a postcard is that it is inexpensive and relatively simple to design and have printed. It arrives on an art buyer's or a photo editor's desk ready to view—the addressee more or less can't avoid looking at it.

However, you don't have to design your card as a typical postcard. I have never used Modern Postcard to produce a card as a postcard—that is, with an image on the front and information, including a space for an address, set in type on the back. Instead I create a card that I mail in an envelope. Rather than use the back of the card for information and space for an address, I print a second photo in black and white or a black-and-white detail from the photo on the front. I use the back

as another way to show the photographer's work and the design he has created.

Other pieces require an envelope in order to arrive in good shape. **Tri-fold cards, prints or other "flats,"** and **sourcebook reprints** (see chapter 8) generally fit well into a 6- × 9-inch or a 8 × 10-inch envelope, though sometimes photographers send out larger prints or mini-posters. For one promotion, Denise Chastain created a mini-poster that we mailed out in a flat envelope.

When you are trying to come up with an unusual promotion, think "eye-catching." Try to use something that relates to your images and that will make your viewer remember you, something new that the person has never seen or usually does not receive.

Denise also did a couple of direct-mail cards designed to fit into a #10 envelope. Try to think about the envelope size at the time you are designing a promotional piece. Using a #10 envelope makes life a lot easier because it is a standard business-size envelope.

Then there are **irregular parcels**—pieces that need special packaging or special handling, such as a box or a key chain or something else that won't go through the postal machines. Once Denise sent out homemade chocolate bars with her images as the wrappers; one winter she sent out a box of hot chocolate mix partnered with a snowy image.

When you are trying to come up with an unusual promotion, think "eye-catching" and "new." Try to use something that relates to your images and that will make your viewer remember you, something the person has never seen or usually does not receive.

ABOVE: **A winter promotion from Denise Chastain included hot chocolate mix.**
RIGHT: **In another promotion, Denise Chastain sent out homemade chocolate bars.**
DENISE CHASTAIN

Designing Your Mailing

How to best present yourself? Remember, the image you send and how you present it will determine how people see you—as arty, glossy, down and dirty, sentimental, arrogant, flip, a gentle soul, mainstream . . . whatever. Never forget that a mailing piece has one purpose, and that is to impress.

Since design concepts are always changing, your best bet is to find a great designer to work with. With a good designer there is so much you can do. Choose someone who designs with originality—you don't want to date your mailing pieces with trends. Base your designs on your image. Use concepts—if a piece has multiple images, tell a story by linking them with a theme that makes them relate to one another. Or send out a series of cards with an ongoing theme.

The image you send and how you present it will determine how people see you—as arty, glossy, down and dirty, sentimental, arrogant, flip, a gentle soul, mainstream . . . whatever.

There are a lot of things you can do with a Xerox machine. Michael Brian used vellum paper to create this dreamy direct-mail promotion card. When the card is folded the images overlay in an evocative way.
MICHAEL BRIAN

When Michael Brian's promotion card is closed, one image shows through the other and gives an interesting, ghost-like quality to the card.
MICHAEL BRIAN

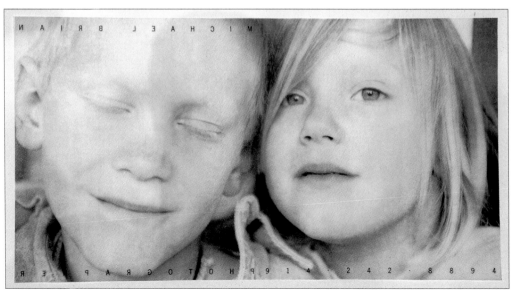

When the card is open you can easily see the images. His name is in a very simple, readable typeface.
MICHAEL BRIAN

You don't need to look far to find the right images for your mailings. Just open your portfolio. Use all the images in your portfolio, sending them out one at a time or in groups. By the same token, don't mail out a promotion until you have a finished portfolio. A successful promotion will make the phone ring with requests for your portfolio: You want to have it ready to take in or drop off when those calls come.

A basic point to keep in mind: Don't clutter a promotion piece with a long mailing address, but do indicate your general location, so a photo editor or art buyer knows if you are local or not. Photo editors usually find e-mail and/or website addresses useful as an easy way to contact photographers. I remember trying to dissuade Kevin York from putting his address on his card. "I don't think anybody is going to write you a letter," I told him, "and if they want your fax number, they'll call you—that's a great way to start a dialogue."

My rule of thumb is to give the name of the studio and the city, the phone number, and the e-mail address and/or website address. If the name of your studio is Jones Photography and your name is Jack Jones, handwrite Jack Jones beneath the studio name; it adds a personal touch and lets the recipient know who to ask for when calling.

If you plan to use a mailing house (see p. 96), talk to the people there before you design a mailing piece. Ask them about dimensions, size and weight, the color of the envelope, and other issues that can affect the cost and effectiveness of your mailing. Their advice can help you avoid problems.

What's an Indicia?

Your indicia is your bulk permit number (contact your post office to apply for one). Some photographers have the indicia printed on their cards, which can save money because you or the people at your mailing house don't have to go to the trouble of creating and placing the indicia on the materials for each mailing.

Also, a photographer can design an indicia to match the card. It's important to know where to put the indicia and how much visibility is required. For example, in bulk mailings writing is allowed only on the left side of the card. A mailing list company or the post office can provide information about obtaining the indicia and how to place it properly on a mailing piece.

PRSRT STD
U.S. Postage
Paid
Bohemia, NY
Permit No. 702

This is Kevin York's first promotion piece, a 6 × 9-inch postcard. The image is a little over two-thirds of the card area, and the type is very under-stated, giving the necessary information in a clear and concise way.
KEVIN YORK/DESIGN BY JOHN GENTILE

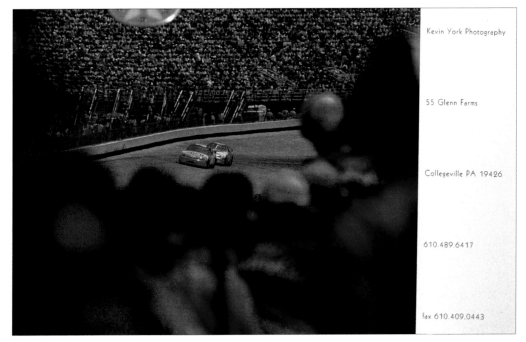

Kevin York Photography

55 Glenn Farms

Collegeville PA 19426

610.489.6417

fax 610.409.0443

Mailing Lists

In addition to designing and printing a promotion piece, you need to decide who you're going to send it to. The first step is to create or purchase a basic list that targets your areas of interest. Some people like to create their own mailing lists, and others buy lists from a mailing house. There are advantages to both approaches.

Creating Your Own List

If you want to create your own mailing list database, start with *The Workbook Directory* or one of the other directories. (Advice on using directories is given in chapter 8.) It would be a waste of postage, though, if you sent your promotion piece to everyone in the directory. Instead you should customize your list to target a client type. You'll find it easiest to manage an "A list," a small list of potential clients.

When I research agencies and design firms in a particular region, I shop by area code. I search online by putting in an area code or in a printed book by placing a check next to the telephone area codes or postal zip codes for that region. I look at each agency or design firm and note the art directors or designers who are listed and where they are located. Then, with their address and the names of the art directors and designers in front of me, I can then call them. If you are doing this research online, it is easy and worthwhile to check out the company's website in order to become familiar with their work, style, and overall company background.

Online directories are free, and a copy of a print directory costs roughly $30—a minor investment to make in your business. It is something that you will always find yourself referring to.

It definitely pays to do research. I researched a targeted list for one of my photographers who photographs children. My assistant made 1,000 calls to national art buyers and asked how often they used "kid" photography. If they produced one or two shoots a month, they went onto my list. If they told me that they use mostly stock photography, I knew I would never get an assignment from them, so I didn't put them on the list. We found twenty-four creative people who needed children-based photography two or three times a month. It took us three months to call the list of 1,000 names. Even so, if you are a kids-based photographer, what would you pay for this list of twenty-four names? Just kidding—it's not for sale. But you get the point. That's my A list. And

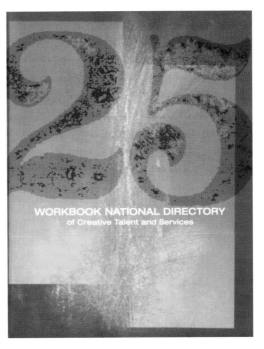

The Workbook directory is a great source for finding clients.
WORKBOOK DIRECTORY/ PHOTOGRAPH BY ROBERT WILEY

Simon Griffiths'
portfolio and
promotional
pieces have one
consistent style.
SIMON GRIFFITHS

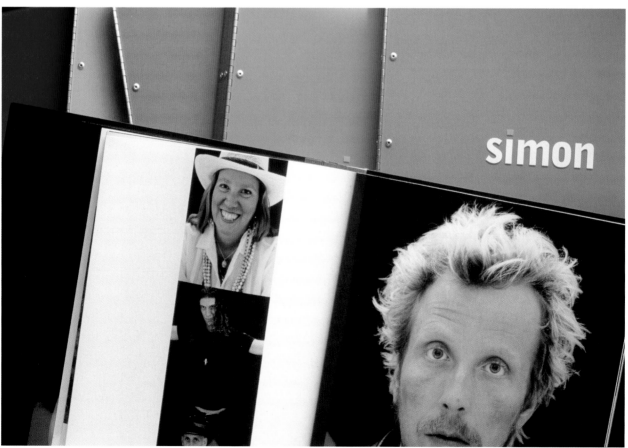

yes, I got work from these people. Since the list is a manageable size, it is very easy to stay in touch with these people.

Once you've come up with a customized list, the next step is to look at it carefully. There will be companies you have done business with and want to approach again. On the other hand, you will have found that you don't want to work with some other companies, so there's no point sending them a promotion piece.

Sometimes, in fact, it can pay to mail to a smaller list. You are a commercial photographer in order to make money—this is a business, you have a set budget for promotion, and you want to make sure every penny you spend works for you. Photographer Scott Spiker and his wife, Jennie, who handles his promotion, started off with a mailing of 3,000 cards four times a year. "A mailing this large was impossible to keep up to date and was an overwhelming task for just one person to handle—although it did pay off," says Jennie. Every time the cards went out they got new calls and repeat client calls.

The best results, though, came when they cut their mailing list down to 600 names and began mailing eight times a year. "Scott had been looking to pull away from stock agencies and do more assignment work along with maintaining his own stock shooting," she says. He got his wish as soon as this regular mailing started.

Buying Mailing Lists

Another approach, if it's in your budget, is to work with a mailing house (see page 96). One of the best, Agency Access, can put you in touch with the clients you want to reach. Call a few mailing houses and ask them about the types of databases they maintain and the lists they can tailor for you. Typical categories include ad agencies, fashion magazines and fashion houses, department stores, catalogs,

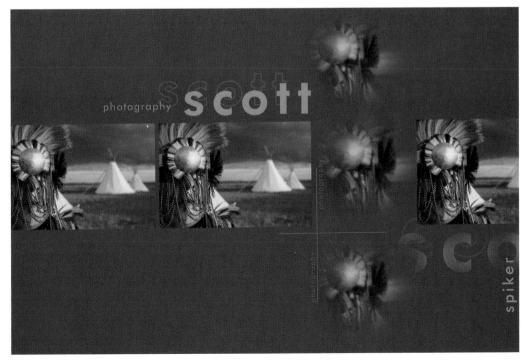

Scott Spiker's promotional card is a good example of just how effective a creative design can be.
SCOTT SPIKER

record labels, music companies, corporations with in-house art departments, cosmetics companies, travel companies, graphic design firms, and publishing companies.

All of the categories can be limited by city, state, or region. You may also receive a copy of the lists and select individual companies by hand, tailoring a list to a specific number reaching only the contacts that are interested in your work. You can buy lists that include only top, award-winning agencies or companies.

You may also further limit the database to names that work in certain specialties and subject matters, such as animals, architecture, arts and entertainment, automotive, beauty,

bridal, computer/internet, corporate/financial, crafts and hobbies, electronics, family and children, fashion, film and video, gourmet, health, interiors/home/garden, landscape/location, lifestyle and culture, local/regional, music, news/political/economics, photography, professional/trade, science and nature, sports, transportation, and travel.

Customer service representatives at most mailing houses will be pleased to work with you. Some, like Agency Access, will create a specialized list targeted to your needs. They might also provide some advice along the lines of telling you not only to try art directors at department stores or catalog companies but also members of in-house creative staffs at fashion houses.

Check out the quality of the mailing list you are thinking of buying. You need to confirm that the list is current and that you are sending to the correct people. Call a major advertising agency, like Ogilvy & Mather, and get a current list of art buyers. Compare the names on your list with the ones on the list the mailing house is offering. If the mailing house list differs from that of the advertising agency, you know it's not up to date.

Here is an example of the Agency Access checklist—the starting point for creating your own mailing list.
AGENCYACCESS.COM

Mailing Houses

A mailing house can be a great resource, provided the cost of using one fits into your budget. See their websites for a breakdown of the services they offer. In general, mailing houses maintain lists (see left) targeted to the types of clients you want to reach, understand postal regulations and procedures, and will sort and mail your pieces.

A mailing house is an especially big help when it comes time to drop the promotion in the mail. Mailing house personnel can stuff and/or label your promotion pieces, presort them, pack them in trays or place them in sacks, and take them to the post office.

Presorting is useful. It means the post office won't need to put your pieces through sorting machines, which can damage the mailing piece. If you don't use a mailing house, be sure to take the time to sort your mailing pieces by zip code. Then take them

agencyaccess.com
create a custom list!

1. Your Profession:
- [] Photographer
- [] Representative
- [] Designer
- [] Illustrator
- [] Other

2. Targeted Companies:
SELECT WHICH OF THE FOLLOWING KINDS OF COMPANIES YOU WANT TO REACH WITH YOUR MAILING
- [] Ad Agencies
- [] Catalogs
- [] Department Stores
- [] Graphic Design Firms
- [] In-House Corporate
- [] In-House Cosmetics
- [] In-House Fashion
- [] In-House Media
- [] In-House Travel
- [] Magazines
- [] Music Companies

3. Specialties:
PLEASE CHECK YOUR PHOTOGRAPHIC SPECIALTIES
- [] Animals
- [] Automotive
- [] Beauty/Cosmetics/Toiletries
- [] Beer/Wine/Liquor
- [] Beverages
- [] Children
- [] Computer/Internet
- [] Corporate/Financial
- [] Electronics/appliances
- [] Entertainment
- [] Fashion/Apparel/Accessories
- [] Food
- [] Industrial/Chemical
- [] Interiors/Furnishings
- [] Jewelry
- [] Landscape/Location
- [] Medical/Pharmaceutical
- [] Sports
- [] Telecommunications
- [] Tobacco
- [] Travel

4. Targeted Titles:
SELECT WHICH OF THE FOLLOWING CREATIVE DECISION-MAKERS YOU WANT TO REACH

Ad Agencies
- [] Art Buyers
- [] Art Directors
- [] Creative Directors
- [] Assoc. Art Directors
- [] Designers
- [] Print Production Managers

Design Firms
- [] All Titles (suggested)
- [] Art Directors
- [] Designers
- [] Creative Directors

Magazines
- [] Beauty Editors
- [] Fashion Editors
- [] Editors
- [] Art Directors
- [] Photo Editors
- [] Creative Directors

5. Top Agencies & Award Winners:
DO YOU WANT TO TARGET TOP AGENCIES OR AWARD WINNERS? IF SO, PLEASE SELECT FROM ONE OF THE FOLLOWING COLUMNS

Ad Agencies
- [] Top 100 Agencies
- [] Top 50 East
- [] Top 50 West
- [] Top 50 New England
- [] Top 50 Southwest
- [] Top 50 Midwest
- [] Top 50 Southeast

Award Winners
- [] Ad Agency Award Winners
- [] Design Firm Award Winners

6. Select only if you want to restrict by location, otherwise click ALL:
NARROW MY SELECTIONS GEOGRAPHICALLY. I WANT SPECIFIC CITIES, STATES OR REGIONS (select one).

City	State	Region
No Selection	No Selection	No Selection
Atlanta	Alabama	East Coast
Austin	Alaska	West Coast
Baltimore	Arizona	Southeast
Boston	Arkansas	Southwest

- [] ALL USA

7. All Done!
PLEASE FILL IN ALL BOXES BELOW AND THEN CLICK SEND

Name
Company
Address
City State AK Zip
E-mail [] (preferred method of contact)
Phone [] (preferred method of contact)
Fax [] (preferred method of contact)

- [] PLEASE CONTACT ME AS SOON AS POSSIBLE.

----- Send ----- Reset Entire Form

to the post office in a box or tray, and explain that they don't need to be run through a sorting machine. Even when you mail bulk rate (which costs less and takes only a little more time for delivery), presorting allows the post office to bypass the machine sorting process.

You can also request that the post office hand-stamp your pieces rather than putting them through the automatic canceling machine. In some locations, this request won't be honored, but hey, you never know, and hand-stamping can mean that a postcard or other mailing piece arrives looking much nicer than when it has traveled through a mechanical contraption.

Scheduling Your Direct Mailings

How often should you mail a promotion? There is no set formula. Obviously, the schedule you set will be affected by how much work you need, how much exposure you want, and how much money you have available to spend on promotion.

Some people recommend every month, some every two months as the most successful frequency. Talk with other people in the industry—those who mail and those who receive the mailings—for their feedback. Find out what they feel works best, then apply that to your own situation.

There is one constant, however. You must do promotion—the process of making your name and the look of your work familiar to potential clients—on a continuing basis.

Repeat mailing is the key to success, says Keith Gentile of Agency Access. By the time you do your fifth or sixth mailing, people are going to recognize what you are doing, he says. After all, your mailing is just like any other kind of advertising. An advertisement might make an impression but ten minutes later you forget what it was promoting. But if you see the same ad over and over again, eventually the message sinks in. By the same token, eventually the photographer's name will become committed to memory.

When photographer Gary Gelb came to me and said he wanted to shoot for national

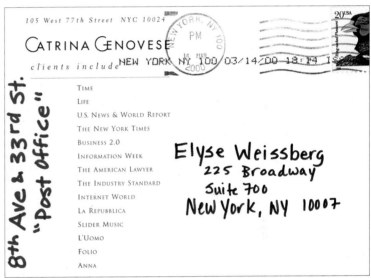

magazines, we mapped out an aggressive marketing plan. He printed postcards (fifteen in all) and mailed them out on a monthly basis. Gary mailed out 150 cards for the first mailing. By the fifteenth card, his mailing list had grown to 325 names. His response rate was excellent. His first response came after the fifth card. His client list grew, with names from national magazines. He had repeat business. A photo editor in London told him he had been receiving his cards and was familiar with his name. As Gary says, "The promotion did what it was supposed to do". The fifteen cards cost Gary less than $4,000, including the cost of hiring someone to stuff envelopes when he was busy shooting. The promotion brought in at least $27,500 worth of work.

Sometimes I have photographers code postcards and mail them from various locations in order to find the post office that uses the fewest and the least intrusive cancellations marks.
CATRINA GENOVESE

E-promotions

A new and very popular way for photographers to promote themselves is via e-promos—digital promotions, in the form of jpegs, sent via e-mail. E-promos are generally built around one strong image—they usually look like the front of printed postcard—with contact information that appears along with the image. If a photographer has a website or a portfolio online, the jpeg e-promo and the site URL can be linked. The viewer can run a computer mouse over the image of the e-promo, click on it, and be taken right to the website.

The benefits of e-mailing your promotion are many: You incur no postage costs or printing costs. Once you master the relatively easy-to-learn technology, jpegs are easy to send. If the viewer is intrigued by your e-promo image, he or she can immediately review more of your work. And you instantly receive an error message if there is a problem with an e-mail address you have sent to.

DO . . .
- Make sure the dimensions, size, and weight of your promotional piece meets the requirements of the mailing house.
- Check out the quality of the mailing list you are thinking of buying.
- Use all the images in your portfolio.
- Consider sending e-promotions (see p. 98).

DON'T . . .
- Worry about sending images that you've shown art buyers before—you want them to look at an image and connect it with you.
- Forget that a mailing piece has one purpose, and that is to impress.

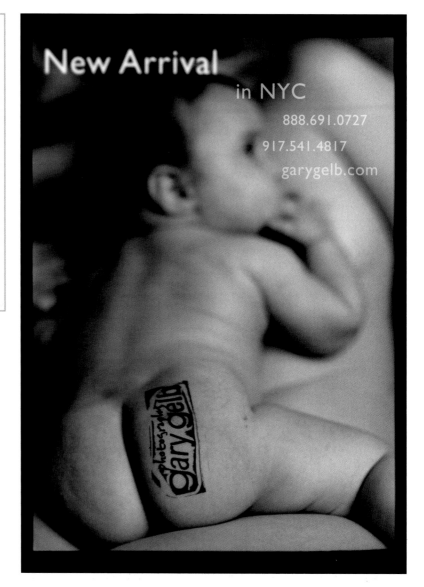

This promotional card from Gary Gelb is likely to grab attention.
GARY GELB/DESIGN BY JOHN GENTILE

Many art buyers swear by this type of promotion. It saves them time—there's no more opening mail and wondering what to do with all the hard-copy materials that build up day after day and week after week. And there's the immediate gratification of being able to link directly to a photographer's website—and bookmark it for future reference.

To create a successful e-promo:

- Create it as you would a printed piece (carefully select the image to reflect your identity and style, and use a strong design and type treatment).
- Make it short and sweet (avoid long typed-out descriptions, which buyers usually don't read). Just include your name, phone number, rep, website address—and your style, via the image you select.
- Produce the image as a jpeg (tiffs, PDFs, and other documents are not always user-friendly). Make sure the image is of good screen quality and size—but not too large that it takes a long time to load.

Just as you do for the printed promotions you send via the post office, schedule e-promos regularly. Many photographers do both types of marketing. Remember, the goal is to get buyers to recognize your name and your photographic style.

Here are two examples of e-promos that Denise Chastain has designed and sent out. They are set up to be linked to her website. A click over the image takes you directly to the site.
DENISE CHASTAIN

denise chastain
PHOTOGRAPHY

AGENT CHIP WESTERMAN

.725.3925

denise chastain
PHOTOGRAPHY

AGENT CHIP WESTERMAN

Make the Most of Portfolio Reviews

DENISE CHASTAIN

Presenting Your Portfolio

No matter how long you have been shooting photographs or how far along you are in your career, you have in your possession the best advertisement you will ever have—your work.

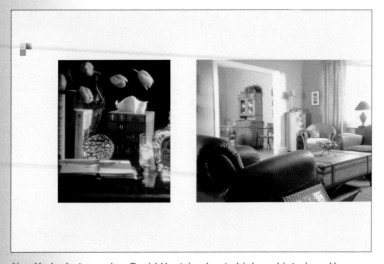

New York photographer David Hautzig shoots high-end interiors. He worked with designer Bill Kobasz at Reliable Design to create a portfolio that has a feeling of elegance and stresses his ability to capture such elements as texture, color, and fabric.
DAVID HAUTZIG

The size of David Hautzig's portfolio is 11 × 11 inches, so either a horizontal or a vertical image fits comfortably within the space. Stretching a photograph across a double-page bleed makes it look like a magazine ad.
DAVID HAUTZIG

Presented professionally in a portfolio, your work will speak for itself. Your portfolio has the power to get an art director excited about your work, or to set it aside and move on to the next portfolio.

Sometimes you will show your portfolio to an art director or an art buyer at an appointment set up just for that purpose. At other times, an agency or magazine will call you and ask you to drop off your portfolio so the creative staff can review it in terms of a specific job. Or you may drop off your portfolio even when there is not a specific job in the offering so the creative staff will have a chance to get to know your work. Whatever the circumstances, showing your portfolio around does make a difference, a big difference.

Looking at portfolios helps art directors get to know new photographers with whom they might be able to strike up productive, ongoing relationships. Jo Ann Giaquinto, art buyer/art producer at the advertising agency Young & Rubicam, says she always encourages photographers to send her their books; she looks at portfolios at the end of almost every work day. When she thinks someone has a terrific book, she will make sure every art director in her agency sees it.

Getting a Portfolio Appointment

A portfolio appointment is an appointment with a potential client to show your portfolio. If you work with a photographer's rep (see "Photo Agents or Representatives" at the end of chapter 5), your rep might accompany you. These meetings typically last from twenty to forty-five minutes, depending on the art buyer's, art director's, or photo editor's schedule for that day.

If a book has potential, sometimes the meeting lasts longer. If the person who first looks at the portfolio thinks that the photographer has talent, he or she may bring other creative people in the company into the meeting to see the work. Or the company might hold on to the book for additional days so that others can see it.

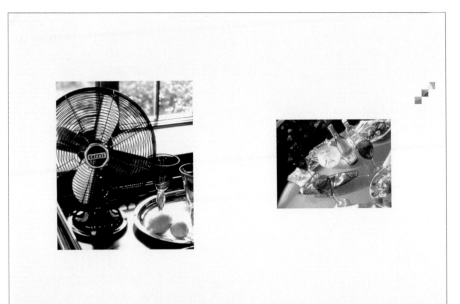

Many interior design trade publications pay close attention to color and detail, so designer Bill Kobasz decided to pick up a part of grouped sections of David Hautzig's photographs and placed three squares of color next to them. Each photograph is thoughtfully placed on the page and plays off the opposing image in an elegant way. This idea is repeated throughout his book.
DAVID HAUTZIG

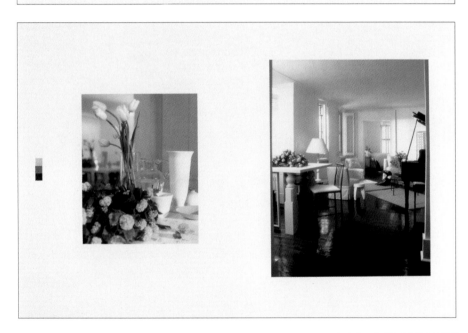

Grouping a shot that uses food as a prop with a prepared-food shot helps David Hautzig introduce the food section of his book.
DAVID HAUTZIG

Two styles of photography can work well together—in this case, a classic shot of a rocking chair and a selective focus shot of a flower. The use of white around the photographs maintains a clean look throughout David Hautzig's portfolio.
DAVID HAUTZIG

In an ideal world, you would have the opportunity to personally present your portfolio to every art director who might be interested in it. An in-person meeting is the best way to know who you are selling to. Likewise, many art directors want to meet as many photographers as they possibly can and review their portfolios with them. Most people, in all client categories, conduct portfolio appointments with photographers. A few feel they are too busy to see photographers, but most of the best art buyers like to update their lists of the photographers who are available for shooting.

Unfortunately, art directors don't always have time to meet with you. Later in this chapter I discuss other ways of getting your portfolio seen. However, you should always strive to personally meet the art directors you most want to work with.

Sean Justice's promotional pieces use some of the spreads in his portfolio and some new concepts created by his designer, John Gentile, an art director at an ad agency. These direct-mail cards, printed on his Epson printer, stress the photograph and have a minimal amount of copy.
SEAN JUSTICE

Don't start with a phone call because it can be almost impossible to reach a busy art director by phone and, frankly, you run the risk of being a real nuisance if you do get through. When your name is not familiar to the people you are trying to reach, it's definitely better to use the mail.

Here's an effective approach to make sure an art buyer will recognize your name—and answer your calls. Start with a small group of art buyers you'd like to meet—say, ten people. Produce and mail ten appealing promotion cards (this is covered in detail in chapter 6). Send out a card with a different image two weeks later, and continue to do so every other week for twelve weeks, until you've sent six cards.

It's nice to have an interesting story about how one or two of the images were produced, but it's overwhelming for an art buyer to hear a story about every image in the book.

Anyone who receives a promo card every other week for twelve weeks will remember your name. Then call the art buyer to set up an appointment or to drop off your portfolio. If you leave voice-mail messages, be candid: Tell the art directors for whom you leave messages that you "hand-picked" them to target, that you've been sending them promotions because you like the work they produce, and that you would like to work with them. Being honest and sharing your enthusiasm usually works.

Call the day before the appointment to confirm it. Make sure your portfolio is in good shape (see chapter 4) and that you have a promotion card to leave with the art buyer. If you've been sending promotion cards, have a new card—something fresh—ready to present.

Many photographers tell me that they do not feel comfortable going on appointments. Knowing that the art buyer is interested in meeting you and seeing your work should make it easier for you to go.

Going on a Portfolio Appointment

Enter the office, open the portfolio case, and hand the portfolio to the art buyer. Many photographers feel the need to pass images across the art buyer's desk one at a time. That's a mistake. Let art directors view your book in the way that is most comfortable for them; most of these people will not want you to turn the pages for them.

If your portfolio is set up correctly, the book will flow well and the viewer will understand your intent. It's nice to have an interesting story about how one or two of the images were produced, but it's overwhelming for an art buyer to hear a story about every image in the book.

Be careful, too, about making a comment about personal effects in the office or work that's lying around. A comment on a photo of a loved one, for instance, can be viewed as a violation of personal boundaries and detract from the focus of the meeting.

Remember, you are there to secure assignments. Talking about who you are as a photographer is the point of the meeting.

Should an art director choose to show you a layout—and this is not uncommon—seize the chance to shine. Problem solving and making solid suggestions will add to your value as a photographer and engage you in a "creative bonding process." Use references to the images in your portfolio to help make your points, especially when discussing lighting and style.

Wrapping up an Interview. Know when it's time to wrap up—overstaying your welcome can leave a very bad impression. At the end of an appointment, I always ask art buyers if they think the work I showed them fits into their thinking about the work they are doing on behalf of their accounts. The question usually solicits an answer about one or

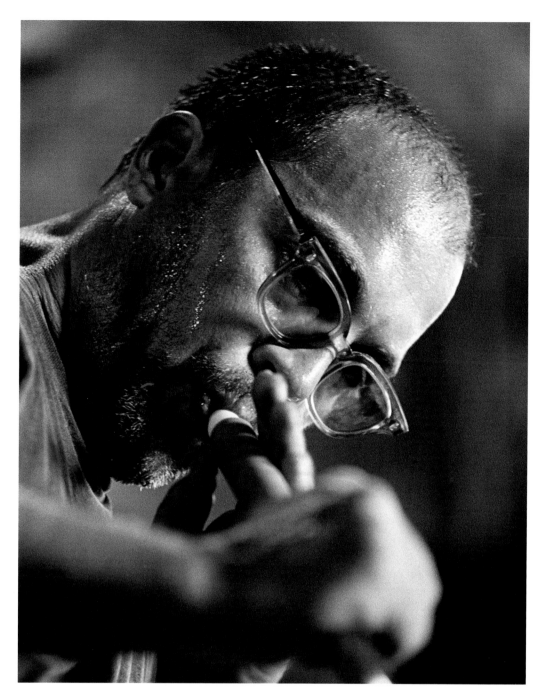

Len Rothman's portrait is an image that can be marketed for both editorial and advertising purposes.
LEN ROTHMAN

two specific accounts. I'll hear something like "the portraits you showed would be good for American Express."

You can also ask for a current list of creative people at the agency—creative and art directors and associate directors, beauty editors, fashion editors, photo editors—and for some recommendations on which people on the list might be interested in your style of work. I sometimes ask if it would be a good idea to contact the art director for a certain account that I know the agency handles. Sometimes art buyers will tell me

to do that or they will call in my book if something comes up on that account.

My last question is always about follow-up. I ask them if I should contact them when I have new work to show, or if I should just keep them on my mailing list. I find that the art buyers are up front in telling you how they like to conduct their business. Never leave without letting the art buyer know that you are interested in working with him or her. You might say that you like the work an agency produces or that you admire an art director's past work.

Portfolio Drop-offs

An alternative to a portfolio appointment is to drop off your portfolio with an agency, magazine, or a client; the book is then reviewed, but without the photographer or the rep. The book is left for period of time that is often specified by the agency. For example, the drop-off day at a magazine might be Wednesday, and the pick-up day the following Monday.

Having photographers drop off their portfolios is a very common practice. There are many photographers out there, and this is an efficient way to see new talent or work without having to spend the time that an actual appointment requires.

Follow the same sequence of actions that I recommend for getting a portfolio appointment: First mail your promotional pieces to the company, then call for an appointment. If an appointment is impossible, then ask if you can drop off your book.

Occasionally, a company won't adhere to a strict schedule for returning portfolios. I once received a call from an agency requesting a portfolio from one of the photographers I represent. I sent it off immediately and did a follow-up call two days later. I was told that the art director needed to keep the book. No problem; as long as we were being considered for a job, the portfolio could stay. I called once a week to check in. Six weeks after the initial drop-off, the art director called to award us a job. The portfolio was returned the next day.

This situation got me thinking. Is it a good sign if a client keeps your portfolio longer than a few days? And what happens to a portfolio when it is called in by an agency?

I called Jana Welch, an art buyer at Amster Yard, an advertising agency in New York City. I asked her why she would keep a portfolio longer then the usual two to three days. She told me that her creative department works in teams. The junior art director may like the book, but the work needs to be viewed by the senior art director as well. In some cases the creative director will want to see the photography choices.

"Some creative people use a photographer with whom they have a certain 'comfort level,'" Jana said. "If they are not familiar with a name or a body of work, they may need to see the portfolio a few times before deciding which way to go. Sometimes the art director has nice things to say about the book but is not one hundred percent sure and will want to see it again."

That is exactly what happened with my portfolio. A new creative director was being hired, and she wanted to go over the photography choices with her new department. It took time for everyone to see the book. Other

LEFT: Child photographer Sean Justice used denim to cover the outside shell of his portfolio, and had his name embossed into the fabric, giving his portfolio a fun yet professional look.
BELOW: When potential clients open Sean Justice's portfolio, they know right away that they are about to see lifestyle photos that focus on children. All the prints in Sean's portfolio are computer-generated.
SEAN JUSTICE

The photographs in this relationship spread come close to looking like stock images, but in the context of Sean Justice's portfolio, the spread works well to show the range of his style.
SEAN JUSTICE

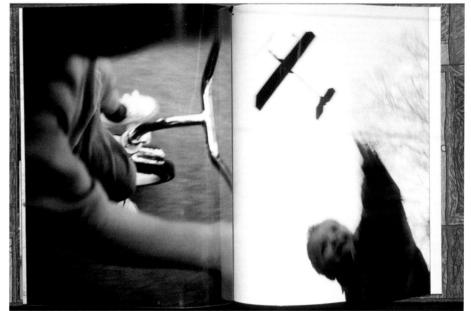

A more personal, fine art spread in the same children's genre adds depth to Sean Justice's portfolio.
SEAN JUSTICE

The third spread in Sean Justice's portfolio is a three-way bleed into which he has inserted a detail-shot outtake from the same shoot.
SEAN JUSTICE

Other times the art buyer or the art director might be busy on another project or distracted by an unexpected emergency.

Things happen. If you have three or four copies of your book, your business will be able to handle "the wait." If you have one copy of your book and it is out with a potential client, you are out of business until you get your book back. My photographers have anywhere from five to seven portfolios. Having multiple books lessens the stress when a client holds onto a book for an extended period of time.

Cold Drop-offs

A cold drop-off is when you drop off your portfolio for an art director or an art buyer when there is no apparent job. Such drop-offs are the result of the photographer's initiative. You want to show your work to creative people at an agency or a magazine that has not seen your book.

It's necessary to do a little homework before dropping your portfolio off at a magazine. Don't send a book that has no relevance to the company, agency, or magazine. Find out, too, about their drop-off policies—that is, when they permit photographers to drop off and pick up their portfolios and, specifically, when can you drop yours off.

These policies aren't always rigid, according to Annemarie Castro, who, as the assistant in the photography department of *Real Simple* magazine, is the portfolio contact person. Castro says that photographers can drop off their portfolio at *Real Simple* on any day of the week. Once the book has been reviewed, someone in the department will call the photographer to say the book is ready to be picked up; sometimes the magazine messengers it back to the photographer. There is a possible benefit involved in picking up a portfolio at a magazine: When you arrive in person, the receptionist generally calls the photo department to let them know that you are there to pick up the portfolio, and you may thus have an opportunity to meet face to face with a photo editor, however informally or briefly.

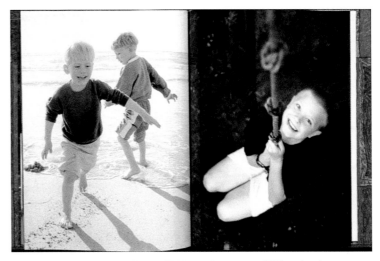

Sean Justice had a lot of beautiful "caught moment" lifestyle photographs. We set the images on a large table and looked for ones that played well next to each other. It was like matching puzzle pieces together to see what worked best.
SEAN JUSTICE

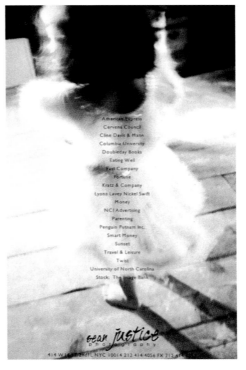

ABOVE: Sean Justice felt it was important to have a client list in his portfolio. I don't think such a list is necessary, but a photographer who feels it is important should include one. The final image Sean chose creates a perfect closing to his portfolio. LEFT: Sean Justice decided that the last page of his portfolio would make a good promotion piece, so he used it for one of his cards.
SEAN JUSTICE

If there is no assigned or otherwise agreed-upon day to pick up a dropped-off portfolio, a photographer should never arrive to pick up a book until he has heard from the potential client that it is ready to be picked up. Many photographers do this, and it means that their book is not reviewed.

It pays to be understanding about a client's schedule. If, for instance, the photo editors at a magazine are in the middle of a big shoot, they probably won't have time to look at your book, even if you drop it off at an assigned time. On the other hand, there are times at a magazine—like during closings, when the editorial staff might be busy fine-tuning stories but the photo editors have already completed their work—when a photo editor has the time to peruse your book. The bottom line: Call first to inquire about the drop-off policy, make arrangements, but be flexible.

If you drop off your portfolio with an art buyer, don't expect her to show it around. You are dropping it off for her. She is not your rep, and it is not her job to get it to

Jack Reznicki creates an interesting image with selective focus.
JACK REZNICKI

other people in the agency. What you can do, once you have dropped off your book, is to call other art buyers in the agency, ask if they are interested in seeing your book, and tell them that it is already there. Ask them if they mind going down the hall to pick it up at a co-worker's office. I have tried this many times and it has worked for me. It can save on shipping costs or on the time you spend personally dropping off and picking up your book.

If you are sending a portfolio that an art buyer or art director did not request, you should be prepared to pay the return postage. It's a good idea to include a prepaid shipping form filled out with your return information. This will make it easier for the recipient to send back your portfolio.

Call-ins

Photographers often drop off their portfolios with clients in response to a "call-in," the informal term for when an art director, art buyer, or photo editor calls your book in for

review for a particular job. When this happens, the books of anywhere from ten to twenty people are usually called in.

Call-ins are a very common way for photographers to get work. Throughout the business world—ad agencies, in corporations, at magazines—photographs must be shot for thousands of jobs every day. For the great majority of these shoots, a photographer is hired and assigned, and to hire a photographer, the photo person needs to review the portfolio.

A call-in happens when an art director or art buyer has heard of you but does not know your work, or wants to review your work in more detail. Sometimes a potential client will grant your request for an in-person appointment because he or she has seen and liked your direct-mail pieces; in the same way, a well designed and sustained direct-mail campaign will often result in a call-in for review of your book.

When an art director or art buyer calls your book in (usually for a particular job), the review process is usually faster than it is with a cold drop-off (when the reviewer may be looking at your book just to get a sense of who you are rather than for a potential assignment). "I will look at your book immediately and screen it, which may mean taking out pieces that are hurting your chance of getting the job," says Andrea Kaye, art buyer for the McCann Erickson advertising agency. "Or I may reorder the book, putting images that work well next to each other. During that time I also eliminate portfolios that may not be appropriate."

An art buyer like Kaye can help an agency find the right photographer and assist a photographer in getting the job. When an account was looking for a photographer to shoot a campaign, Kaye called in six portfolios and looked at all of them, editing some of the images and eliminating one portfolio she did not think was right for the client. The creative director looked at Andrea's choices and selected one of the photographers to shoot the campaign.

A few months later that photographer was not available to shoot another campaign for the same client. Kaye needed to find a replacement and remembered the portfolios she'd reviewed earlier, including one she had edited. Before the photographer sent the portfolio, Andrea reviewed the contents with the photographer to point out images that would be more successful with the client—he got the job.

Following up

It's best to wait two or three days before calling to find out if your portfolio is ready to be picked up. You always have to assume that the person has not had a chance to look at the book or is busy showing it to other people, which is what art buyers do when they see a really good book.

Although someone is likely to be holding onto your book for a good reason, it is important to stay in touch. Voice mail can be very helpful in this. A quick voice-mail message will remind the person that you are aware that she still has your book, and that you are staying in touch.

When you do leave a message as a follow-up, say something like, "I dropped my book off for a project. Is there any word yet? I'm really just checking in. Keep the book as long as you need it." If you still don't hear, call again, be friendly, and say it's been another week, and there is no problem with that, you're just checking in.

If it goes into a third week and you still haven't heard, chances are the project could have started, stopped, started, stopped, changed direction, and then gone back in the original direction. Be prepared to say that the editors/creatives can hold onto the book until they have to time to look at it. This way you're saying you're flexible and cooperative, and that you understand their schedules. Often the silence means the art buyer is considering your work.

If you desperately need the book, it's best to tell the art buyer that you need your book for another job. Art buyers will usually call back and let you know the reasons they have held the book, and they may ask you to return it to them as soon as possible.

Group Portfolio Shows

A group portfolio show is an appointment in which one photographer or several photographers present their work to a group—for example, the entire creative department of the agency or magazine. Such an event usually lasts about three hours, during which the creative people come and go, dropping in to view the work when it is convenient for them.

The portfolio breakfast is a good way to make such a meeting a success. Free food is a sure draw—the photographer or the photographer's rep brings in juice, coffee, and bagels (and more, if the budget allows) to entice the creative types to come view the work. Because portfolio shows are an effective way to get the creative staff to see new talent and new work—and in the process perhaps get new ideas for upcoming projects—many agencies schedule group portfolio shows once every two weeks or once a month.

At many agencies, photographers must first join a waiting list for a group showing, and most agencies like to have a certain number of photographers and portfolios in order to schedule a showing. Photographers' reps try to organize group shows for several of their clients, and sometimes two reps will team up and do a show together.

Try to learn from word of mouth which agencies hold group portfolio shows, then call and get your name on a list. Again, if you've made your name known through aggressive direct-mailings, you'll stand a better chance of making the cut.

Len Rothman also makes good use of depth of field, along with foreground and background.
LEN ROTHMAN

Portfolio Feedback

Will you always be able to know the response of the person who has looked at your work?

Obviously, you will get at least some idea, on the spot, when your work has been reviewed at a portfolio appointment that includes you. However, some art buyers and art directors are more talkative than others, and some are direct, while others may have quiet personalities or lack the ability to communicate what they like and don't like. Nevertheless, at an in-person appointment you will be able to get some sense of the response to your work. The same is true with group portfolio shows, you will typically get comments directly from the art directors or art buyers who attend.

In the case of drop-offs and call-ins, sometimes when you call to check on your book you might get some feedback. Most often, however, they will just let you know that your book is ready. If you want more feedback, you will have to call the person directly and ask their opinion.

Not receiving a note or a call does not mean your work was not good or would not work well with a client's needs.

Most art buyers don't have time to call every photographer who has dropped off a portfolio. If the art buyer, art director, or photo editor has really enjoyed your work, sometimes you will get a note in the portfolio saying so or that they liked a certain piece. Other times you may get a call, but that is the exception, not what usually happens. Once you have your book back, let a couple of days elapse and then follow up with a call or e-mail. A good way to follow up is by e-mail, which is a sure way to get in touch yet doesn't involve much pressure as a phone call; plus it's quick and easy for you, and quick and easy for the person on the other end to respond.

Finally, don't worry if, no matter how long the wait, you pick up your portfolio and it's not accompanied by a note or a photo editor doesn't follow up with a phone call. Not receiving a note or a call does not mean your work was not good or would not work well with a client's needs. In many cases, the creative people are simply too busy to contact you. In fact, you may not hear from an agency or magazine until months down the road when an appropriate job comes up. You need to have patience—and a large amount of self-confidence doesn't hurt either. Take comfort in the fact that you've succeeded in one big way—you've gotten your work out there.

DO . . .
- Establish a rapport with art directors and art buyers.
- Learn about agency accounts and philosophy.
- Find out who selects portfolios and who makes hiring decisions.
- Find out how an agency or magazine finds creative talent.
- Find out how a magazine or agency wants you to follow up.
- Make it clear to an art buyer or art director that you want to work with them.
- Always take along promotional materials to leave behind.

DON'T . . .
- Control how an art buyer or art director looks at your portfolio.
- Overstay your welcome on an appointment to show your portfolio.
- Make your follow-up a harassment.
- Use an art director or art buyer as a reference without asking them first.

Other Marketing Methods

Sourcebooks

In addition to mail promotions, there are many other ways to promote yourself. Some require an investment of your marketing funds, and others require no more than the time and energy required to enter a contest. The point is to get your name and your work into the marketplace any way you can.

Sourcebooks are the industry "yellow pages." Photographers advertise in these annual and semi-annual print vehicles—buying anything from a single page to a double-page spread or several spreads—as showcases for their work. People who buy photography use sourcebooks as an essential way to find the talent that is right for their needs. Most sourcebooks are published once a year, though some appear more often.

Sourcebooks also offer an excellent marketing investment for busy or procrastinating photographers. In fact, source books represent the largest part of the advertising budget for many photographers. And photographers who are making a major marketing effort will use both direct-mail and sourcebooks as a means of becoming known.

Many photographers appear in more than one sourcebook, targeting the different markets reached by the different books. Again, your need for work and your advertising budget—and, eventually, the number of calls you get from a sourcebook—are the determining factors for deciding how many books you should be in. The cost varies from book to book, but typically a photographer can pay anywhere from $1,000 (for a single page) to $30,000 (for a ten-page spread) to appear in a sourcebook. Sourcebooks can be very expensive.

The Major Sourcebooks

Each sourcebook has its own style and its own audience. Two of the most popular are *The Workbook,* probably the most widely used sourcebook today, and *The Black Book,* which was historically the first sourcebook. Other books that are known for their style and trendiness or that focus on a particular niche are *Alternative Pick, Select, Klik,* and *Le Book.*

Measure the success of your sourcebook ad by the number of phone calls you receive for your portfolio.

The Workbook offers an impressive suite of products and services:

- *The Workbook Photography Annual,* the print sourcebook.
- *The Workbook Directory of Creative Talent* (see discussion of directories on p. 121) provides contact information for photographers, artists' representatives, and support services.
- *Workbook.com,* the online sourcebook (see below for more on these) features the photographs from the entire current printed issue of *The Workbook Photography Annual,* plus 700 additional portfolios from photographers and illustrators. It also includes *The Workbook Directory of Creative Talent;* besides making the print directory available digitally, the online directory lists advertising agencies, design studios, and other companies that buy art (including the names of the people who review portfolios), as well as services and suppliers.
- Workbook Lists, updated bi-monthly, are available for twenty-one different categories and in three formats—on disk, as labels, and as pdf files.
- *The Workbook* publishes two spin-offs: *Single Image,* distributed twice a year to buyers in the graphic arts community, can be used to show a photographer's most current work; it also showcases trends

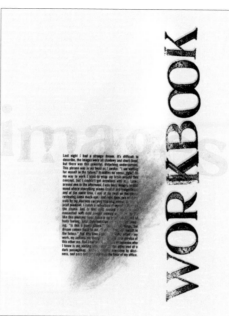

Sourcebooks are a popular media buy. Although they can be expensive, many photographers will tell you that their ads help bring in new business. WORKBOOK; BLACK BOOK/PHOTOGRAPH BY ROBERT WILEY; THE ALTERNATE PICK; SELECT; KLIK SHOWCASE PHOTOGRAPHY 10

the
alternative pick

and the newest directions in advertising. *Framed,* also published twice a year, is distributed to corporate buyers of fine art.

- Workbookstock.com is an e-commerce, digitally fulfilled website with more than 60,000 rights-managed stock images from photographers, image libraries, and illustrators. *Workbookstock* catalogs are distributed twice a year (one of them internationally) to buyers of rights-managed stock.
- Finally, through Workbook Consulting, company sales reps are available to help photographers and illustrators formulate their marketing programs or find an agent.

The Black Book (www.blackbook.com) has been in business since 1970. It started out as a black-and-white listings format—like a telephone directory—and has evolved to showcase beautiful four-color imagery.

Alternative Pick (www.altpick.com) was created in response to the need for a sourcebook specially targeted to an audience of art buyers in the advertising, editorial, and music entertainment industries.

Select (www.selectonline.com) incorporates two earlier sourcebooks, *New York Gold* and *Tilt.* Some 60 to 70 percent of the copies of this book go to advertising agencies, with the balance to design companies, magazine and book publishers, entertainment companies, fashion and beauty firms, and retail stores. About 10 percent of the copies go to photographers; agents; model, talent, stock, agencies; and production companies.

KLIK Showcase Photography is part of *American Showcase* (www.americanshowcase.com), a company that advertises the work of photographers and illustrators. *American Showcase* was also one of the first sourcebooks in the industry. *Klik* offers all styles and genres of photography to anyone who hires photographers.

Le Book (www.lebook.com), which features more than 800 pages of visual work and listings, is especially important for the fashion and advertising industries.

No sourcebook is "better" than another—I can't tell you which is the best. I have had zero results from ads in some books and glorious successes in others. One book may work for one photographer, while another does not. But on one thing I'm definite: All the photographers I represent appear in sourcebooks, and I recommend them as a solid investment of the money in your marketing budget. Sourcebooks have helped bring my photographers both name recognition and financial success.

If you're thinking about advertising in a sourcebook for the first time, contact a few photographers who advertise in the book or books you are considering. Find out which ones were effective for them and how long it took them to get responses from their ads. However, when all is said and done, you need to find out which sourcebook is best for you by the time-honored method of trial and error. If your current sourcebook isn't getting you calls, try another.

Measure the success of your sourcebook ad by the number of phone calls you receive for your portfolio. That is why people use the books—to find photographers.

You should have realistic expectations for your sourcebook ad; be patient and fair. A sourcebook's job is to get a photo buyer (art director, art buyer or photo editor) to ask to see the portfolio. (However, if the call does not lead to a job, that is not the fault of the sourcebook. When your book is called in for review and you don't get job, you need to reevaluate your book.) It's not uncommon to get a call from a potential client based on a sourcebook ad that's a few years old. People seem to keep the old books around and use them on a continuing basis.

Some books offer a discount if you send in the deposit for next year early, so by early-deposit time you will find yourself trying to decide whether advertising in a given sourcebook was the right decision and whether you should advertise with them again next year—but without proper evidence. Most sourcebooks arrive at potential clients in February, and the early deposit deadline to hold space for next year's book is generally April. You can't evaluate the success of last year's ad in the six weeks

between distribution of this year's source-book and the deadline for early deposits for the coming year, so you may have to either wait for the later deadline and pay the full price to appear in the next issue, or just accept the fact that you won't really know if a book is helping you until you've appeared in it for two years.

Designing a Sourcebook Ad

Most photographers take out double-page sourcebook spreads, which allows the spotlight to remain on that photographer for as long as the book is open to that spread, without competition from another ad on the right or left. But many photographers use single-page ads, which can be effective if they are well designed.

In addition to the photographer's work, the ad typically shows the photographer's and/or the studio's name, the e-mail or website address, and the telephone number.

Some photographers design their own pages, but I strongly recommend using a professional designer to create your page. You have a lot of money invested and paying a little extra money to a designer will prove to be a good investment in the long run. You can hire a designer on your own, or use the designers that the sourcebook sales reps can provide or recommend.

Many sourcebook sales reps are extremely helpful with image selection. They know the market well and have experience choosing the right images, if you and your designer want help with that.

Do some visual research before you think about how you want your ad to look. Mark the pages you like from the sourcebooks you're considering. Look for content as well as design within those pages. Ask yourself why you like them. When you start to think about your design, first think of who you want to get work from. Select an image or several images that best show your style and talent, and have the ad designed so that it speaks the language of the prospective client.

The first time my photographer Jack Reznicki decided to appear in a sourcebook,

we hired a designer—Red Herring, in New York City—to create the spreads for three ads that turned out to be very successful; they brought in a lot of calls for Jack's portfolio. Jack and I both feel that having a designer working for us enhanced the salability of the ads.

Here's a selection of Jack Reznicki's sourcebook ads, which have been very successful.
JACK REZNICKI

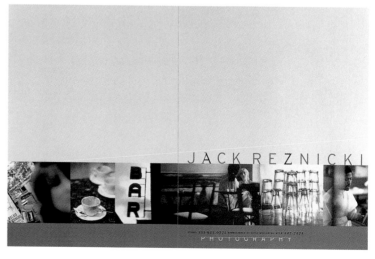

A good designer for a sourcebook ad will balance the images and the design to make the ad stand out from those of the other photographers in the book. Someone reviewing a sourcebook looks through many, many pages—a tremendous amount of photography and design. When you find the right designer—one who can combine your photography with their design to make a successful page—the creative people will notice you.

Spin-off Benefits of Sourcebook Advertising

Advertising in a sourcebook has a built-in spin-off benefit: You can use the reprints (tear sheets) from your sourcebook ads as mailers. In most cases, a few reprints are provided at no additional cost, and you can usually order extra copies. One of my photographers landed an important client from a reprint mailing.

Mailing reprints to your list(s) will help make your name and the style of your work familiar, especially if you are also promoting your work through postcards and other types of mailings. The client sees your photographs when she gets a postcard, when she opens a reprint mailing, and when she flips through a sourcebook. By the time she sees your name and your work half a dozen times, you are no longer a stranger—you're a serious, professional photographer who is looking for work.

Find out the other services offered by your sourcebooks. Many of them offer an online presence (see the section below). They also have "sister" publications you may be interested in. For example, *The Workbook* publishes *Single Image* twice a year to showcase new trends and the newest work of photographers, and *Framed* is directed to the corporate fine art market.

Online Sourcebooks and Portfolio Sites

It is also important to get your portfolio in one or more online sourcebooks and/or on portfolio sites. Each company has its own policies, which change year by year, so I'm not going to give them in detail here. Usually the photographers in the print edition are automatically featured on the web version of the sourcebook, and often photographers who do not appear in the printed edition can sign up to appear in the online edition. See pages 114 and 116 for online addresses of the six major sourcebooks.

Portfolio sites that are exclusively online—that is, they have no print edition—include PDN's www.photoserve.com and www.portfolios.com (where one can go onto the site, search, and see examples of photog-

Advice from Denise Chastain: Working with a Sourcebook

Some sourcebooks show you only one proof, and you may have to fight to make changes and see another proof, and sometimes pay an additional fee to do so. To avoid this situation, when submitting your artwork use digitally prepared files and have the final film and match print created by a preproduction service bureau instead of the sourcebook's printer. (The sourcebook art department usually can recommend a service bureau.) Creating the film beforehand lets you see the closest reproduction to what will appear in the final book ad.

The service bureau first creates a "loose proof"; you can discuss with them any color corrections or other necessary adjustments. In the case of minor tweaking, you may want to make the changes and then go straight to the film (which the printer uses to make the plate that goes on the printing press) and the match print (the proof from the film). If a lot of work needs to be done, you might want to make another loose proof before creating the final film and match print. (Keep the loose proof so you have a copy of the ad for your reference.)

This approach is invaluable in avoiding potential print quality mishaps. The printer has the match print and knows what you want your ad to look like. The printer uses the film you supplied, from which the match print was created. When you receive the sourcebook's proof, you just have to approve it, and you are done.

raphers' work), and www.Visuallocity.com (a site on which individual work is viewable by invitation only).

Both online sourcebooks and portfolio sites sometimes provide links to photographers' individual websites. (For a discussion about creating your own website, see "Your Portfolio on the Internet" in chapter 4.)

One disadvantage of having your work displayed not on your own site but within an online sourcebook or portfolio site is that some online resources do not allow for individual design and instead offer a standard layout that all the contributors use. In such cases, your choice of images becomes extremely important.

Some buyers primarily or exclusively use online resources in their searches for photographers. If photo editors are looking for a specific person, all they need to do is go online and type in the name. This is a lot easier than flipping through a book looking for a specific photographer. Or if photo editors have specific needs—such as someone who shoots lifestyle and lives in Boston—they can go into the search engine of an online sourcebook and type in key words. You can search a lot more quickly by style and genre, or by location.

A search using the online sources usually starts using either genre or location. Once the photographers' names appear, the searcher is directed to the website or online portfolio of individual photographers. Some online portfolios have only a few images, while others have twenty or more. The number is not that important. What is important is that the images are your best, that they represent you properly, and that your contact information—including, if you have one, your website address—is displayed clearly.

Art buyers and photo editors use online resources on a daily basis, as they save buyers and producers huge amounts of time, typically reducing research time by half. Online research is a key part of the future of buying, so you must be findable online, if not through the display of your images, at least in a directory.

Directories

If you can't afford to take out an ad in a sourcebook, be sure that you are included in directory listings. It is like being in the phone book of our industry. Though they are generally connected with sourcebooks, directories are a resource in themselves, an important tool that creative people use to contact and hire talent.

Directory listings are the phone book of our industry.

Most sourcebooks also publish a directory, which is a section in the back or—as with *The Workbook Directory of Creative Talent*—a separate book for free listings, but today most people use directories in their online form, which makes searching fast and efficient. Several of the sourcebooks I've mentioned above have directories that are online only.

All directories include listings for photographers, and some, including *The Workbook Directory* online, also list art buyers, photo editors, ad agencies, design firms, etc.—anyone who hires photographers. (Chapter 6 discusses using directories in building a mailing list.) Some list model agencies, location options, makeup artists, art consultants, retouchers, and other people and organizations involved in creating artwork.

There is usually no charge to photographers for these listings, but directories often require you to qualify to be included. For some you need to fill out a form, and others will ask you to send a promotion card or a business card to show that you are a working photographer. For example, to be included in the *Black Book* directory, photographers must fill out and sign a form (available on www.blackbook.com).

Free listings can bring in jobs. I represented a photographer who lived in Phoenix, and he got calls just for being listed in his region. Someone needed a photographer in Phoenix and consulted the list for the photographers who were in Phoenix. Even though my photographer did not have an ad in the book

but was just listed in the location they needed, they called us and asked to see his portfolio.

Another time, a call came in from a client who had a CEO located in Phoenix. Since my photographer was there, the client felt that he could just drive over and take the photograph; they wouldn't have to transport a photographer to the location and instead would pay for only a half-day shoot. They were shopping by location.

It's simple to be listed in a directory. Just call and make the request. You'll be asked to provide your basic information: your name, your agent or representative, address, phone number, e-mail address, and website. Some directories are free; for others, you may have to pay to be listed, but the price is worth every penny.

Contests and Competitions

At any given moment, somewhere there is a photography contest going on. The energy and creative talent in our industry is so abundant that there is plenty of material for all these competitions. Winning a contest is great, of course, for validating the value of your work. But being a contest winner also brings exposure and recognition to your name and your work.

Contests and competitions are important because the creative people look at who is winning. *Photo District News* editor Holly Hughes says she knows people who didn't win a contest but got jobs because a judge remembered seeing the work during the judging. Paul Moakley adds that the judges always ask him for a list of phone numbers of people they saw from the contests. To win contests you have to appeal to a big section of the panel of judges, explains Hughes; you have to get a lot of votes from a lot of judges. But that doesn't mean that one judge can't be wowed by your work. You can sometimes get meaningful attention through entering contests.

Photo District News conducts three main contests: the PDN/PIX Digital Imaging contest, the PDN/Nikon self-promotion awards, and the *PDN Photo Annual*. Photographers who enter the contests that are in *PDN* also get exposure, according to editor Holly Hughes. It takes just one image—someone likes it and they are really interested in that. "Even that little exposure in *PDN* really helps photographers," she says. For more information, check out www.pdnonline.com/contests/index.html.

There are several other important competitions.

Yuri Dojc's website, which was featured in *PDN*'s Photo Annual.
YURI DOJC; WEB DESIGN BY FLAVIO MESTER

YURI DOJC
PHOTOGRAPHER

Communications Arts magazine holds four annual contests related to photography. Their website has downloadable entry forms, submission guidelines, and information: www.commarts.com/CA/magazine/comp.

- Photography: The best photography used for advertising, design, editorial, and any other area of the communication arts. Winners are showcased in the August *Photography Annual.*
- Advertising: The best in consumer and institutional print ads, posters, and television commercials. Winners are showcased in the December *Advertising Annual.*
- Design: The largest and most eminent of all juried competitions in graphic design. Winners appear in the November *Design Annual.*
- Interactive Media: The most prestigious design competition for interactive media. Winners are announced in the September/October *Interactive Annual of Communication.*

Here are more competitions:
- *Graphis Advertising Annual:* Open to any print ad or campaign created between the dates specified; winning entries are published in the *Graphis Advertising Annual.* (http://www.graphis.com)
- *Graphis Photo Annual:* Any photographic image produced in twelve subject categories for any purpose between the dates specified. Winning entries will be published in the *Graphis Photo Annual.* (http://www.graphis.com)
- *How* Self-Promotion Competition: Any self-promotional or pro bono material produced during the specified period for the purpose of promoting the designer or the company is eligible. Best entries appear in *How*'s October self-promotion annual, and certificates of excellence are awarded. (http://www.howdesign.com/compete)

You can find deadlines and other information on these and other contests in the *The Workbook Directory* online (www.workbook.com/andmore/calendar.lasso).

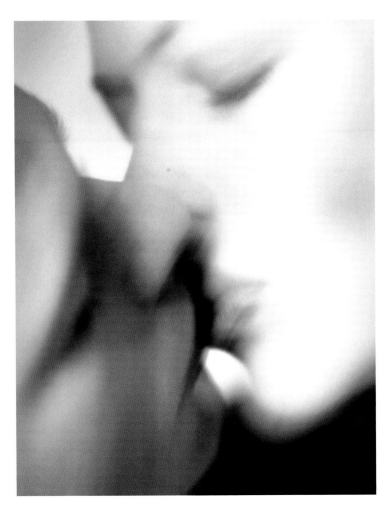

Working with a Stock House

A photography stock house is a company that owns or controls a large collection, or library, of images that are available for licensing (use under a specified set of circumstances). Among the most popular categories of images that stock houses offer are lifestyle (business, family, active lifestyles), portraiture (infants to seniors from every ethnic background), still life (food and almost any other subject), fine art, and conceptual (everything from business shots to images that depict an emotion). Almost any type of image you can think of is available from a stock house.

Some of the most important stock houses are Getty Images, Corbis, Masterfile, SuperStock, Workbook, and Photonica. And a number of specialty stock houses offer images in one category—some examples: food (www.stockfood.com), panoramic images (www.panoramicimages.com), flowers (www.flowerphotos.com),

Jack Reznicki's image of the couple kissing can be marketed for both advertising and editorial and works well as stock, since it can be marketed to several different arenas.
JACK REZNICKI

women (www.seejanerun.com), nature and the natural world (www.animalsanimals.com), and sports (the news and sport pages on www.gettyimages.com).

Stock houses work with photographers in two major ways—they either buy the selling rights or copyright to existing images from a photographer, or they hire the photographer to do a shoot. The two parties usually negotiate a yearly contract that specifies the formula for compensation, bonuses, restrictions, and other matters, such as the legal representation and protections the house offers the photographer if a legal issue arises with a contracted image. Photographers may submit restrictions on where their images may be seen. Contracts vary, of course, from house to house.

Each house has its own general formula for paying the photographer when an image is licensed; for example, Getty Images pays photographers based on "contract return percentages," formulas that typically break down into two major types, based on how the image was obtained. If photographers created the image on their own, they receive roughly 50 percent of the fee ("license revenue") the house collects from the licensor (art buyer or photo editor). If a stock house finances a photo shoot and licenses images from that shoot, the photographer receives around 30 percent of the fee and the stock house retains roughly 70 percent.

What a photographer earns per image depends on how the stock house licenses usage. Generally a stock house licenses images in two ways:

- *Rights-managed images.* The photographer owns the copyright and original image, and allows the stock house to represent it for a certain time period. Licensors pay a fee based on specific use and factors that include size, placement, duration of use, and geographic distribution; beyond those specified, no further use of the image is permitted. The price a client pays for use of such an image is often negotiated.
- *Royalty-free images.* In some cases, the photographer owns the copyright; in others, he or she may be paid a one-time flat fee, transfer the copyright to the house,

and relinquish all rights to the image. The price the licensor pays is based solely on the size of the product, not the specific use; purchase, typically at a fixed price, entitles a licensor to use an image multiple times for multiple projects, for no additional fee.

Leigh Ann Kocur, an account executive at Getty Images, notes that income from a stock house depends on how many images a photographer has with the house or how much he or she shoots for the agency, and which clients and industry segments buy the images. Images can be sold for anywhere from $175 to $45,000, depending on license and usage, and since one image can be sold several times around the world, a photographer can make multiples of these fees. On the other hand, a house may contract with a photographer for rights to an image that is never licensed. So payments from stock houses can minimally supplement your yearly income or be very substantial. Some commercial photographers make the bulk of their money through stock.

Many photographers work with more than one stock house, but each house obtains the selling rights to a particular image. If you shoot for one house you cannot do a similar shot for another house, nor can you submit to house A outtakes from a shoot you did for house B. Only when a house no longer wishes to sell an image or relinquishes the photographer's contract can the photographer submit that work elsewhere. As long as a photographer holds the rights to any image, including outtakes from other clients, it can be sold to a stock house.

An added benefit of being represented by a stock house is increased exposure. Since many houses promote themselves and their photographers through attractive promotional catalogs and most provide images for review online, representation by a stock house is another way for art buyers and art directors to see photographers' latest work. Years ago many photographers felt that stock was beneath them, but today many of the best photographers worldwide are promoted through innovative houses like Photonica, Getty Images, and Workbook.

To work with a stock house, you need to be open-minded and flexible, and you must be willing to use a variety of techniques. Go online and take a look at the images offered by the different houses. If you want to be considered for representation by a stock house, call and ask for the submission form, which will specify how many 2 1/4, 35mm, medium-format, and high-res files you can submit. Also inquire about the house's system for reviewing portfolios.

Word of Mouth

Yes, word does get around. "Word of mouth" is the main way many magazine photo editors find photographers.

On a shoot a stylist might say, " I worked with this person. I think he would be really appropriate for your magazine." Since art buyers at advertising agencies usually see more books than photos editors at magazines do, they are great sources of information. The staff of *The Workbook* tells me photo buyers often call looking for a specific person or for a person who shoots/illustrates in a certain way or in a certain state. Steve Fine of *Sports Illustrated* says that he and his colleagues know about 90 percent of the people in the industry who are picture editors and often recommend photographers to one another.

You get the point—you want to make sure that the word of mouth about you is good. Doing a good job and acting professionally is the best way to ensure this will be the case.

DO . . .
- Use direct-mail pieces and sourcebooks as a means of becoming known.
- Get your portfolio in one or more online sourcebooks and/or on portfolio sites.
- Make sure you are included in directory listings.
- Enter contests as another means of promotion.

DON'T . . .
- Have unrealistic expectations for your sourcebook ad.
- Overlook the fact that old-fashioned word of mouth still goes a long way.

These two images from Jack Reznicki are great examples of images that can be used in several markets and could easily be licensed several times in different markets.
JACK REZNICKI

123

Make Your Marketing More Effective

Ten Ways to More Effective Marketing

Here is a set of promotion cards from photographer Michael Goldman. His database had grown by the time he did these cards, so it made sense to have them printed rather than produce them from his desktop printer.
MICHAEL GOLDMAN

1. Pay Attention to the Identity You're Promoting, and Promote It Often

So far we've covered the major activities you need to engage in for a successful career as a photographer. This chapter offers ten pieces of "smaller-scale" advice—tips for refining your dealings with clients and ways to make your professional life a little bit easier.

No matter how busy you get shooting jobs or showing your portfolio to prospective clients, don't lose sight of the central elements of your promotional strategy. Keep your portfolio looking fresh, and make sure it showcases your strongest photographs. Edit out those "filler" images! Remember, less can be more. Replace worn mats, damaged laminations, and scratched plastic sleeves. And make sure you heed the following important pointers:

- Make sure the identity you're promoting is the one you want to put out there. If you feel you need a change, create a new identity for yourself with an inventive type treatment that better represents your style of photography. Design a new promotion piece. Create a fresh look for your mailer or leave-behind.
- **Maintain an active promotional strategy.** Do this even if it's something as simple as sending out a promotional card four times a year to all the clients you've worked for. You need to keep your name and talent fresh in the minds of clients, who are constantly bombarded with photographers looking for work.
- **Make a wish list, but keep it a manageable size.** For example, choose five new clients you want to shoot for and go after them. Be proactive! Send out or drop off your book to one new client a week. Make an effort to get more editorial work; the rates are low, but the credit lines provide you with good exposure.
- **Above all: Keep a positive attitude.** Remember, your talents are both needed and valuable. And be patient.

2. Follow Up and Support Your Mailings

The conventional wisdom is that part of a successful marketing campaign is effective follow-up. But how extensive should the follow-up be, and what's the best way to do it?

"Hello, this is Pat, the photographer. I'm calling to see if you received my promotion card." No, wait, that's no good. What if the person says yes—then what? "Hello, this is Pat, the photographer. I was wondering if you had any jobs coming up that you may want to consider me for?" No, no, too direct. "Hi, this is Pat, the photographer. How was

your weekend? See any good movies? By the way, are you having trouble finding the right photographer to shoot your next campaign?" This may not be the way to go either.

Follow-up can be depressing and anxiety-provoking at best, but it doesn't have to be. First, what is follow-up? Do we need to do it? Do our clients need us to do it? Is there a way to make it pain-free?

Follow-up is a way to keep potential clients thinking about you after a portfolio appointment, or a way to support and extend the value of your major promotional mailings. In essence, it's a reminder, a way to let clients know you are "still out there" and interested in shooting for them. So it's a good thing to do, but too much follow-up can overwhelm a client and be off-putting, and perhaps diminish your chances of getting work.

The good news is that there are ways to follow up that don't involve a time-consuming, burdensome, or pointless conversation. It's possible to avoid regular phone calls and to instead use monthly mailings or voice mail and e-mail to keep your name in front of potential clients.

Avoid Caller ID by Sending Monthly Mailers.
Many creative people have caller ID to protect them. They say it helps them "weed out" the photographers who call repeatedly in an effort to get work. One art buyer told me, "I have a hard time with photographers who call too often and try to start a friend-ship with me. I view photographers as suppliers, not confidants."

If you can't get through for a live phone chat or if you are just plain uncomfortable with following up by calling, consider a visual alternative. Send frequent postcard mailings—once a month, if you can manage it. As each card arrives, it reminds your potential client that you are available for an assignment. In fact, the card is better than a voice—the client sees your name *and* an image as a reminder of your style.

One photographer I represent tried that approach. He had never promoted himself before, so art directors were not familiar with his name or his work. He sent out

photography
gary gelb

postcard images every month in what began as a lesson in patience. The phone didn't ring until the eighth month, but then it didn't stop ringing and he secured many jobs. Some months later, the photographer stopped sending cards because he was too busy shooting to keep up his direct-mail campaign. Guess what happened? The calls stopped coming. To this day he continues to send monthly cards. He doesn't have to "follow up" with anyone as long as he keeps sending the postcards.

How to Use E-Mail and VoiceMail Effectively.
You can also use e-mail and voice mail to support your major promotional mailings. Send an e-mail at any time during the day or, if you're aiming for a voice-mail message, call over the lunch hour or after the close of business. Your brief message should be something like, "Hi, this is Pat. I just mailed my new promo card to you today. It's a photo of a large pig on top of a car. I hope you like it."

Don't bother giving your phone number when you e-mail or call, as there's no reason for the client to contact you—and your phone number will appear on the promo card. The idea is to "preview" your soon-to-arrive card so that when your pig shot arrives, your name and even the type of image are familiar and the art director makes the connection.

Another example from one of Gary Gelb's campaigns.
GARY GELB/DESIGN BY JOHN GENTILE

How to Check in When the Assignment Is Finished. Follow-up is extremely important after an assignment has been completed. Many art directors tell me they expect to hear from a photographer after a job has been shot—after all, the assignment was a team effort. You should be interested in knowing which image made the final pick, how the job looked in print, and what the client had to say about the final piece.

This is the time when you and your art director can go over the shoot and "bond." Tell your client you look forward to working with him again—hopefully soon. Since there are so many photographers vying for jobs, this type of follow-up is important. Your competitors are sending their own promotional mailings, showing their portfolios, and advertising in sourcebooks and trade magazines. The competition is heavy, so you need to help clients remember you.

Many people feel uncomfortable following up and asking for more work, but remember: You provide a valuable service. Your clients need your talent. Whether you are contacting the client in support of a promotion piece you've mailed or a job you've done well, follow-up should be an integral part of your business.

3. Understand the Language of Clients

Why does a client tell you she loves your portfolio yet doesn't give you a job? Clients have a language all their own. The words a client uses do not necessarily reflect what she wants to convey. Here are some of my favorite "client sayings" and what they really mean.

What they say: "Keep in touch."
What they mean: "Mail me a promo piece. Don't call."

What they say: "Keep me on your mailing list."
What they mean: "Stop calling to see if I have a job for you."

What they say: "We thought your estimate was fair and reasonable, but the client fell off his chair."
What they mean: "I want you to take money off your estimate."

Clients have a language all their own, and the words a client uses do not necessarily reflect what she wants to convey.

What they say: "It's a three-way bid, and we like you all equally."
What they mean: "You are not the favorite." (If you are the favored photographer, they will tell you.)

What they say: "If you can't do it for a lower price I have someone else who can."
What they mean: "I want to see how much lower you will go."

What they say: "We don't have a lot of money for this job, but we will make it up to you on the next one."
What they mean: "Help me solve my immediate problem and I will probably forget you in the future."

What they say: "You didn't get the job. It was the client's decision."
What they mean: "Our art director chose another photographer."

What they say: "This is a cheap client."
What they mean: "We don't have a lot of money to produce this job. We are spending the budget on buying the media space."

What they say: "Can you shoot this in a half day?"
What they mean: "We do not want to pay your full-day rate."

What they say: "Getting you a cash advance is an accounting nightmare," or "Accounting doesn't let us give cash advances."
What they mean: "A cash advance is a pain in the neck. I don't want to deal with it."

What they say: "It takes three people to sign off on your invoice," or "We have to wait to get paid by the client before we pay you."
What they mean: "We are trying to hold on to your money as long as possible."

What they say: "The check's in the mail" . . . well, you know that one.

4. Turn Stressful Situations to Your Advantage

Occasionally you will find yourself in a situation that could turn out badly if you're not expecting it. However, if you are prepared, you can turn a potentially negative situation to your advantage. Here are six typical potentially stressful scenarios and solutions I have found to be effective.

■ *You finally get up the nerve to call Jane Cold Shoulder, the art buyer who works on many of the accounts you want to shoot for. You place the call. It connects, and you hear: "You have reached the voice mail of Jane Cold Shoulder. Please leave a message at the tone, and I will return your call." What should you do?*
Don't hang up. Use voice mail—which I view as free postage, a quick reminder without a stamp—to help you. Keep your message short and concise, and Jane will get your point.

■ *You're waiting in the agency reception area, on time, to see Tony, the art director you made an appointment with two weeks ago, after he had canceled two previous appointments. Twenty minutes go by and Tony appears: "I'm sorry, but I can spare only two minutes to look at your book. I just got called into an emergency meeting." What should you say?*
Say no—politely, of course. You want his undivided attention, and it is doubtful that Tony or anyone else will remember a portfolio viewed under stressful circumstances.

This is an example of a commercial ad with an editorial look.
JAMEY STILLINGS

© Jamey Stillings 800.724.0209

Try to reschedule right then and there. Tell Tony that he is important to you and you want to work with him. Say that you prefer seeing him when he is not rushed. In the long run, it's worth the extra time it may take to have the proper setting for a client to look at your work.

- *You finally get an appointment with art buyer Mary Frazzled. As soon as she sits down and opens your portfolio, her telephone rings. She picks it up and engages in a detailed conversation. All the while, she continues to page through your book. What should you do or say?*
This has happened to me many times. Most people can do more than one thing at a time, and that's fine—but you do not want Mary multitasking with your portfolio! Don't talk over her conversation. Just use hand gestures to get her attention and ask her to wait till her phone call is done before looking at the book. When she gets off the phone, explain (again, politely) that you want to have her full attention because this appointment is very important to you.

- *After three years of promising yourself to update your portfolio, you finally begin. In order to save money, you're using part of your old book, which you've taken apart, and your new book is well on its way. But then you receive a call from art buyer Flash Quickly, who needs your book immediately. It's impossible to finish your new presentation quickly, but Flash's agency does great work, and you want to send him something. Now what?*
If you have a website, you can refer Flash to his computer screen to see your work. And if you have done some promo cards, you can send those. However, if you have neither of these and no portfolio ready to show, you lose. Meanwhile, you learn a very important lesson. Never take apart your current portfolio unless there is a finished one ready to be sent out. You are not in business if you do not have a portfolio that can be sent to a client. Create a new portfolio separately. You can always dismantle your old book after the new one is completed.

- *You get a call from Susie Precisely. She is working on an annual report and needs to shoot a series of portraits of an executive in his office. She wants you to send a portfolio with all your "executives in their office" portraits. Although you know you can do this assignment, your portfolio's people pictures either were shot on seamless as formal portraits or are "real people" images in a journalistic style. What should you do?*
Send Susie your best work. You do not have to send a client exactly want she thinks she needs to see—especially if you don't have it! Most creative people can interpret what they see in your book and judge it in the context of the current assignment. If Susie can't do that, you have nothing to lose by sending your work; after all, she called you. If this job doesn't work out, maybe her next project will be right for your style.

- *Creative director Sam Surebet just saw your portfolio and loved it. He says he should have a project coming up in the next few weeks and to stay in touch. You call him ten days after the meeting and he remembers you and your work, but the project has been pushed back a few weeks. You want to figure out a way to stay in his mind but don't want to become a pest. What should you do?*
Send him mailers. You can make them just for him using your computer. Send him one a week or every ten days, using a different image from your portfolio each time. You can also call or e-mail him every two weeks or leave messages on his voice mail.

5. Use Proper Etiquette

You are a valuable supplier in our industry, but there are many photographers available, and you need to distinguish yourself in every way possible. It may seem like a small thing, but using good etiquette will make you more professional and, therefore, attractive to clients. Although some people make a lot of fuss about etiquette, there's really nothing mysterious about it. Etiquette is just good manners, and it goes hand in hand with common sense. Here are some tips.

Send a professional thank-you note when that is appropriate. And, depending on the situation, you can also write a personal thank-you note, even if it is a business situation or a business favor. Often people appreciate knowing that you really appreciate on a personal level something that's been done.

Using good etiquette will make you more professional and, therefore, attractive to clients.

Never send anything to a potential client—or to anyone in the business—that you expect to get back without getting their permission first. People have a hard enough time dealing with the portfolios and materials they request. Before you send your portfolio, be sure the recipient knows it's coming. A photographer called me to complain about an art buyer to whom the photographer had sent her portfolio, but who had never returned the book. The photographer had waited two weeks and then, during the third week, left four voice-mail messages, but her calls were not returned. She wanted to work with this agency and did not want to alienate the buyer, but the lack of respect bothered her. It bothered me, too, until I asked for a detailed account of what had happened, from the beginning. After calling the buyer to qualify her as a potential client, the photographer decided that she was a good prospect, put her at the top of her "A list" of twenty-five names, and sent her portfolio. The problem: She did not call the buyer to ask if she should send the book or, at the least, to tell her she was sending it—she just sent the book and waited for a response. That is bad manners, and a thoughtless action that resulted in wasted time and energy.

Another photographer left me two voice-mail messages saying he wanted me to return the prints he had sent me. I didn't know who he was and didn't remember receiving the prints. I could hear the anger

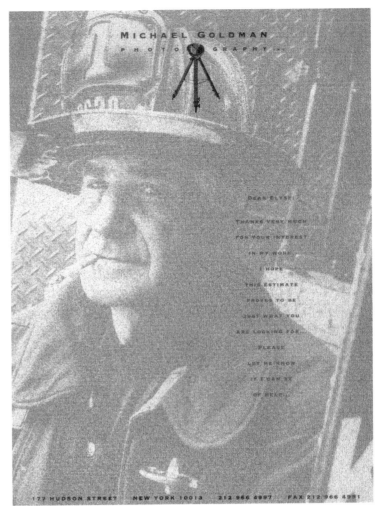

Michael Goldman's stationery has the same ghosted-image feel that he uses in his promotion pieces. Michael created the stationery at low cost with his desktop printer and prints it as needed.
MICHAEL GOLDMAN

Michael Goldman's ghosted envelope image, achieved with a 30-percent ink coverage, is an intriguing design. It says, "Open me."
MICHAEL GOLDMAN

in his second message, but he did not leave a number for me to call back. When he called the third time, I was at my desk and answered the phone. He said he had sent me the photos because he wanted some free advice. I told him it was unprofessional to send prints to me—especially ones he expected back—without asking me first.

Never assume you know what a client wants. Several art buyers have told me it's a mistake for a photographer to send a sample image or point out a photograph in a portfolio with a comment like, "This is just right for you." Don't prejudge what the clients wants or needs; instead, listen to what they say. And let them decide whether your photography will suit their purposes.

Maintain a professional manner when you're on a shoot. For example, do not initiate conversations about personal matters. An art director had confided to a photographer that he and his wife were having problems. Nothing wrong with that. But on the set, when clients, account managers, and other people were standing around talking, the photographer asked the man how things were going with his wife. His response—that he was getting a divorce—made everyone uncomfortable and put a major damper on the shoot. That kind of conversation is for another place and time, not the shoot.

Don't drop by an art buyer's or art director's office without a prior arrangement—even if you have an appointment with someone in an agency. It's not fair to catch them off guard. If you want to see if they are available, leave them a voice-mail message saying when you will be at agency on an appointment and that you will call them from the receptionist's desk to see if you can come by to show them new work or just say hello.

Keep friendship and business issues separate. It's very likely that you will create friendships with people you do business with. There will be times when you have to talk about money or scheduling a job or asking

for work, and you have to respect the fact that those conversations will be different from the kind of conversation you have with a friend. So when you're having a conversation that includes familiarity—How are your kids? What is going on with school? What movies have you seen?—always try to make it clear when you're making a transition to the business part of the conversation. If you don't, it may seem that you are trying to take advantage of the friendship. An easy way to keep things straight is to simply say something like, "Can we now spend a few minutes talking about business?"

I have had people try to get business from me under the auspices of being my friend, and I don't like it. One sourcebook rep, for example, called me to talk about schools that my children were going to and ones she wanted to send her kids to, and in the middle of the conversation she tried to sell me a source book ad. When I got off the phone, I felt violated because she hadn't announced that she was making the phone call for business reasons. I gave her all this personal information about my children and their schools, and we ended up talking about a sourcebook ad. I do something like that too as a salesperson, but I am more honest about it. She could have said, "Thanks for all the information on schools. Now I have a business question. Is this a good time to discuss business, or should I call you back?" If I have been softened up by the personal conversation and it is a good time, great. But warn me. Be up front rather than try to slide a sales pitch in through the back door, which only makes you look sleazy.

6. Fix Your Blunders

A few years ago, I received a call from the owner of a graphic design company who needed help recovering from a blunder. The company owner had alienated his clients by hosting a "by invitation only" party at an out-of-the-way restaurant and bar. The problem was that when his clients arrived they found that it was not an "open bar," as they had expected; they had to pay for their

drinks themselves; the design company was providing only snacks. Many people at the party felt cheated and thought that the party the designer had thrown was tacky.

The company owner hired me as a consultant to "smooth over" his mistake. I made calls to the creative people I knew who had been at the party. Most comments were, as expected, negative. The company owner needed to dig himself out of the hole he had created and get on the good side of these people again.

Our objective was to get these clients to call the designer and start a dialogue. Then the designer could "schmooze" and ask about the possibility of future work. But what would get them to call him? When we looked at his invitation list, we saw it was 99 percent women. I asked the company owner to research the cost of a single red rose in a bud vase, to be delivered by hand with an attached note card that he would create. Valentine's Day was four weeks away, so there was time to tie in this promotion with the upcoming holiday. He sent out 100 vases, each with a rose, at a cost of $5 each. The promotion's total cost was $600, including delivery charges.

The responses, which came almost immediately, consisted of many thank-you calls. The recipients were flattered to receive the rose in the vase; they found it a very thoughtful gesture. The designer made the most of these calls. He asked for portfolio drop-offs and got many appointments for buyers to look at his book. This gesture even landed him a few assignments with clients he hadn't worked for in the past. Most important, it helped reposition his company as the nice guys who sent out roses, rather than cheapskates who made people buy their own drinks.

Len Rothman's food photography is always well styled—a key element in creating a successful still life or food image.
LEN ROTHMAN

Each promotion serves its own purpose, and you should understand what you are trying to accomplish with each one. Design all your promotions to position you and your work as unique.

7. Get and Keep House Accounts

To be hired a second time, a photographer must do a very good if not an excellent job the first time around. First, a quick review of what that means.

- Listening carefully to and creatively communicating with the client and other key people (and personalities) on an assignment.
- Doing the shoot professionally, with all equipment and support personnel in place and functioning well.
- Producing high-quality images that perfectly fit the client's needs.
- Following up to make sure the client is happy and to see if there is anything else you can do to help.

Photographers who deliver this kind of professional performance are likely to be asked to do repeat assignments, and sometimes a close relationship develops in which the client regularly calls on a photographer to do work the client knows he or she will do well. Photographers call these clients house accounts.

The benefits of a house account are many: The relationship is established, so the people involved probably get along well; the client trusts you, and you know what the client wants. The work and the income are steady. However, as with most things in life, there are also downsides: Keeping a house account may require you to turn down other assignments if they would jeopardize your work with the house account, in terms of scheduling, conflict of interest, or some other factor. And because house accounts often depend on personal relationships, when your key client contact leaves the company the house account relationship may be over.

A beautiful landscape created by Lonna Tucker can be used in editorial, advertising, and fine art markets.
LONNA TUCKER

Since a house account means steady work, perhaps for several years, it is something that many photographers value highly. And having one or more strong house accounts can function as a marketing tool. What better recommendation to give a prospective client than that you work regularly for someone else?

8. Work Successfully with Younger Art Directors

Successful corporate photographer Gary Gladstone has been shooting for many years. His solid client base consisted mainly of design firms that hire photographers for the annual reports they produce. He told me that "his buddies," the designers he had worked with over the years, were no longer calling. He showed me his portfolio, and it looked just right for the work he was going after, so I asked him to do some research—to call up a few of his accounts and ask them a series of questions about who they are hiring to shoot and why.

What Gary found out was that "his buddies" had moved up the ladder. They were not doing the designing anymore, nor were they hiring the photographers. The younger designers—newly hired people who were generally under thirty—were now responsible for that. The older guys were attending client meetings and were not as involved with the actual shoots. Gary has since done his research and amended his client list, which now shows the names of the creative people who are currently assigning work.

Many newly hired creative people are learning on the job. Since they are strong conceptually—they know what they want in an ad or a report and thus in a photograph—clients are buying their ideas. However, they lack on-the-job experience and thus welcome and value the knowledge and problem-solving ability a seasoned photographer brings to a project. If you emphasize your experience, and show them how it can help, they will rely on your input.

In general, because young art directors are new to their careers, they are willing and eager to see portfolios, either in person or by way of a drop-off. They understand the importance of knowing the talent available to them.

When it comes to finding photographers to shoot assignment work, the most popular places for younger art directors to look for talent are *Communication Arts* magazine, *Archive* magazine, and trade magazine award annuals. Younger art directors also use the Web as a major source for finding stock images. And they keep files of direct-mail promotion pieces and constantly use them as sources for new talent.

When approaching younger art directors for photo assignments, it helps to know as much as possible about their buying and researching habits. As with any potential client, each will have a characteristic approach. Take each person individually. Develop a solid relationship with each individual art director, and you will be on your way to cultivating a loyal client base.

9. Make Your Holiday Gifts Effective

To give or not to give? I called a series of art directors and art buyers across the country and asked them about their favorite (and least favorite) Hanukkah and Christmas holiday gifts and cards. The consensus: They love getting them! "It's fun to get something unexpected, especially if it's packaged well," said one Chicago art buyer. It's important to go about your gift-giving in the right way, though.

A print of work you've done for a client is usually welcome, because the client will have some special connection with it. Most clients prefer small prints, for the practical reason that they don't have room to display big prints and posters, which then become a kind of nuisance.

For high-billing clients, a substantial gift is appropriate. Some ideas: A well-made scarf or other accessory, a half-day at a spa, a gift certificate from a department store, or if you know the client well and understand his

hobbies and interests, a certificate to a specialty store. But these are only appropriate if you have a strong relationship with the client.

Don't overdo it with mid-level clients. Wine is popular, but one buyer told me she hates it when someone sends her a case: "It's a month before I get all the bottles home." A basket of fruit is nice, but don't send too much, as it goes bad fast. Some photographers send clients "a night at the movies"; a clever way to do this is to place the coupon packet, surrounded by candy, in a large popcorn cup.

For buyers who are almost (but not quite) clients or for people you have worked with in a small way but do not yet know personally, keep your gift generic and not expensive. You might send a toy: a disposable camera with prepaid developing, or an Etch-a-Sketch (one photographer said she had a great response after sending this fun gift: "Clients loved it and even made a Xerox of their Etch-a-Sketch artwork to send me!"). Another nice idea is a magnet with one of your best images.

Don't bother getting a gift for someone you have not worked with—a card will suffice. Many people say they like receiving cards, especially when they focus more on holiday cheer than promotion. "It's how I decorate my office for the holidays," one art director told me. "I get more cards at work than I do from friends and family." One art buyer mentioned that he was glad to receive a card from a photographer whose book he had called in many times, even though the photographer had never made the final cut. The buyer told me he likes the acknowledgment of the time they have spent in the hopes of working together in the future

Donating to charities. Although fruit, wine, and toys are all acceptable holiday favors, a gift to charity is thoughtful and caring, and it makes you feel good, too. Such donations, a favorite type of gift among professionals, are always in good taste. If possible and appropriate, choose a charity that relates to an assignment you've done for a client—a gift to the National Wildlife Foundation, for instance, if you've shot a story on endangered polar bears for a magazine.

One year we made our donation to the Children's Aid Society. A week after the acknowledgment cards went out, one of our clients called to say she had received the card and was very touched. Her nephew was helped by the organization. That made me feel great. In fact, the largest number of thank-you calls have been in response to donations to charity.

You can choose local or national programs. In New York, for example, there's God's Love We Deliver, which delivers food to

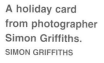

A holiday card from photographer Simon Griffiths.
SIMON GRIFFITHS

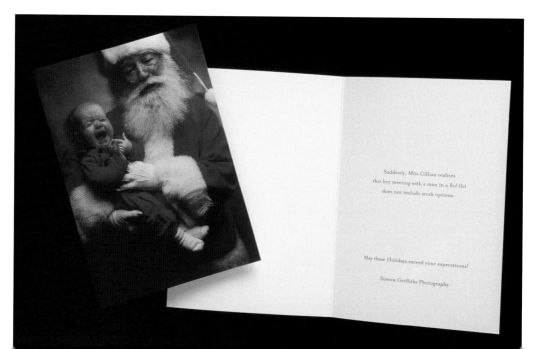

home-restricted individuals, or the Fresh Air Fund, which provides the city's neediest children with free summer vacations away from the urban streets. Many localities have Meals on Wheels programs. And there are thousands of national organizations—like environmental groups, the Make a Wish Foundation, Big Brothers Big Sisters, and the American Heart Association, to name just a few—whose good work improves the quality of life for millions of individuals and helps conserve the planet's resources.

If you're interested in this gift-giving option, several websites make it easy for you to do research. The BBB Wise Giving Alliance, affiliated with the Council of Better Business Bureaus, distributes information on hundreds of nonprofit organizations. On its site—www.give.org—go to Information for Donors and Reports on Charitable Organizations for alphabetic listings of organizations, including descriptions of their programs. Philanthropic Research, Inc., operates www.guidestar.org; once you're on the site, go to Donor Resources, where you can search by category or by city and state for information about the operations and finances of a variety of nonprofit organizations. The American Institute of Philanthropy allows prospective donors who visit its site—www.charitywatch.org—to peruse a list of top-rated charities (those that put 75 percent or more of contributions toward program costs).

For Hanukkah and Christmas holiday gifts, do your research in the early fall—no later than October 1, since some organizations require a substantial lead time. When you call to make arrangements, you should get answers to the following questions:

- Is there a minimum donation?
- What is the payment method?
- Who does the mailing? Many organizations do it themselves, with a nice message on a holiday-style card. In other cases, you must do the mailing.
- What kind of cards do they send, with what kind of greeting? Some may ask for wording from you. Others have a standard message, along the lines of:

One of Sean Justice's promotional cards.
SEAN JUSTICE

"A generous donation has been made on your behalf from John Smith Studio."
- What about timing? When do you need to make the donation and send your mailing list? Some organizations require a long lead time.

Once Hanukkah and Christmas are over and the New Year has arrived, you can call, e-mail, or send a card to each client you've worked with over the past twelve months—with a "Happy New Year" greeting. Tell them you are looking forward to working with them in the new year (hint, hint!).

10. Work with Students and Interns

A few years ago, my husband asked me what I'd like to add to my business. I answered, "How about a young person who can run errands and help with paperwork, and whom I do not have to pay?" Two weeks later a friend who is a photography professor at Drexel University, in Philadelphia, called and asked if I would like to hire a student intern, something I had never done before. He explained that his students need practical,

on-the-job experience. As long as all their responsibilities evolve around the industry—no picking up the dry-cleaning!—serving as an intern helps them get a feel for how things work in the creative and the practical parts of the photography business.

Since then I've worked with interns—motivated students of photography, business, design, or marketing—who work on a short-term basis (several months or more) for a low hourly rate or for free, in exchange for real-world, hands-on experience and on-the-job training, and perhaps some small compensation and college credits.

Call colleges and universities in your area to find those that have intern programs, or contact your alma mater or other schools with photography or design programs. Ask to speak to the career services department or the person in charge of the internship program. If there are many big corporations in your area and the schools you call are well known, your initial inquiries may not get

This image is a well-produced shot by Hoachlander Davis. Every detail was perfectly composed, down to the positioning of the moon.
HOACHLANDER DAVIS PHOTOGRAPHY

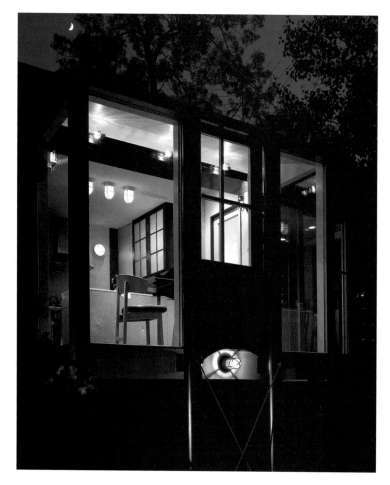

much response. Keep trying, and be sure to let the school know the value the student will gain from working with you and your studio. If you strike out with your first-choice schools, try calling smaller colleges and community colleges. You can also put up help-wanted notices through the university career-placement center, and place small ads in college and local newspapers.

Like most people who take advantage of this form of labor, I do not pay my interns—though, in fact, it actually does cost me, in both time and money, to train them. However, working for professionals is of definite value to students. Where else are they going to learn the basics of a business and how it feels to work in it? Another benefit: Interning is often a springboard that launches a young person's career. My interns have usually worked in my office for six months, then moved on to other jobs in our industry. My last intern now works at the ad agency Ogilvy & Mather in New York as an art buyer. The previous one is an account manager at an agency in Pennsylvania. Two other former interns are art directors at New York agencies.

One professor at Drexel University told me, "In many cases, our students establish relationships during their internships that last a lifetime. The ability to make a phone call to a person in the industry and have that call taken has value that cannot be measured in dollars. I try to teach my students that their ability to succeed in this business will often come down to the networking they began during their college years."

It's very important to be realistic in your expectations about the amount and level of work an intern can do and the amount of training he or she may need. Colleges and universities do not prepare students for the real world, and students generally know little about budgets, marketing and business plans, the needs of clients, or even how to fill out a Federal Express form. Interns are novices and often little more than, literally, helping hands. However, while they don't have the benefit of experience, my interns have always helped

me keep current with trends and lingo, and their points of view are consistently refreshing and interesting. And occasionally you may employ an intern you value so much that you hire him as a regular employee.

Making it work requires planning. The school's internship program generally sets ground rules, such as the type of work that qualifies for the program, the minimum and maximum number of hours students can work, the minimum salary or stipend (if any) employers must pay an intern, and any reports the employer needs to provide for the intern to get college credit. Some programs require that you pay an intern, though often payment can be in the form of travel expenses, lunch money, housing, school or photographic supplies, or some other non-monetary arrangement. Many interns work during the summer, but some students intern during the semester and combine their work with their class schedule.

It's up to you to clearly define the tasks you expect an intern to perform, to state the skills or course work the student needs to have, and to determine how you will train and supervise the intern. In terms of scheduling, you'll have to conform with the student's needs to be in class.

Here's a list of possible responsibilities for an intern in a photography studio or office:
- Copying, faxing, and filing
- Buying supplies for the studio or office, or for a specific shoot

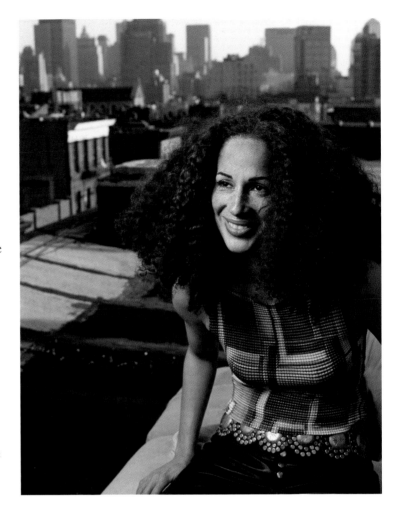

Denise Chastain scouts and selects models for each test photo shoot. Testing and casting are important elements in creating successful images for your portfolio.
DENISE CHASTAIN

- Researching clients for promotions and creating client databases
- Entering data into the computer
- Answering phone calls
- Internet research
- Running film
- Cutting and contacting film
- Dropping off and picking up portfolios
- Running errands—dropping off film at labs or prints to clients, picking up or sending mail, picking up lunch
- Cleaning—clearing out garbage, washing dishes, cleaning the office space or darkroom
- Painting backdrops
- Stuffing and labeling envelopes, and taking mailings to the post office
- Preparing Fed Ex send-outs—assembling and packing materials, filling out forms, dropping off the package
- Making deposits at the bank
- Loading and unloading equipment

DO . . .
- Make sure your portfolio showcases your strongest photographs.
- Turn stressful situations to your advantage.
- Choose holiday gifts and cards wisely.

DON'T . . .
- Always interpret a client's message literally. Look for the real meaning.
- Hang up when an art buyer doesn't answer the phone. Leave a voice-mail message.
- Send your portfolio without first calling the prospective client.

Stay
Successful

Spotting Trends

Throughout this book I've discussed how to come up with a strong identity for yourself as a photographer and how to present your unique identity to clients. You'd better accept the fact right now that you'll never stop doing this. These efforts constitute a lifetime project, and throughout your career it is necessary to make sure your images remain relevant to the markets in which you work and to continue to promote yourself.

It's easy to keep up with trends in the photography business—if you know where to look. For starters, read the industry magazines. *Photo District News* reports on changes in stock agencies, where clients are going, who is shooting what ad campaign, who has won what awards, and business and legal trends. The magazine looks at photographers who are doing interesting work, have provocative projects, and are pushing trends in a new direction, and also reports on magazines and agencies looking for photographers.

Remain informed about the trends, but have something fresh to say.

Some other magazines that look at industry news are *Communication Arts,* a good place to see the kind of photography that advertising agencies and other creative outlets are using and how they are using it, and *How,* which showcases the best work in the advertising and editorial industries. You should also make a point of looking at edgy magazines like *Flaunt, Big, Tank, Spoon, Index, ID,* and *Black Book.*

You're looking for more than news, though. You should also be looking at magazines, and not just industry publications, to spot trends—that is, the styles, the types of shots, the themes, the looks that are appearing in commercial photographs. You'd be surprised at how much these trends influence the photography marketplace.

For instance, a lot of creative people look at hip magazines to see what sort of trends are coming up and who's creating them. They like what they see in these edgier magazines, and pretty soon the same look, toned down a bit, begins to appear in publications and advertisements that are more mainstream.

You don't have to buy dozens of magazines—just go to a newsstand and browse, and buy a few of the magazines that seem most interesting to you. When you flip through a magazine, think about what looks really powerful. This is a good way to become aware of your own sense of aesthetics.

See how the layouts are designed—the use of color, shape, and type, and how images are placed. See how the magazine uses photography. Notice how the type goes with the imagery and how the elements on the page play off one another. Ask yourself what went into the design decisions—why did they use a particular color, what feeling are they going for in the placement of shapes, what emotions or ideas are they trying to convey with the design?

There are a lot of other places to spot trends in photography, too. Consider the following sources.

Ads in industry sourcebooks. Photographers pay a lot to show off their work in these books, so chances are they are going to make sure they choose an image that's currently hot and effective—that is, one art buyers are going to find desirable. When you flip through one of these books, you'll see some of the most successful photography out there.

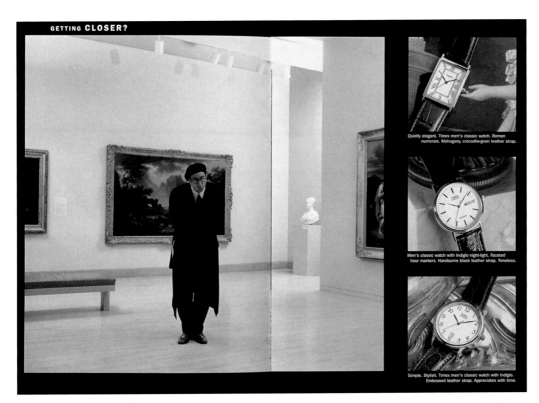

GETTING **CLOSER?**

Quietly elegant. Timex men's classic watch. Roman numerals. Mahogany, crocodile-grain leather strap.

Men's classic watch with Indiglo night-light. Faceted hour markers. Handsome black leather strap. Timeless.

Simple. Stylish. Timex men's classic watch with Indiglo. Embossed leather strap. Appreciates with time.

Photographers can show many different styles of photographs in the same portfolio and even on the same spread, as long as the images are related thematically. I like these ads that show, on the right, three still lifes of watches. In the ad below, a woman is waiting for a train; since the scene includes a clock, the images work well together conceptually.
TIMEX—GEOF KERN
(FRIEND AND JOHNSON)

IS IT **HERE?**

Be punctual. Be fashionable. Roman numerals. Elegant black leather strap. Classic design.

Arabic numerals. Mineral glass crystal. Distinctive brown leather strap. May be just what you're missing.

Comfortably chic. Arabic numerals. Push crown activates Indiglo night-light. Tan, crocodile-grain leather strap.

Industry websites. For example, on *PDN* online (www.pdn-pixs.com) you can see current work, current trends, and new techniques; it's a great place to see what is going on in the industry—stock photography, legal issues, current exhibits, contests, and current advertisements.

Direct-mail and department store catalogs. Ideas are probably arriving in your mailbox every day. Remember, though, that direct mail tends to be mainstream to reach a wide audience, so these usually aren't the best sources for seeing the cutting edge. Even so, direct-mail and catalog pieces will give you

an idea of the setups, lighting, angles, and other technical aspects, as well as the overall look, that companies are looking for.

Fashion ads and fashion shows. Fashion designers spend millions of dollars a year on advertising, and out of those big budgets come some of the most intriguing photography you're going to see. Some of the European fashion magazines use the most interesting photography, in both editorial coverage and in advertising.

Department store displays. You see these huge, splashy backlit photos all the time, often in the cosmetic departments and expensive clothing sections of big department stores. Take a careful look at these displays, because companies often pay hundreds of thousands of dollars for them and, at that price, go to a lot of effort to make sure they use innovative photography that's likely to catch the eye.

Billboards. Have you been in Times Square lately? The displays just seem to get bigger and flashier. Again, companies spend huge amounts of money to be there, and they often use photography that makes a statement. And you don't have to be in New York to see big outdoor displays. Photography is being used in creative ways on billboards all over the country. Since roadside billboards are meant to catch the eye as viewers whiz by, they can be amazingly clever.

Museum photography shows and photo catalogs. More and more museums are mounting photography shows, and photographers should never to miss a chance to see one. These shows often showcase the work of the best photographers currently working, or historically important photographers, and sometimes they feature new, cutting-edge styles as well. Larger museums often print catalogs of these shows.

Books. Aperture and other publishing companies regularly produce books of photographic work. Next time you're in a bookstore, take a look at the photo collections. You'll probably encounter exciting work by photographers whose works you haven't seen before.

Films. When you read reviews, keep an eye out for special mentions of photography and cinematography. Many recent, commercially successful films have gotten special notice for their photographic effects. As you've probably noticed, even a bad film can be brilliant from a photographic standpoint. The photography in old classics, like Bergman and Fellini films, can also be inspiring.

So what do you do with all this inspiration? One thing you won't want to do as a good photographer is to buy into each passing trend hook, line, and sinker. When you've been in the business a while, you've seen the trends come and go. I had to laugh when Holly Hughes of *Photo District News* told me, "Sometimes I loathe the trends I see." She mentioned the unhappy waif look that was popular in fashion photography a while back. "I would look at portfolio after portfolio of fashion work and think, 'If I see one more unhappy girl with dirty knees sitting on a hallway floor with her legs spread out, I am going to start throwing portfolios out the window.'"

Holly's comment brings up a good point: Don't simply copy what you see and like. In fact, the results of going out and shooting subjects you don't care about in ways you don't like, just because they seem to be big at the moment, can be disastrous. "Don't be a lemming," says Lewis Blackwell, Vice-President, Creative Director, Getty Images. "Be an individual who can contribute something fresh." Try to learn from whatever is relevant and then move on beyond that point to a new synthesis of visual thought, to a new image. That is, remain informed about the trends, but have something fresh to say rather than just regurgitate what somebody has already done. Believe me: The result will be much more interesting than something you've just copied.

How to Turn Disappointment into a Positive Lesson

An art buyer from an agency in San Francisco once contacted me to send a portfolio of one of the photographers I represent. Happy to get the phone call, I responded immediately. I waited an appropriate amount of time, then did a follow-up call. The art buyer told me that the art director loved my photographer's book. She said, "You are our first choice for this job." The agency faxed layouts, and my photographer was immediately on the phone with the art director discussing some well-received suggestions about producing the job.

The next day, the art buyer told me how much the art director enjoyed talking to my photographer, and she confirmed that we were, in her words, "the number one pick for the job." She discussed shoot dates with me, and we faxed our estimate to the agency. The next morning I had a message on my machine saying that the estimate looked good; the art buyer told me she would be calling to give me the "go ahead" by lunchtime.

She called at lunchtime, but the conversation did not go as I expected. The art buyer informed me that another photographer was bidding the job. "Our client wants a backup in case your photographer gets sick," she said. I told her that in the twenty years I had been representing this photographer, he had never missed a shoot due to illness. She assured me that the second bid "was just a precaution." The following morning, though, the art buyer called to tell me that the other photographer got the job. "It had nothing to do with price," she assured me, then told me that the other

photographer was the client's first choice and the art director bowed to the client's decision.

Even though I understand that I can't get every job I bid on, there are times when I feel certain I am getting the job as the process of estimating is unfolding. Of course,

James Davis investigated many options before coming up with this casual-looking typeface. It works perfectly with his images. James Davis's card (above) folds out into six panels made from shoot outtakes to tell a story.
JAMES DAVIS

this is a fairly dramatic example. I was led to believe that we were the number one choice throughout the bidding. Was this wishful thinking? No. The art buyer said it was our job. More often, we pick up on subtle vibes from clients. It doesn't matter—disappointment is disappointment, and the best thing you can do is learn from the experience. We do not always have control over our client's decisions, but we do have control over what we choose to take away from a disappointing experience.

- *Think over the situation, looking at it from the client's perspective.* When I got over my anger and disappointment and thought about the situation above, I realized the art buyer did what she needed to do. She went with the photographer that her client and art director wanted to use, and as part of a team, she was right in giving them what they wanted.

- *Try to determine what went wrong.* In the example above, nothing "went wrong"; the client simply wanted to work with a different photographer. But things do sometimes go wrong. Looking back on situations, you might realize that you should have shown different work or been more flexible with price and dates. Perhaps you weren't accommodating enough. Did you come across as professionally as you should have?

- *What was good about the way you acted?* Think about the good points. Take pride in the fact that you were approached in the first place, that an art buyer liked your book, that you made it to the final running. Yes, I'm talking about the old adage—"Look at the bright side." But if you realize that you sent in a good portfolio, were professional in your interactions, bid fairly on the job, and showed a willingness to be flexible, you've made great strides in realizing how to act like a photographer whom clients are going to take seriously.

- *What could you have done differently?* Be hard on yourself here and review the situation realistically. Did your portfolio look as good as it could? Were you professional in the way you handled follow-up calls?

Did you bid the job carefully? Don't be afraid to face up to your failings here, because by recognizing them and acting on them you'll make yourself a stronger candidate for the next job.

- *How would you handle a similar situation in the future?* This is a useful exercise. How many times in life have you said, "If only I had . . ." Here's a chance to put those wishes into action. Make a list of what you could have done differently. This might be a good time to use the questionnaire I discuss on page 150 in "Keeping the Big Picture in Focus."

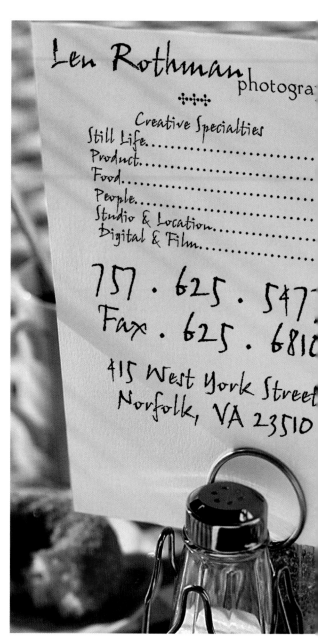

Len Rothman's business card.
LEN ROTHMAN

What to Do When Business Is Slow

Did you ever pick up your phone to make sure that there was a dial tone? You know that you paid your phone bill and that your phone is plugged into the wall, so why is it not making any sound? It is very painful for all of us when the phone does not ring. We have all, at one time or another, experienced a slow period. However long such a period lasts, at some point the phone rings and the business starts up again. It is important to make the most of the quiet times. These are precious moments, and they should not be wasted.

I keep a list next to my desk of things that need to be done when business is slow. Accomplishing some of these goals can greatly improve your business in the long run. That, of course, depends on your list. Hopefully it will include some of these suggestions:

- *Shoot new images for your portfolio.* You always need new images for your book. Many photographers tell me that they "have been meaning to shoot some new shots" but never find the time. Well, if business is slow, you have the time. Call some model agents for head shots—a great face may inspire you; in this kind of testing, the talent models for you and in return you supply them with prints for their book. Or, drive to that beautiful spot you pass so often, or load your camera and take a walk. You'll come up with some new shots.
- *Consider new ways to showcase your work in your portfolio.* Work with a designer or use your own creative sense to create layouts. For example, maybe you should try to combine lifestyle and still life photography. Especially if you are a generalist, try to come up with ways to show particular things you are good at. Try to regroup your portfolio images, finding shots that work well together, perhaps by telling a story. If you're working digitally, try changing colors within images or cropping photographs to make them work together.
- *Plan your next series of promotion cards.* Choose or shoot a series of images for your direct-mail campaign. Set up a meeting with your designer, or research and interview designers to work with. Spend time looking at their portfolios.
- *Call your house accounts or drop them a note or an e-mail to say hello.* In fact, do this with all your clients with whom you have a good relationship. You have the time to call or write, so why not check in? You are not necessarily asking for work—you are keeping in touch. This will help you feel more "connected" to the outside world.

> *It is important to make the most of the quiet times. These are precious moments, and they should not be wasted.*

- *Send work to stock houses.* In chapter 8 I discussed how selling images through stock houses can be a minor source of income for photographers. If you are established with one or more stock houses and have time on your hands, submit images from your most recent work. If you haven't yet started working with a stock house, get in touch with one now.
- *Have lunch with other photographers.* My photographer Jack Reznicki says he never has enough time to schmooze with his photo pals, and when he does, he always comes back inspired. In fact, you might want to look into professional photography

organizations. It is important to maintain productive affiliations with other photographers. Some of them may be your competition, but you'll find that a good relationship with other photographers can be supportive.

If you manage your time properly, your business can be always moving forward, whether the phone is ringing or not.

BELOW AND OPPOSITE:
Sean Justice sends out new cards frequently to give his business a fresh look.
SEAN JUSTICE

- *Set up meetings with sourcebook reps.* If you are not in a sourcebook and you are considering the investment, now may be a good time to educate yourself. You will feel less pressure to make a decision if you can compare directories when there is no deadline looming over you.
- *Plan, or shoot, for your sourcebook page.* Send some images to your designer to play around with.
- *Go to a bookstore.* Look through the magazine and photography sections. You might be inspired by the photographs you see in publications. Write down some of the photo editor's names and add them to your mailing list.
- *Send out your portfolio!* It doesn't do you or your business any good to have it sitting in your studio.

The message here is, there is no such thing as "slow time." If you manage your time properly, your business can always be moving forward, whether the phone is ringing or not.

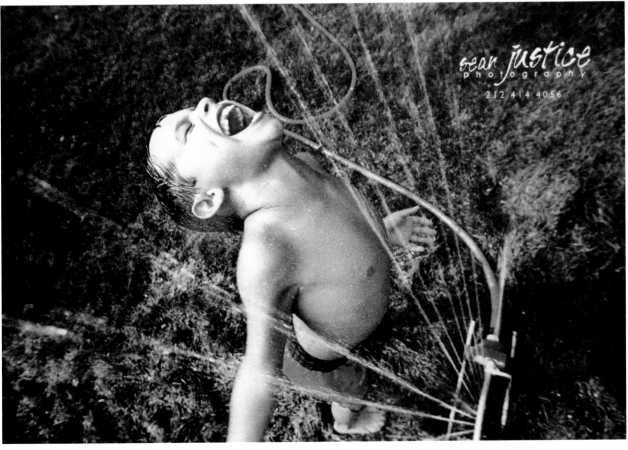

Keeping the Big Picture in Focus

This questionnaire should help you evaluate your business. Rate your performance on your promotions, portfolios, presentations, and follow-up procedures.

1 Promotions: I am doing promotions . . .
- ❏ monthly.
- ❏ quarterly.
- ❏ semi-annually.
- ❏ annually.
- ❏ still trying to figure out which images to use.

For inspiration: See chapter 6, "Promote Yourself with Mailings"—not just the section on scheduling, but also the sections on types of mailings and mailing lists.

2 Images: The images in my portfolio . . .
- ❏ are a good indication of the assignments that I want to be shooting.
- ❏ are in the process of being updated.
- ❏ are fine.
- ❏ should be better than they are.
- ❏ were created more than five years ago.

For inspiration: See chapter 2: Focus Your Image, especially the section "Editing Your Images," and chapter 4: Structure Your Portfolio.

3 Presentations: My portfolio . . .
- ❏ looks great, I'm really proud of it!
- ❏ is in the process of being updated.
- ❏ is fine.
- ❏ should be better than it is.

For inspiration: See chapter 4: Structure Your Portfolio, especially the sections on selecting, shooting, and presenting images.

4 Response: The response to my portfolio is . . .
- ❏ very positive, I am booking jobs.
- ❏ very positive, but I am not asked to bid on jobs.
- ❏ not what I would like it to be.

For inspiration: See chapter 7: Make the Most of Portfolio Reviews.

5 Follow-up: My follow-up procedure . . .
- ❏ is working well for me.
- ❏ brings me useful information, but I'm not sure what to do with it.
- ❏ makes me feel uncomfortable.
- ❏ is not established at this point.
- ❏ is a lesson in procrastination.

For inspiration: See chapter 9: Ten Ways to Make Your Marketing More Effective—look especially at "Follow up and Support Your Mailings," but also at "Understand the Language of Clients" and "Turn Stressful Situations to Your Advantage."

6 Conclusions:
- ❏ I am very satisfied with my business.
- ❏ I need motivation.

For inspiration: See chapter 1, "Define Your Goals." That's right—go back to the beginning and think about your career as a photographer!

sean justice
p h o t o g r a p h y
212 414 4056

Another sample of a promotional card by Sean Justice.
SEAN JUSTICE

ART DIRECTORS LOVE IT WHEN A PHOTOGRAPHER . . .
- is organized and runs the business efficiently and professionally.
- is easy going and has a sense of humor.
- keeps things flowing (the meter is always running).
- shows interest in the job.
- makes sure every detail of a shoot is covered and the shoot runs smoothly.
- shows enterprise and goes beyond what's expected to come up with a visual solution that's original.
- becomes part of a creative team.

ART DIRECTORS HATE IT WHEN A PHOTOGRAPHER . . .
- has an attitude.
- is disorganized.
- shows little interest in the job, as mundane as it may be.
- doesn't offer creative input.
- has a messy studio.
- is pushy, too persistent, or otherwise overaggressive.
- gives a reason a picture won't work before the picture has been made.
- doesn't take criticism well.
- doesn't listen.

Terms and Titles Used in the Business of Photography

ACCOUNT EXECUTIVE OR MANAGER At an advertising agency, person who directs and coordinates day-to-day efforts on behalf of a client's product or service; sees that the agency provides sound and responsible marketing counseling and planning and proper execution of work.

ACCOUNTS PAYABLE Department of a company that pays the bills; the people to call when looking for payment of an invoice (be sure to have on hand the invoice number, job or purchase number, amount of the invoice, and the date of the invoice).

ADVERTORIAL Special advertising section of a magazine or newspaper designed to fit the editorial look of the publication and appeal to its readership; includes more consumer information than an advertisement and requires a disclaimer identifying it as advertising.

AGENT Person who acts as an agent for a photographer, illustrator, model, studio, retoucher, etc. Also known as a representative.

ALL REPRODUCTION RIGHTS Refers to permission to use an image while the copyright remains with the creator. Securing all reproduction rights gives the client the widest range of rights. All reproduction rights can be limited by time or geographic scope, but specific terms should be noted on the purchase order.

ANIMAL HANDLER Individual who supplies and works with animals at photo shoots.

ANIMATICS Test TV commercials based on storyboards, with frames of illustrations or photographs filmed in stop-motion and other camera techniques, accompanied by the audio script. A minimum of movable action is sometimes employed—for example, one arm or leg may move.

ART BUYER/ART PRODUCER In an advertising agency, expert responsible for the purchasing and assigning of photography, illustration, and stock photos for use in print ads; secures required legal documents and is familiar with copyright and other laws affecting the acquisition of print advertising materials; can report to the head of print services or the creative director, or directly to management; cooperates closely with account management, creative, and print production.

ART DIRECTOR In an advertising agency, a book or magazine, or a design firm, person responsible for the conception, design, and execution of innovative visual materials; may supervise others and have client contact.

ASSIGNMENT OF RIGHTS The sale, gift, or trade of copyright; an exclusive license giving the legal right to reproduce, sell, distribute, or publish a creative work. It is possible to sell the copyright and retain the original artwork. Transfer of copyright must be in writing and signed by the copyrights owner(s). Also known as transfer of copyright ownership.

BABY WRANGLER Expert in handling children and infants.

BIDDING Submitting an estimate for the fee that a client will pay for a job. Often bids are broken down into component parts to which dollar amounts are assigned.

BLEED Advertisement in which part or all of the illustration or copy runs completely to the edge of the magazine.

BOUND-IN INSERT Multiple-page advertisement that is printed separately and then incorporated into the magazine's binding.

BROCHURE Booklet or pamphlet announcing or explaining a specific product, service, organization, etc.

BUYOUT Ambiguous term that often implies unlimited use rights.

CANCELLATION Withdrawal of an assignment.

CASTING Process of taping or photographing for the selection of talent to be used in advertising.

CENTRAL AMERICA Belize, Costa Rica, El Salvador, Guatemala, Honduras, Nicaragua, and Panama.

CHROME (SHORT FOR KODACHROME OR EKTACHROME) Positive film on which an

image is viewed when light is passed through it; a slide. Also known as a transparency.

CLIENT Company that an ad agency or a creative person works for.

CLIENT DIRECT Term used when an artist or photographer works for a client directly, without the participation of an advertising agency or design firm.

CLIP ART Illustrative material available at low or no cost.

COLD CALL Calling someone you don't know and asking them for work or a portfolio review.

COLLATERAL Printed material displayed in retail establishments, such as display cards, shelf hangers, signs, leaflets, shopping cart posters, catalogs, and brochures. Also known as point-of-sale materials.

COMP (SHORT FOR COMPREHENSIVE) Layout of an ad designed for internal or client presentation or demonstration purposes, to give the effect of the finished ad.

CONFIRMATION FORM Document verifying agreement on details of information previously discussed.

COPYRIGHT Exclusive legal right to reproduce, sell, distribute, and publish a creative work. See also reproduction rights.

COPY WRITER Writer responsible for translating concepts into finished copy for print, television, radio, and collateral material, usually under supervision; works as part of an account team to achieve the client's objectives through

creative imagery and effective message strategies.

CORPORATE PHOTOGRAPHY Photography usually done directly for a company to enhance public awareness of the company—for example, in annual reports, newsletters, and other company publications.

COST CONTROL Refers to the review of bids and resulting recommendation of changes in proposed fees and expenses for a project.

CREATIVE DIRECTOR Within a advertising agency, person who oversees the art director, designers, and copy writers.

CREDIT LINE Photographer's name when it appears in conjunction with his or her work.

DAY RATE Fee paid for services rendered on a daily basis.

DELIVERY MEMO Document that itemizes materials received.

DIRECT-MAIL OR DIRECT-RESPONSE MATERIALS Advertising material that is mailed directly to potential consumers at their homes or offices; for example, leaflets, catalogs, and brochures.

DISTRIBUTION RIGHTS Limitations placed on the use of photos or artwork based on the time and geographical scope of their use; generally used in reference to collateral pieces and direct-mail materials.

DOMESTIC USAGE The right to use photos or art in the United States, its possessions, commonwealths, territories, and nondomestic military installations. Also known as

national usage and United States rights.

DUMMY Assembly of blank pages with exact indications for placement of type and visuals; a dummy is made to the precise size and proportion of the projected finished piece.

ELECTRONIC ADVERTISING Advertising transmitted over the Internet, websites, CD-ROMs, or other electronic devices.

ESTIMATE (AGENCY TO CLIENT) Detailed listing of the costs to be incurred for all components of a project, submitted to a client before the start of a project for preliminary approval of costs.

ESTIMATE (SUPPLIER TO AGENCY) Written estimate from a supplier detailing the costs and fees for an assignment per specifications provided by the agency.

EXCLUSIVE LICENSE Sole right to all or part of a copyright; can be subject to specific conditions, such as time, media, and scope of use.

EXPERIMENTAL PHOTOGRAPHY Test photographs taken to determine the photogenic qualities of products or to test concepts.

FEE Amount of money paid to supplier—for example, a photographer, illustrator, or retoucher—in return for goods or services rendered.

FINISHED ART The final illustration, design, or photograph submitted for reproduction.

FORMAT Specific requirements for a printed piece—for example, size and cropping.

Also applies to film size—for example, 35mm, 4" × 5", 6" × 7", 8" × 10".

FREE-STANDING INSERT Material inserted but not bound into newspapers or magazines.

GRAPHIC DESIGNER Artist who creates logo designs, packaging, and other materials for the promotion of corporate brand identities or visuals using illustration, photography, typesetting, and hand lettering.

GRAPHICS Relating to the pictorial arts, such as design, drawing, lettering, engraving, etching, and digital imaging.

GUTTER The inner margins of two facing pages, as of a book or magazine.

HANG TAG Type of direct-response advertising.

HOUSE ACCOUNT Long-time client.

INDUSTRIAL PHOTOGRAPHY Photography produced for companies engaged in heavy industrial production, such as automobiles, trucks, steel, etc.

INTERACTIVE USE User-directed interactivity with advertising through electronic transmissions.

LAYOUT Art or process of arranging printed or graphic matter on a page; overall design of a page, spread, or book, including elements such as page and type size, typeface, and arrangement of titles and page numbers.

LICENSE Legal permission in writing to use artwork or photography under specific limitations.

LOCATION Site of a photography shoot other than a studio.

LOCATION FEE Agreed-upon fee paid for use of a specific site for the taking of a photograph.

LOCATION RELEASE Legal document that grants permission by an owner, or a person empowered to grant such permission, for the use of a specific property for advertising purposes.

LOCATION SCOUT Person hired to research and provide photographs of potential sites for photography shoots.

LOGO Symbol or graphic image created for a specific individual, company, or product; can be used alone or with a name for identification.

LOGOTYPE Two or more connected letters creating a symbol; serves to identify a company, product, individual, or publication.

MARKETING DIRECT Refers to promoting a photographer's work directly to a client rather than to an advertising agency or design firm.

MECHANICAL Final assembly or paste-up of type, photos, or artwork (digitally generated or manually assembled); used as a guide in assembling all elements of an advertisement. Also know as a keyline.

MEDIA Refers to the vehicle in which a photograph is used—print, television, collateral materials, etc.

MIDDLE EAST Bahrain, Cyprus, Iran, Iraq, Israel, Jordan, Kuwait, Lebanon, Oman, Qatar, Saudi Arabia, Syria, Turkey, United Arab Emirates, and Yemen.

MODEL RELEASE OR CONTRACT Document, issued by an advertising agency, that a model signs prior to a photo shoot; states agreed-upon fees and usage.

NATIONAL USAGE The right to use photos or art in the United States, its possessions, commonwealths, territories, and nondomestic military installations. Also known as domestic usage and United States rights.

NONEXCLUSIVE LICENSE The sale, gift, or trade of artwork to more than one party at the same time.

NORTH AMERICAN RIGHTS The right to use a photo and/or artwork in the United States and its possessions, commonwealths, territories, and nondomestic military installations, and in Canada and Mexico.

ONE-TIME RIGHTS The right to use photography or art one time only.

OUT-OF-HOME Print advertising that is not point-of-sale—for example, painted bulletins, 30-sheet posters, and transit and bus-shelter posters.

OUTTAKES Photographs taken during a photographic session but not selected for reproduction in an ad or commercial.

PACKAGING Artwork and design used on product containers.

PER DIEM (LATIN FOR "PER DAY") Daily expenses, usually on location; includes hotel, meals, and transportation.

PERMIT Legal document licensing used of a specific property.

PHOTO EDITOR On the staff of a magazine or book publisher, person who chooses photographs or photographers to support the editorial content in the publication; cooperates with a designer on positioning, cropping, and otherwise styling the photograph for publication.

PHOTOJOURNALISM Journalism in which news stories are presented through photographs; photography commissioned for inclusion in the editorial content of publications.

PHOTOMATICS Test TV commercials based on storyboards with frames of still photography filmed in stop-motion and accompanied by the audio script.

POINT-OF-SALE OR POINT-OF-PURCHASE (POP) MATERIALS Printed materials displayed in retail establishments, such as display cards, shelf hangers, signs, leaflets, shopping cart posters, catalogs, and brochures. Also known as collateral.

PORTFOLIO Samples of a photographer's work, designed and packaged with the intention of obtaining assignments.

POSTPONEMENT Rescheduling of a photo shoot.

PRESENTATION USE Concept development of materials for use in in-house or client presentation; presentation materials are not used in advertising to consumers.

PRODUCTION COORDINATOR Person who coordinates all

aspects of a photographic shoot; responsibilities may include arranging transportation, booking talent, styling (prop and /or wardrobe), and renting equipment.

PROMOTION RIGHTS Use of art or photography for publicity, public relations, and self-advertising.

PROOF Sample viewed prior to a production run for the purpose of making desired corrections.

PROPS Items, other than wardrobe, that are purchased or rented for use in photo shoots. May include camera-ready, color-corrected products made specifically for photo shoots, as well as custom-made items, also referred to as "models," that are created specifically for photo shoots.

PUBLICATION USE Includes use in newspapers, Sunday supplements, trade and consumer magazines, internal publications, and any material included as part of a publication, such as freestanding inserts and bound-in inserts.

PURCHASE ORDER Legal document authorizing work; should include all terms and conditions, complete description of the assignment, agreed fees and expenses, and usage; should be signed by both parties.

REFERENCE FILES Files of illustration and photography clippings from magazines, newspapers, and other creative reference sources. See also *scrap*.

REGIONAL ADVERTISEMENT Advertising limited to a specific geographical region.

REPRESENTATIVE Person who acts as an agent for a photographer, illustrator, model, studio, retoucher, etc. Also known as an agent.

REPRODUCTION RIGHTS Negotiated license to use art or photography. See also *copyright*.

RESEARCH USE Materials developed to determine consumer reaction to potential advertising.

RESHOOTING Retaking photographs when the original photography has been deemed unacceptable.

RETOUCHING Correcting or revising original artwork or photography by means of an artist's airbrush, computer, or other instrument.

REVISION Any change made to alter original work.

ROUGHS Loosely drawn layout ideas, done by an art director to represent an ad or storyboard; usually done in pencil, pen, or marker.

ROYALTY-FREE DISKS Disks containing illustrative material for which there is no license fee required; sometimes limited to specific media.

SALE OF ORIGINAL ARTWORK Transfer of art by its creator, owner, or other authorized party to another party. Rights to reproduce from the original are not automatically transferred unless specifically agreed to in writing by the creator.

SCRAP Clippings from newspapers, magazines, and other print sources used by art directors, artists, and illustrators for visual representation. See also *reference files*.

SELF-MAILER Cards (on card stock) or folded pieces of paper placed in the mail without an envelope.

SERVICE CHARGE Amount of money paid to a stock-photo house for research; a percentage added to a fee and paid to a photographer's agent for services rendered.

SHOOT Photographic production session.

SPEC (SHORT FOR SPECULATIVE) Work done in anticipation of future assignments.

STOCK PHOTOGRAPHY Existing photography or artwork that can be licensed for use as reference, in comps, in books or magazines, or in advertising.

STORYBOARDS For a proposed TV commercial, individual illustrations, or "frames," arranged in consecutive order to depict the important changes of scene and action. A corresponding audio script is written under each frame.

STYLIST Specialist employed to perform specific services required for photo shoots, such as hair, makeup, food, props, and wardrobe.

TEST ADVERTISEMENT Advertisement produced for use in a limited number of markets to test a concept or product for possible later expanded use.

TRAFFIC PERSON Follows established procedures to ensure accurate placement of a client's commercial advertising in various broadcast media—for example, network, syndication, cable, and spot; placement is determined by client-authorized media purchases.

TRANSFER OF COPYRIGHT OWNERSHIP The sale, gift, or trade of copyright; an exclusive license giving the legal right to reproduce, sell, distribute, or publish a creative work. It is possible to sell the copyright and retain the original artwork. Transfer of copyright must be in writing and signed by the copyrights owner(s). Also known as assignment of rights.

TRANSPARENCY Positive film on which an image is viewed when light is passed through it; a slide. Also known as a chrome.

TV USE Use of photography or art in a television

commercial requiring a separate negotiation with a photographer or other artist.

UNITED STATES RIGHTS The right to use photographs or art in the United States, its possessions, commonwealths, territories, and nondomestic military installations. Also known as national usage and domestic usage.

USAGE Refers to the time period, the area of distribution, the number of insertions, or the size of a print run in which a photograph is used.

VIGNETTE Art that fades or blends into the background so as to create a soft edge.

WEATHER DAY Rescheduling of a photo shoot due to the inability to work in inclement weather.

WORK FOR HIRE Term used to describe a written agreement between two parties—for example, employer and employee—in which the employer or client owns the copyright from the moment of inception of the work.

WORLDWIDE USE An unlimited geographic scope of use.

More on Finding and Using a Photographer's Agent or Representative

The information provided here expands upon the discussion at the end of chapter 5.

Expectations

Agents offer an array of services to photographers. There are reps who will send your book to agencies that they feel have the appropriate accounts for you. They will do follow-up calls and negotiating but not attend shoots or do billing. Other reps will not send out books unless a client calls one in, nor will they go on appointments; instead, they focus on direct mail and promotion. The other day I spoke to a New York City rep who does all the production for her photographers for shoots. (She bills separately for this.) Some reps negotiate, estimate and do the billing. There are some reps that prefer to "broker" jobs on a freelance basis. They get calls from clients for assignments and "farm them out" to photographer's that they have relationships with. Each job is done on an individual basis.

Selling a photographer's talent and negotiating are the most important aspects of having a rep. Evaluating your strengths and weaknesses may be the first step to deciding the type of rep you are looking for.

There are many other aspects of the photographer/rep relationship that must be considered. These include such things as the anticipated term of the association. Long term is best. While some assignments might be generated in the short-term—less than a year—photographers should be realistic about what can be accomplished. If a rep is interested in you, ask many questions about each other's expectations and obligations.

It is important to have realistic expectations of a rep. It's a good idea to make a list of the responsibilities you feel he or she should handle. This will help you have a clear plan for your business. Before you start your rep search be sure to have a clear idea of your style and a professional looking portfolio that supports the work you want. When you do find that perfect agent, work hard to make it a team effort. What are your expectations of a rep? You should be realistic about them and your capabilities. Make a list of those expectations and when you make contact with a rep and consistently refer to that list. Some of the items on your list might be:

- Does the rep have a client database?
- Does he or she have existing relationships in the places you want to find work?
- How often will potential clients see your book?
- How does the rep follow up a portfolio drop-off?
- Does he plan your marketing strategy?
- Is she responsible to organize your promotion?
- Who implements the promotion?
- Does the rep expect you to have a national media buy? (that is, source book or a magazine ad)
- Do they do the negotiating? (Never take anything for granted.)
- What does the rep expect of you?
- Does the rep handle billing for you?
- Does he or she read the purchase orders?
- Does the rep understand usage and rights as these relate to photographers?
- Is the rep involved in the local photographic and business communities?
- Is the rep involved in a network of other reps with whom they are on good terms?

I have always heard that a rep/photographer relationship is like a marriage. Some photographers are the "marrying kind" and some photographers are destined to be single. If you are trying to evaluate whether or not your business would benefit from having a rep you might want to consider these thoughts. Most agents can't afford to be at every shoot or go out daily with your portfolio. They prefer instead to do aggressive marketing campaigns. Any photographer that has developed and produced their own marketing campaign knows how difficult and time consuming this is. Add to that the tracking of clients and maintaining an excellent database . . . and you have created a full time repping job.

More on How to Find a Rep

Having found the reps you want to approach, use direct mail. Don't make cold calls. Reps don't want to hear your life story; they want to see your work. So let your work do the initial talking. Mail out printed promotion cards of your best work that show your style. If you have several promo cards, send them all in one mailing. Don't start a mailing campaign series. Give it your best shot in one mailing. Send only materials you don't want back. Do not send a portfolio unless you have permission first. The promo cards should look professional; if you don't

have any, seek expert help from a designer in developing some.

If you call an agent and you get their voice mail, tell them you are a photographer looking for a rep. It is not fair to call an agent and leave your name and number without the reason you are calling. Yes, they will call you back quickly, but they may think you are an art director in a rush to get a portfolio. You are misleading them. Why not wait for a comfortable time for them to talk.

Include in the mailing a concise letter stating, in essence, that you know that the person represents a certain photographer or photographers whose work you admire, and you would like to be in the same group. Again, keep in mind that your promo materials will speak more eloquently than your words. If you have a Web site, make sure you give the address.

Finding the right rep for your business can be an arduous task. If you look under "Artists' Representatives" in *The Workbook* directory, you will see thousands of names listed. If there are actually that many reps out there, why aren't they lining up to represent you? The truth is, once you start calling all those reps listed, you will find that many will tell you that they are not looking to take on new talent. Some will have you send your book and then tell you that they are not taking on new talent. (Wouldn't it have been better to save the shipping costs and know that up front?)

Agent Ralph Mennemeyer told me that a note sent with your promotion piece mentioning the referral from an art buyer or art director will help you get through to him. He has a great respect for photographers. But Ralph's main job is to get work for the talent he represents. It's difficult for him to make time to look at portfolios. But, his point is well taken—use your contacts.

What Makes a Rep Want You?

I asked a New York rep what the three most important factors were when he considers taking on a photographer. The personality of the photographer was the most significant thing to him. It is important that he gets along well with his talent. The second most important factor was the photographer having business smarts and an understanding of how "the business" works. The third factor was talent. I asked him why talent was last on his list. He told me that talent was the easiest thing to nurture.

Another rep told me that having a unique vision that can be applied to the commercial market was most important on his list when looking for photographers to represent. Next was a clear focus on what the photographer wanted a rep to do. The photographer's professional business manner was crucial as well.

Agent Colleen McKay specializes in fashion and beauty. She feels that for a photographer to be taken on by a rep, the photographer must have a good existing business. She told me that years ago the rule of thumb was that a photographer should be billing $100,000 in fees before a rep could consider taking them on. This was because a studio needed to be able to pay their own bills and have working capital for promotion and marketing. Reps also looked for photographers that had house accounts. When a photographer has loyal clients, the rep knows that whatever business they bring in can more likely turn into repeat clients.

Other Issues and Ideas

Is there a problem if you shoot in the same category, say food or people, as a photographer currently represented? Generally, no. The "category"

is not the competitive aspect it once was. Style of shooting, the "look" is. Competing categories will work; competing styles won't.

Don't expect, or ask, a rep who turns you down to recommend someone you could approach. Reps don't like to impose on their colleagues that way. However, reps do pass on information to their colleagues. For instance, they might receive a promo package from a talented people photographer but have someone whose work is similar. One of their colleagues could be looking for a photographer with that style and would appreciate getting the materials. Lucky breaks, for both parties, do occur.

Which is better, an agent who represents two photographers or an agent that represents ten? While it could be argued that the one with fewer photographers can devote more time to them, the other rep, with a larger talent pool of shooters, will probably have work coming in from many more sources.

The Society of Photographers and Artists Representatives (SPAR) is a rep organization, located in New York City, that was started thirty years ago by a group of photography and illustration agents. Members try to meet quarterly and they periodically publish a newsletter. When you are looking for a rep, the SPAR newsletter is a place you can advertise; the rates are not high. Call them and leave a message and your phone number. Remember, this is a volunteer organization, so you need to be patient, as often the person who checks the message service is not getting paid and will return your call when he or she has the time. Your ad can simply read along these lines: "Boston-based photographer looking for a rep. Beautiful portfolio, well designed promo pieces."